third edition

APPLIED
VISUAL
MERCHANDISING

KENNETH H. MILLS, Ed.D.
Regional President
South Central Technical College
North Mankato, MN

JUDITH E. PAUL, Ph.D.
Professor of Business Administration
University of Wisconsin-Platteville
Platteville, WI

KAY B. MOORMANN
Marketing Instructor
Chippewa Valley Technical College
Eau Claire, WI

Prentice Hall, Englewood Cliffs, New Jersey 07632

Library of Congress Cataloging-in-Publication Data

Mills, Kenneth H.
 Applied visual merchandising/Kenneth H. Mills, Judith E. Paul,
 Kay B. Moorman. – 3rd ed.
 p. cm
 Includes bibliographical references and index.
 ISBN (invalid) 0-01-304198-9
 1. Display of merchandise. 2. Merchandising I. Paul, Judith E., (date).
 II. Moorman, Kay B., (date). III. Title.
 HF5845.M54 1995
 659. 1'57 – dc20

Acquisitions Editor: *Priscilla McGeehon*
Editorial/production supervision: *Patrick Walsh*
Interior design and page layout: *Diane Koromhas*
Cover design: *Mary Jo Defranco*
Cover art: *Mary Jo Defranco*
Manufacturing Buyer: *Ed O'Dougherty*

Previously published under the title *Create Distinctive Displays*

© 1995, 1988, 1982, 1974 by Prentice-Hall, Inc.
Englewood Cliffs, New Jersey 07632

All rights reserved. No part of this book may be
reproduced, in any form or by any means,
without permission in writing from the publisher.
Printed in the United States of America

10 9 8 7 6 5 4

ISBN 0-13-041989-3

Prentice-Hall International (UK) Limited, *London*
Prentice-Hall of Australia Pty. Limited, *Sydney*
Prentice-Hall of Canada, Inc., *Toronto*
Prentice-Hall Hispanoamericana, S. A., *Mexico*
Prentice-Hall of India Private Limited, *New Delhi*
Prentice-Hall of Japan, Inc., *Tokyo*
Pearson Education Asia Pte. Ltd., *Singapore*
Editora Prentice-Hall do Brasil, Ltda., *Rio de Janeiro*

KENNETH H. MILLS, Ed.D.

This text is dedicated to Darlene my lifelong wife, partner, and best friend; the new lives and loves in our family, Christina Marie Theodoroff and Alexander James Theodoroff, who have caused us to remember the past, be cognizant of our blessings of the present, and have great hope for the future. Jesus is in each of them.

A special thank you to Dick Holmen for his excellent photographic work and professional expertise.

JUDITH E. PAUL, Ph.D.

To Tom, Mary Jae and Tobianne for the years of love and laughter. They allowed me to be creative.

Thanks also to Stacy Hampton DeGroot and Rita Brown for their time, interest and contributions to this text.

KAY B. MOORMANN

To my parents, Mr. and Mrs. Roy Benkendorf, for their love, support and encouragement.

The authors would also like to thank the Mall of America, Lands' End, Jockey International, Snap-On Tools, Dayton's, & J.C. Penneys for their contributions to the third edition of *Applied Visual Merchandising*.

CONTENTS

PREFACE

This third edition of *Applied Visual Merchandising* offers up-to-date trends, practices, and procedures in the world of display. The era of the "shopping mall" has made a considerable impact on the field of visual merchandising. Chapter 7 offers a view of the Mall of America and the impact it has made on visual presentation. Also new to the third edition is the chapter on Lands' End (Chapter 13). The purpose of this chapter is twofold: to show students how a direct mail merchant uses visual merchandising, and to show how the principles of display are applied to retail store layout and presentation.

Visual merchandising is a sales-support activity that considers every window and shelf of a retail establishment a stage on which to display, and thereby promote, the products and services offered by that store. According to visual merchandising professionals interviewed by the authors, visual selling—merchandise presentation in window and interior display—is responsible for about one out of every four retail sales. In addition, it is the visual merchandise director and his or her staff who give shape and substance to this vital force in retail.

The visual merchandise person's chief responsibility is to help the store increase its sales by effectively using display areas throughout the store, inside and out, to display merchandise. The average pedestrian spends only a few seconds looking in each store window that he or she passes, so it is essential that displays have impact in conveying the type, quality, and uses of the goods for sale.

The visual merchandise person's specific duties depend on the type and size of the establishment for which he or she works. In a large store, duties may consist solely of creating ideas, drawing sketches, and supervising other workers in making props and setting up the display. In smaller stores, the display expert may not only originate the idea but also carry it out in detail, right down to car-

consist solely of creating ideas, drawing sketches, and supervising other workers in making props and setting up the display. In smaller stores, the display expert may not only originate the idea but also carry it out in detail, right down to carpentry, remodeling of old equipment, and so forth. A display person also may be self-employed and freelance display services, or may work for a wholesaler.

Many people who work in merchandising need to know about display, regardless of their job titles and duties. The retail buyer will select merchandise to be displayed from his or her department and often will be responsible for replacing items purchased from floor or window displays. The fashion coordinator also will be involved with the display department, as will members of the advertising department. Therefore, it is essential that all merchandisers have a practical working knowledge of the purpose and functions of display so they may better present merchandise to the consumer.

It will be noted that throughout this text the practical application of display is stressed through a gradual building process. The text should be supplemented with knowledge gained through working with fellow students, giving demonstrations, creating displays, and contacting leading business people in the retail community. A well-rounded approach to display is necessary for anyone interested in management as his or her future goal, as well as for those wishing to pursue a career as a professional display person.

By mastering the materials in this text, the visual merchandising student will become proficient in:

1. Understanding the components of display
2. Analyzing and evaluating the various types of displays
3. Understanding the principles of color, lighting, and design
4. Constructing both hard-line and soft-line displays that are effective in selling merchandise
5. Designing, laying out, and producing showcards
6. Defining and properly using visual merchandising terminology
7. Selecting appropriate props for a given display
8. Understanding the place that visual merchandising has in a store, a department, or a corporation and its promotional effort
9. Developing a personal portfolio reflecting acquired visual merchandising skills

The final goal of the study of merchandise display is to provide the individual with the knowledge, skills, and understanding that will enable him or her to arrange a functionally effective display area. This display area should attract the customer's eye and induce him or her to enter the store, approach the merchandiser, and say, "Wrap it up, please."

By following the methods and procedures set forth in this text, you will be prepared for that occupational goal.

Kenneth H. Mills
Judith E. Paul
Kay B. Moormann

INTRODUCTION TO VISUAL MERCHANDISING

LEARNING OBJECTIVES—CHAPTER ONE

1. Define *visual merchandising.*
2. Discuss the importance of studying visual merchandising.
3. Discuss the importance of proper coordination between the advertising and display departments in a merchandise establishment.
4. List and explain the ten criteria that are used in an effective merchandise presentation.
5. Describe the guidelines that should be followed when planning a merchandise display.

WHAT IS VISUAL MERCHANDISING?

Visual merchandising is the presentation of a store and its merchandise to the customer through the teamwork of the store's advertising, display, special events, fashion coordination, and merchandising departments in order to sell the goods and services offered by the store. Visual merchandising is becoming more and more important in giving a store a competitive edge, since many stores share merchandise sources and therefore carry similar items. The thing that makes the difference is *how* the merchandise is presented. In other words, good visual merchandising gives the merchant an invaluable competitive edge as well as defining a store's personality in today's marketplace.

Neither advertising, display, special events, fashion coordination, or merchandising can function alone; all must be combined into a single team with one aim—selling the goods and services offered by the store.

Particular emphasis must be placed on the necessity for coordination between the advertising function and the display function—two major aspects of the various sales-supporting functions in a merchandising establishment. Advertising is usually planned well in advance of its presentation, as are the major seasonal displays. Advertising themes and campaigns must be backed up by interior and exterior displays, and the creators of both must be certain that the media space purchased and the display space used will contribute to the firm's profits.

Another factor requiring emphasis is the merchandise being promoted. Because complete coordination is necessary among copywriters, buyers, artists, and display people, all of them must be acquainted with the merchandise first-hand. There is no better way to lose a customer than to presell merchandise that does not fulfill the customer's expectations.

WHY STUDY VISUAL MERCHANDISING?

A study done by Waukesha County Technical College identified the following competencies that were, and continue to be, essential for careers in retail management or fashion merchandising.

1. Promote the company image and develop a plan for visual merchandising.
2. Establish high visual merchandising expectations for the staff.
3. Determine visual points of interest.
4. Follow company plan-o-gram for visual presentations.
5. Use appropriate hardware and props for a merchandise display.
6. Work with special events coordinators to promote the store.
7. Convey color coordination, fashion, and/or industry and seasonal trends to staff.
8. Be aware of stock levels and replenish basic stock as needed.
9. Re-merchandise markdown items creatively.
10. Determine the location of visual presentations and change displays on a timely basis.[1]

Developing, creating, and implementing effective visual displays requires an understanding of the company image and how this image can be conveyed to the customer. With that goal in mind, study of the mechanics of display creation and implementation can begin. The subsequent chapters were developed to prepare individuals to plan and create visual displays and become proficient at merchandising products to the consumer in a manner that will follow the principles of design, attract attention, and produce a sale.

[1]Dean Flowers, Jan Lathrop, and Barbara Ollhoff, Ed.D., *Visual Merchandising Curriculum DACUM Study*, Waukesha County Technical College (Pewaukee, WI, 1992).

FIVE STEPS OF A SALE

Visual merchandising must sell. It can do this most effectively when all the principles of design and arrangement are employed intelligently. This is possible only if the display person fully understands these principles and, by applying them, leads the customer through the five steps of a sale with the display. These five steps are:

1. Attract the attention of the passerby.
2. Arouse his or her interest.
3. Create desire.
4. Win confidence to give the customer faith in the store and product.
5. Cause the decision to buy (the customer, barriers broken down, makes the purchase).

Attract Attention

Visual merchandising must *attract* and *hold* the passerby until interest is aroused. A display can attract a person from over a block away, yet fail to arouse buying interest in the merchandise displayed. (See Figure 1–1).

If a display is sufficiently surprising and unusual, a potential customer will cross the street to view it more closely. It makes no difference whether this result is achieved by movement, color, lighting, form or lettering. *Contrast* especially can be relied on to attract the attention of a maximum number of passersby. Any method may be used as long as it does not evoke any disapproval or conflict in the observer's mind.

FIGURE 1–1 A display needs to attract attention, arouse interest, create desire...Courtesy of Dayton's, Oakwood Mall, Eau Claire, WI

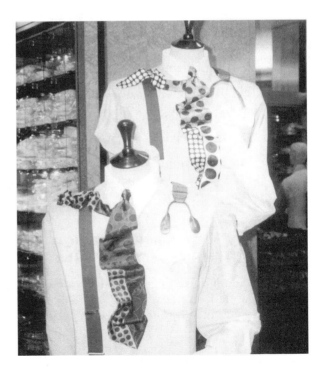

Arouse Interest

In a display, an observer's mental process should be directed systematically toward the target. For the most part, passersby approach windows without purpose. Attention is arrested by something positive, some striking point that we will term the *focus*, or optical center, of the display. This focus may be created by lighting, movement, color, or the merchandise itself. From there, the eye of the observer will move in the desired direction through the display by use of devices such as arrows—subtle or definite—that lead to the salable merchandise.

Observation should be guided along lines easy to follow: from decoration, to merchandise, to showcard (lettered display card that provides additional merchandise information), and finally, to the price tag. Use quality effects and make every attempt to create a favorable reaction in the mind of the potential customer.

Create Desire

The consumer may be made to want the product being featured when you

1. Demonstrate the qualities and benefits of the product.
2. Demonstrate the use of the product.
3. Present the product in such a way as to increase the possibility of inducing a sale. It is not sufficient just to please the observer; the objective is to sell the merchandise. Therefore, an impulsive desire for the merchandise must be aroused. Explain the necessity of the product, show its advantages, and win the potential customer's confidence in the establishment's firm faith in the product.
4. Sell the idea that the article is exactly what the spectator needs and that owning this article will bring complete satisfaction.

Win Confidence

Tell the truth about the product, bringing out the positive characteristics of both the store and the merchandise being offered.

Cause Decision to Buy

If you have done your job well up to this point and have successfully impressed your potential customer, the sale will be automatic. The customer will walk into the store or department and buy.

TEAMWORK: THE IMPORTANCE OF DEPARTMENTAL COORDINATION

When a department is redecorated, a new shop is opened, or a special event is planned, the advertising and display departments involved must know what's going on; and they must be as excited about the project as the planners.

A close relationship among the departments is not only advisable, it is essential. This is particularly true in sales promotion, which must reach out and entice the customer to the store again and again.

In every store, there should be one person with the final responsibility for the presentation of the store through sales-supporting activities. To do the job properly, that person must create the atmosphere and provide the means for understanding and the will to cooperate. Both are steps to the cash register, and one should not be emphasized over the other.

Good in theory, surely, but a problem in practice. It calls for

1. Planning ahead and planning together.
2. Adding more meetings to an already tight schedule.
3. Freely exchanging ideas (including a willingness to accept criticism and express likes and dislikes).
4. Ensuring that departments meet to discuss implementation of the plan for total coordination.

This list could probably be extended, but it all boils down to a communication of ideas, a great challenge, the wise use of talent, and ultimately, a better store in which to work. The display person's role in this total team effort will become clear as you proceed through the text.

Working together positively does not happen automatically. People have to be committed to working together, and they need to understand and practice effective human resource development skills if the "team" is going to be successful. These topics are covered in Chapter 16, The Visual Merchandising Team.

MERCHANDISE DISPLAY: SOME SPECIFICS

Merchandise display is the arrangement and organization of display materials and merchandise to produce a stimulus that leads to the sale of merchandise and services. It attracts the viewer's attention and induces action; it is visual selling and acts as a silent salesperson for the organization. Merchandise display is the three-dimensional, nonpersonal, physical presentation of goods and services.

Good display does ten things:

1. Sells products and services.
2. Publicizes the business.
3. Lays a foundation for future sales.
4. Builds prestige.
5. Educates the public.
6. Builds up the goodwill of the public.
7. Offers the public useful, practical demonstrations.
8. Familiarizes the public with the operations of the business.
9. Supports popular trends.
10. Harmonizes business interests with esthetics.

John Simone, in an article on the future of display, very appropriately stated the following:

> Windows must not only draw people into the store but must support advertising and even attract publicity. Interior display must augment suggestion selling and beef-up sales per square foot. Display must also serve a company's institutional objectives—not just selling. The emphasis is increasingly on a store's image, not just a look.[1]

Window Displays

Because the average pedestrian spends so few seconds considering a window, the display has to *talk fast*. To do this, the display must serve as an information link between the consumer and the store. The display tells the consumer what is available, frequently at what price, and why it is desirable.

The *why* factor (*psychological motivation*) is emphasized in sales promotion today, but it has not been used to a great extent in display. The use of psychological motivation in displays is important, because displays appeal primarily to people's emotions.

Businesses, small or large, cannot exist by selling only replacement merchandise. They must seek additional business by making merchandise emotionally or psychologically necessary. *They must create a demand for new types of consumer goods.* For example, in recent years, the promotion for men to wear colored shirts as part of a coordinated look for business has increased sales in shirt departments. The same is true of women's hosiery, sheets, towels, and almost every line of merchandise.

Window displays, whenever possible, should suggest that the merchandise give pleasure, comfort, or improved appearance, or that it will make some other addition to the consumer's life. Good window display will strive for this *benefit* technique. Every item in any store has such benefits. You have to evaluate the item in terms of how you can make it appear desirable to the consumer.

In planning the window display, the first step is to consider the store's policy. The window should reflect the store's merchandising and selling policies. Most stores make use of two basic types of displays: the *institutional display*, which promotes the total store, its benefits, services, and image, and the *promotional display*, which promotes one or more items of merchandise. The greater the number of merchandise items in a display, the more highly promotional the display. A detailed discussion of promotional and institutional displays appears in Chapter 12, Visual Merchandising Areas and Aids. Suffice it to say that a store's total policy, be it promotional, semipromotional, or nonpromotional (institutional), must be reflected in its interior and exterior displays.

[1]John Simone, "Visualizing the Future, The Direction of Display," *Visual Merchandise and Store Design* 124 (January, 1993): 67.

Interior Displays

Effective interior displays attract the eye and turn store trafficers into *stoppers*—people who stop and examine the goods. Often the difference between an ordinary display and an outstanding one is slight, consisting of the right decorative touch—one that, like frosting on a cake, helps to tempt buying appetites.

The kinds of displays used in a store depend, of course, on the types of goods handled and on the amount of space available; other considerations include budget plans and personnel available to do the job.

When you present your merchandise by putting it on display, your goal is to turn store traffic into shoppers and shoppers into buyers. Your success depends on the type and quality of display you use.

Sometimes a shopper merely glances at a display in passing. It attracts the eye but does not make a strong impression. A good display, however, will turn many of these "lookers" into stoppers who pause and study the displayed merchandise. In addition, some of the traffic that uses the store as a shortcut to another destination may stop to look at an outstanding display.

RULES FOR DISPLAY PLANNING

The following rules (refer, also to Figure 1–2) should be observed in planning a display:

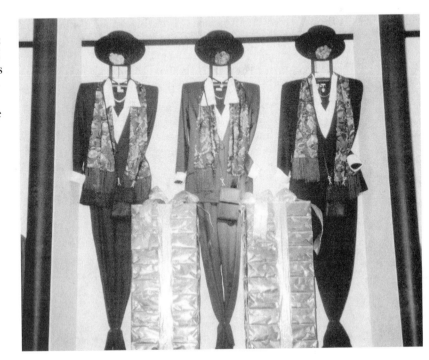

FIGURE 1–2
Following the basic rules in display will cause the customers to focus their attention on the merchandise and cause them to *want* the merchandise.
Courtesy of Dayton's Oakwood Mall Eau Claire, WI

1. Aid the eye in finding the focal point of the display easily.
2. Limit the number of competing elements in the display.
3. Give the display one dominant motif, all other ideas in the display being subordinate to it.
4. By using contrast and rhythm, add life to your colors and proportions.
5. Select display props and material having some connection with the exhibited product. Do not use display props that stand alone.
6. Do not allow the display props and material to take up most of the space or the best space in the window.
7. Avoid anything that conflicts with or takes away from the sales message.
8. Use colors appropriate to the season.
9. Do not mix styles.
10. Stand back and see if it *sells*.

Notes Concerning All Display Projects

The text will refer to the use of *shadow boxes*—four-sided structures used to construct displays for practice. Shadow boxes are ideal for practicing display construction because they may be of any size, and they are easily constructed and portable. However, if laboratory facilities do not permit the use of shadow boxes, other kinds of displays can easily be substituted, for example,

> Cardboard or masonite boxes of various sizes.
> Cases or enclosed areas in retail stores.
> Tabletops with pin boards (boards on which may be pinned display props or merchandise) behind them.

Students interested in industrial display may wish to work immediately with larger areas, continuing to apply the same principles. These areas might include:

> A corner of the display lab.
> A booth with a counter surface of several square feet.
> A bulletin board with tables positioned in front of it.
> A company's actual trade show exhibit.

Most of the project assignments in the text will be supplemented by the following practice aids:

> Project objectives
> Project explanation
> A display construction checklist (on page 9)
> A planning sketch sheet (Chapter 2)
> A loan sheet (Chapter 2)
> An evaluation sheet (Chapter 2)
> A peer evaluation sheet (Chapter 2)

One example of these aids is provided here: the display construction checklist, which contains activities and materials to be used in constructing displays.

DISPLAY CONSTRUCTION CHECKLIST

1. Decide on theme for the display. ———————
2. Decide on merchandise to be displayed. ———————
3. Arrange to obtain merchandise (use loan sheet if necessary). ———————
4. Select display area. ———————
5. Fill in display sketch sheet. ———————
6. Lay out the copycard. ———————
7. Produce the copycard. ———————
8. Clean and prepare display area. ———————
9. Accumulate props. ———————
10. Put the display in the display area. ———————
11. Evaluate the display (use evaluation sheet). ———————
12. Return merchandise. ———————
13. Return props. ———————
14. Clean display area. ———————
15. File materials on display in project packet for use in final portfolio. ———————
16. Thank store personnel for use of merchandise. ———————

SUGGESTED ACTIVITIES

1. Read and make reports on merchandising display from such trade publications as *Visual Merchandise & Store Design*. These reports may be written or oral on any aspect of display, highlighting its definition or importance.
2. Discuss the status of present-day displays and positive changes that would strengthen today's display effectiveness.
3. Seek opinions of displays in general from friends, relatives, and students from other classes. Do you find a consensus of the good and bad in displays today?

Student Portfolio Project

The objective of the portfolio project is to provide you with a visible summary of your abilities in the elements of display, merchandise presentation, signing, and display and prop production. The portfolio that you assemble may be used for final evaluation purposes by your instructor. The portfolio also may be used when you apply for employment in the field of marketing.

The portfolio project is assigned at the beginning of the semester and concludes during the last week of the semester. It is an ongoing, continuous activity. The portfolio should include the following items:

1. A list of all the competencies you have mastered in the area of visual merchandising (found at the beginning of each chapter).
2. Store merchandise summaries—display practices (Chapter 2).
3. Field trip summaries—prop construction (Chapter 3).
4. Display slides showing different display areas and application of the principles of design (Chapter 5).
5. Display construction criteria and evaluation guidelines (Chapters 6, 7, 12, and 15).
6. Color wheel and color scheme analysis (Chapter 9).
7. Sign layout and preparation (Chapter 11).

2

CRITICAL ELEMENTS: The Necessities

LEARNING OBJECTIVES—CHAPTER TWO

1. Define and explain the six elements of display that are used in a visual merchandise presentation.
2. List and discuss the components of a planning/sketch sheet.
3. List and explain the criteria that will be used on a merchandise display evaluation sheet.

As a student of merchandise display, you will be instructed in the *organization, planning, preparation,* and *arrangement* of effective displays. The methods and procedures discussed in this chapter incorporate proper display techniques and effective use of materials that are in keeping with the goal of the merchant.

THE ELEMENTS OF DISPLAY

Six elements can be isolated as necessary components in the production of successful display units. They are: *theme, merchandise, shelf or display area, props, lighting,* and *copycards* (showcards).

Theme

A display or merchandise presentation should convey a specific theme or idea; this theme is the framework for creating a visual presentation. Lack of a theme is the most common display error; therefore a theme needs to be properly

planned and developed. (The planning sketch sheet is at the end of this chapter.) A store's promotional policy dictates the appropriate theme of a display. A store may follow any of three basic promotional policies: promotional, nonpromotional, or semipromotional.

The Promotional Store

The *promotional store* is committed to a policy of aggressive merchandising because it has a very low margin of profit and thus needs a large sales volume to exist. Promotional stores generally advertise prices.

Promotional store displays are the most common type of display. They usually feature several items of merchandise, backed up by lighting, signs, props, and traditional display techniques, because many items must be sold if a reasonable profit is to be made. This store's advertising and displays customarily deal with only *physical merchandise*.

The Nonpromotional Store

The *nonpromotional store* generally sells top-of-the-line goods and services and employs only very selective advertising, with promotion techniques.[1] In the *service* display, only incidental mention is made of merchandise; service, special features, or facilities of the store are featured. In the *prestige* display, merchandise of great appeal is featured.[2]

Institutional displays create customer loyalty and goodwill, building a reputation for the store. It is difficult to measure their effectiveness, however, because they do not produce direct sales of merchandise as does a window featuring, say, a specific dress.

Most industrial concerns use institutional displays to get the name of the company to the public. They set up promotional or merchandise displays mainly when working with distributors or entering trade shows.

Institutional displays present a special challenge because the theme becomes all-important, as do appropriate props and signs. These displays must be handled carefully, so that they are not overrun by signs and meaningless props.

The Semipromotional Store

Besides prestige and service displays, many businesses also use merchandise displays featuring regular-price-line items, special-purchase items, and sales merchandise. These stores are said to have a *semipromotional* policy.

[1]Charles M. Edwards, Jr., and Russell A. Brown, *Retail Advertising and Sales Promotion* (Englewood Cliffs, N.J.: Prentice Hall, 1959), pp. 156–57.

[2]Ibid., p. 161.

The semipromotional display follows a middle course between those of promotional and nonpromotional stores. It must appeal both to bargain hunters and regular customers who look for some service and prestige promotion.[3]

DISPLAY THEMES

Before selecting a theme for a display, generally you will first determine how a particular display will tie in to other promotional activities. Displays might feature all merchandise in one color if a "color story" is being presented, or all one type of merchandise such as exercise outfits. Groups of merchandise such as exercise clothes along with leg warmers, warm-up suits, and shoes might be featured. A special event might be featured, such as the Olympics. It is within the total promotional framework of a store and/or business that the specific display area must do its work.

Specific theme ideas might center on a new fashion trend or silhouette or a popular fabric story such as the natural wrinkled fabrics popular in the mid-1980s. Preseason, midseason, or postseason clean-ups might be subjects for specific copycard messages.

Almost any establishment can take advantage of themes for display. Here are a few suggestions:

January White Sale	Academy Awards
Hawaiian Sale	Weddings
Back-to-School	Births
Lincoln's Birthday	Senior Citizens' Month
Forecast: Winter Weather	Grand Opening
New Year's Resolutions	Inventory Sale
Easter	Going-out-of-Business
Independence Day	Gardening Season
Thanksgiving	Mother's Day
Halloween	Father's Day
Chinese New Year	School graduation
Ground Hog Day	Research for disease cure
Christmas	Special foods
Jewish holidays	Fishing
George Washington's Birthday	Boating
Valentine's Day	Dairy Month
Memorial Day	Sports (baseball, football, basketball)
Lenten season	Honor the Veteran
Fall-Summer-Winter-Spring	Cooking
Mardi Gras	Fall Fix-up Time
Octoberfest	Auto-tune-up
Benjamin Franklin's birthday	Floral events

[3]Ibid., p. 157.

In Like a Lion—Out Like a Lamb (March)	Safety Week
Spring housecleaning	Travel
The Environment	Gifts
Church holidays	Bicycle promotion
Seasonal foods	Foreign Fair promotion
Election Year	Musical Fair promotion
Types of clothing (swimwear, skiing, and so on)	

The display person's job is to combine display principles and procedures with the chosen theme according to the display policy of the store.

The following are guidelines as to the correct use of themes in visual merchandising:

1. Overall themes should be selected after the bulk of the merchandise has been bought for the season.
2. Overall themes must relate to the merchandise in both color and concept.
3. Overall themes must create an image instantaneously—and it must be the correct image.
4. Overall themes can be achieved by the use of hanging banners or signs; floor signs; flowers or props that relate to the signs and banners; matching urns; merchandise coordination; and valance colors.

Smaller stores do better with an overall theme than do larger stores. The customer won't be bored by a strong theme in a small area but will become bored with an extensive repetition of an overall theme in a large space.

Separate Overall Themes (Department by Department)

1. Separate overall themes work best where they are related by architecture, color, or merchandise presentation techniques.
2. Separate overall themes can conflict if one is much stronger than another in the shop next door. You want the customer to enter all the shops, not just one or two.
3. When selecting a department theme, make sure that it's compatible with all the merchandise, not just a selection of goods.
4. Developing resting areas for the eyes between theme areas will refresh the customer's desire to see another exciting area.

Combinations of Themes

1. A mixture of total core concept and separate department themes is most effective if the separate themes relate to both the core decor and the unique merchandise classifications within the individual departments.
2. Overuse of the core theme can become dull even when worked in with the separate overall themes.

Merchandise

Merchandise is the element that supports the theme of the display and, ultimately, the final value of the display in the light of the merchandising goal. All other elements are intended to support and promote the goal that this initial selection of merchandise or idea produces—special promotion, holiday, seasonal, high fashion, and so on. The merchandising goal, of course, is to sell the goods or services offered by the store.

Shelf or Display Area

Shelves and display areas provide the actual physical framework for the display. If the display area is movable, its appropriate placement within the total layout of the establishment must be established.

Before the props, lighting, or showcards are considered, this physical facility must be analyzed to determine what, if any, problems could arise involving the use of the area. During such analysis, it is important to keep in mind that the viewer's eye must move easily throughout the display, regardless of the direction from which he or she approaches.

The type of merchandise that will be displayed (or in the case of an institutional display the idea, the service or benefit offered) influences the selection of a display area. A small item such as jewelry will require a case to be properly displayed, whereas linens may require cube units and a floor display to promote the merchandise effectively.

Props

Display props include all physical objects within the display area that are not considered salable merchandise; namely, floor coverings, wall treatments, backgrounds, mannequins, shelves, steps, and other objects involved in creating settings for the merchandise. Display props, however, must not overshadow or dominate the salable items. (Steps for dressing mannequins are discussed in Chapter 12, Visual Merchandising Areas and Aids.)

The major purpose of display must always be kept in mind: to present and sell merchandise to the consumer. Table 2–1 illustrates some props and their suggested uses in setting the "climate," "tone," and "message" of the display.

Props can be of various types. Some props hold merchandise such as mannequins, and some are provided for atmosphere, such as flowers in a vase or wicker butterflies. Others combine function and atmosphere, such as a large wicker trunk used to hold accessories and separates while enhancing the summer theme of a window.

Larger props actually change the shape and size of a window. Examples of these include a movable back panel or a valance used to make a window appear shorter if it is too narrow and tall. Architectural props that can be constructed, stored, and repaired open up many options to the visual merchandising person.

TABLE 2–1 Props and Some Suggestions for Their Use

Props	*Suggested Uses*
Folding chairs	To separate many "go-together" and/or similar items sufficiently so that each item gets its own special viewing.
Colored rods	To lead the viewer's eyes through a collection of various multicolored accessories. (The rods may be of various sizes.)
Stools	To act as risers (of various heights) and supply the rungs that serve as intermediary spaces for merchandising.
Oversized props	To be used with normal-sized props to accentuate certain parts of the display—making clothes seem shorter for example or colors stronger. Giant props include telephones, pencils, electrical outlets, knitting needles, etc.
Mannequins (nonrealistic)	To get attention; for example, to "fly" merchandise from a red, white, and blue mannequin for a Fourth of July motif.
Netting	To suggest a volleyball game; to display fishing equipment and camping wardrobes.
Animals	To enhance promotion, position baby ducks following a mother duck who is trailing youngsters in their back-to-school outfits, for example.
Paper cutouts	To be placed across the front of a display along with giant scissors to look like paper dolls for a back-to-school motif.
Books/step (library) ladder	To give a natural setting for a display of back-to-school merchandise.
Grids (white and colored)	To create an action-filled window by stuffing with clothes in different postures highlighted by signs with simple repeated messages.
Doorway (and a direct down light)	To indicate an office or campus setting where fashionably dressed men and women meet and mingle.
Large cut-out puzzle pieces	To lead viewer through the display by placing appropriately in mannequin's hands.
Balls and balloons	To lead the viewer through display. Can be used with sporting events, celebrations, etc.
Large props	To display small objects (an attention-getting technique). An oversized palette can be used to display a range of colors found in a lipstick collection, for example.
Fans	To create motion and thereby draw attention to the mannequin.
Trees (bamboo, cardboard, fir)	To create seasonal settings in keeping with the time of year *or* to create a resort setting in the middle of winter.
Hammock	To simulate summer mood. Can be accompanied by pitcher of lemonade, straw hats, mannequin dozing in hammock.
"Name" designer display	To highlight a well-known fashion name. Appropriate are a large black and white photograph of the designer in the background with his or her brightly colored creations positioned in the foreground.
Paintings and sketches	To reproduce landscapes, animals, people, etc., with which mannequins interact.
Paper bull's-eye	To generate an action scene with mannequins as archers in various poses.
Formal decorator appointments	To reflect elegance Velvet carpets, ballroom chairs (with velvet seats), damask draperies, and crystal chandeliers create this mood.

TABLE 2–1 (cont.)

Props	*Suggested Uses*
Flowers/shrubs (real or artificial)	To soften display or add formality. Consider satin orchids and a satin moon as background for a mannequin modeling a designer ball gown. Conversely, shrubs can be used to simulate a back-to-nature motif.
Gift boxes/bags (with tissue paper)	To lend a festive tone. Use various sizes, colors, and shape and highlight with spotlights.
Fabric	To lead viewer through the display.
Posterboard	To be cut out, drawn on, positioned in scene to add excitement to seasonal display. (Hearts, autumn leaves, snowflakes, and pumpkins are examples.)
Everyday "found" items	To develop contrast. A brown paper bag as a backdrop for a pair of diamond earrings is attention getting.
Rope	To be used as a clothes line, trapeze, swing, anchor line, or lasso; to spell out letters; or to frame things, such as trees, buildings, and the like.
Shoes, gloves, hats	To emphasize action, give depth, set mood. To enhance merchandise already being displayed.
Screens	To limit area being displayed; to limit merchandise being displayed (used often with lingerie).
Small props	To make normal-sized merchandise appear larger.
Tie-in theme	To use current popular film promotion to promote merchandise (for example, poster from a Halloween thriller used to promote "trick or treat" costumes).
Furniture	To increase display options (for example, an antique desk with drawers, doors, and top in open positions to allow draping of clothing in, on, and around open areas).
Ironing board(s)	To display clothing (but other creative uses may be even more effective).
Display case	To provide mannequin with the "role" of being a shopper. Have mannequin positioned to be examining the merchandise in the display case; have mannequin carrying the store's shopping bag; etc.
Cardboard waves	To simulate ocean, seaside, beach scenes in summer and resort environments in winter. Add sunglasses, bathing caps, suntan lotion for a beach scene.
Hats	To hang on back wall, to position atop walking sticks.
Terra cotta or glazed pots	To be used with clothes—draping merchandise on them and around them.

Lighting

Lighting within the display is used to draw attention to a part of the area or a specific item in the display, or to coordinate parts of the total area. Lighting emphasizes items or areas; it also may be used to bring motion into the various segments of the display and to direct the viewer's eye.

Types of lights, in addition to usual indoor lighting arrangements, include floodlights, revolving lights, black lights, colored lights, flashing lights, and spotlights. Lighting is covered in detail in Chapter 10, Guidelines to Lighting.

Copycards

Copycards or showcards, (lettered cards or signs) provide the viewer with information concerning the displayed items and their benefits to the consumer. Copycards are that additional incentive so important to visual selling. Copycards are designed appropriately in lettering style, content, emphasis, size, and placement, so that the message they convey to the viewers will be in agreement with the purpose of the total display. Lettering is covered in Chapter 11, Sign Layout, and Appendix A, Supplemental Alphabets.

Signs do the talking for a display. They give significant details about the article, such as size, styles, and colors. Thus, as silent salespeople, signs answer customers' questions about price and features and tell where the goods are located in the store. Consider the following suggestions in thinking about the signs you use on your interior displays:

1. Make your signs informative. The wording should be compact and, when possible, sparkling.
2. Strive for a professional look. Compact printing machines can supply lettering if you prefer to do your own signs.
3. Ensure that the signs are clean. Nothing spoils merchandise quicker in the customer's eyes than a soiled sign.
4. Keep signs timely by changing them often.
5. Try to make your signs sell customer benefits rather than things. Signs for clothes, for example, should sell neat appearance, style, and attractiveness rather than utility. For furniture, they should sell home life and happiness rather than just lamps and tables.[1]

FORMS TO BE USED THROUGHOUT THIS TEXT

Various forms and procedures have been adopted to clarify the information found in this text to expedite your understanding of it. The forms introduced here will be used throughout the text.

Sketch Sheet for Planning the Display

Before actual activity begins on the production of a display, the display must be planned. This planning must include consideration of the specific elements involved, as well as the development of a temporary display program to occupy the space so that the display area will not be vacant while production takes place—each moment the area is empty is lost potential for attracting customers.

All materials, props, and so on must be prepared before one display can be disassembled and another constructed. Thus, in the classroom, planning is

[1]Gabriel M. Valenti, *Interior Display: A Way to Increase Sales,* Small Marketers' Aids, No. 111 (Washington, D.C.: Small Business Administration, February 1965), 3.

stressed and should be a part of evaluation; in reality, however, it is taken for granted as a part of the professional routine of the display artist. Constant use of the planning sketch sheet will aid in creating better displays.

Inventory Sheet

The following is a list of display materials that your marketing department should make available. Your instructor will assist you in making such a list for your specific department. Other props and materials may be constructed or refinished by the display students.

Basic necessities
 Masking tape
 White posterboard
 Colored posterboard
 Large stick pins
 Small common pins
 Spool thread
 Fishing line, monofilament
 Thumb tacks
 Finishing nails
 Hammers
 Large scissors
 Wire cutters
 Stapler
 Staple gun
 Transparent tape
 String
 Assortment of crepe paper
 Assortment of fabrics (3-yd pieces)
 Assortment of latex paints
 Exacto knife
 Foam board
 Rubber cement
 Large-item prop purchases (budgeted
 equipment for display laboratory)
 Family of mannequins
 Three turntables
 Spot- and floodlights
 Flashers for lights
 Artificial grass carpets
T-stands
Low-budget props
 Artificial leaves
 Logs (split and whole)
 Wire garbage cans
 Construction paper

India ink
Showcard water-color paints
Two-sided supported screen
Window draperies
Circular stands
Glass counter and case with shelf
Open-back display window with lighting
 and gridded ceiling
Closed-back display window with lighting
 and gridded ceiling
Shadow boxes (either built-in or made
 from pegboard and plywood)
Round table
Guidesticks
Rulers
Yardsticks
Light bulbs
Extension cords
Ladder
Large brooms
Spray paint
Masking tape
Assortment of colored carpets corre-
 sponding to window sizes
Assortment of bricks
Crushed cork
Crushed styrofoam
Bust forms
Artificial potted plants
Cardboard boxes of all sizes (can be
 used as shadow boxes or kiosk centers)
Metal shelves
Fishnet
Pieces of plywood boards (for brick and
 board shelves)
Cutawl

Evaluation Sheet

After preparation, the display will be evaluated for use and arrangement of merchandise and materials, and application of design principles. This evaluation will illustrate problem areas, so that later displays and each person's efforts will become increasingly effective.

The display evaluation sheet that follows shows a suggested evaluation procedure covering the items in display preparation that determine its effectiveness. It is to be used for both self-evaluation and an instructor's evaluation.

SUMMARY

From this point, it is possible to proceed with an orderly and comprehensive study of the art of merchandise display.

In the chapters that follow, the history and philosophy of visual merchandising, a series of demonstrations illustrating techniques of proper lighting, color theory and application, display area preparation, and the proper arrangement of display will be given, and the topics of merchandise selection and types of display and trends will be considered (in Chapters 3, 7, 9,10, 12, 14, 15, and 16.)

Instructional units also are presented involving the actual techniques of layout and lettering, culminating in the production of copycards. The skills necessary for the production of the cards may actually be mastered from these (Chapter 11).

The selection of merchandise and services deemed appropriate for displays are discussed in Chapter 7 and 8, and the principles of design and arrangement that will enable you to select and organize the elements of the display are included (Chapters 4, 5, and 6). Finally, the visual merchandising team is presented.

SUGGESTED ACTIVITIES

1. Take a complete inventory of your display department for future reference.
2. After discussion with the instructor, decide what method of lettering will be used in your displays. Proceed with acquiring the skills and materials for future signs. (See Chapter 11.) Sufficient skills must be attained so that show cards having a professional appearance may be created for the ensuing displays.

Portfolio Project One: Display Process Reports

The purpose of this project is to have students obtain visual merchandising information from the stores in their community and share that information with each other. Each student or small group of students will be assigned one of the following areas of information until all suggested areas are covered. These areas include:

Handling mannequins and dressing them
Pinning merchandise to a flat surface in three-dimensional form
Making props
Lighting effects
Flying merchandise from overhead areas
Draping props and merchandise
Preparing merchandise for display
Steps involved in preparing a merchandise presentation for a seasonal store change, in-store promotion or a clearance sale
Each group will do a written report and present it to the class.

PLANNING/SKETCH SHEET

1. Group Members:

2. Date:

3. Theme of Display:

4. Type of Display:

5. Display Area:

6. Merchandise to be Used:

7. Props to be Used:

8. Show Card (wording and layout):

PLANNING/SKETCH SHEET (CONT.)

9. Merchandise Loan Sheet:

10. Sketch: Please show sketch below.

11. Present sketch to instructor for his/her signature:

MERCHANDISE DISPLAY EVALUATION SHEET

1. Group Members:
2. Date:
3. Theme of Display:
4. Type of Display:
5. Display Area:

Evaluation (5 = high, 1 = low)

	5	4	3	2	1
1. Power to Attract Attention	5	4	3	2	1
2. Theme or Central Idea Readily Identifiable	5	4	3	2	1

Principles of Design: (Formal or Informal)

	5	4	3	2	1
3. Balance	5	4	3	2	1
4. Rhythm	5	4	3	2	1
5. Harmony	5	4	3	2	1
6. Emphasis	5	4	3	2	1
7. Proportion	5	4	3	2	1
8. Use of Props	5	4	3	2	1
9. Use of Lighting	5	4	3	2	1
10. Use of Color	5	4	3	2	1
11. Timeliness	5	4	3	2	1
12. Cleanliness	5	4	3	2	1
13. Showcard Lettering, Size, and Message are in Harmony with Display	5	4	3	2	1
14. A professional thank-you letter is to be presented to the instructor (if merchandise has been borrowed) when the display is evaluated. A grade will not be given until the letter/envelope is presented to the instructor.	5	4	3	2	1

Total Points _____

Grade _____

Comments:

MERCHANDISE LOAN FORM
FOR

(NAME OF STORE)

Directions: Complete columns 1 through 6 when the merchandise is borrowed for a display. At that time the student responsible for the merchandise and the store employee authorizing the loan should sign their names in the appropriate space at the bottom right-hand corner. Any special instructions should be noted at that point.

Column 7 should be initialed by an employee of the store upon return of the merchandise. **IMPORTANT**: Each item must be initialed as that employee checks it back into the store. If there are any problems at that time, they should be noted in Column 8.

Qty.	Style No. & Description	Color	Size	Price	Date Borrowed	Returned	Comments

Special Instructions: _____

Student Responsible for Merchandise: _____
 Signature

Store Employee Authorization: _____
 Signature

PEER EVALUATION SHEET

List group members' names (last, first).

DO NOT LIST YOUR NAME ANYWHERE ON THE SHEET!!!

1. _____

2. _____

3. _____

4. _____

Please indicate each group member's performance by using the ranking scale of 5–1 provided earlier.

	1	2	3	4	5
Attitude					
Meeting attendance					
Cooperation					
Quantity of work					
Quality of work submitted					
Met group deadlines					
Leadership					
Creativity					
Understanding of project					
Kept group goals in mind					
TOTAL					

For additional comments, use the back. Each evaluation sheet must have comments or ten points will be deducted from the evaluator's sheet. If no sheet is turned in, 20 points will be deducted from the evaluator's score. If the sheet is turned in late, ten points will be deducted from the evaluator's score. The completed peer evaluation, with comments, is due at the beginning of class on _____ (the day your display is to be evaluated).

PEER EVALUATION RATING SCALE

5 Superior
The student performed at an outstanding level in all phases of the project, including leadership, contributions of time and ideas, technical quality of work, and ability to cooperate with your group.

4 Above Average
The student's contributions were, although not superior, above average. The student made most meetings, was enthusiastic and cooperative, and contributed more than an average amount and higher than average quality of work.

3 Average
Overall, the student's contributions were adequate; a minimal level of acceptability. The student did not adversely affect the project but did not make more than an average number of contributions nor was the quality of their work higher than average.

2 Below Average
Overall, the student's contributions were below average. While some work was performed, both quality and quantity were below average. No leadership was given. The student missed meetings and generally was not cooperative.

1 Inferior
Overall, the student made no meaningful contributions to the project. The student attended few meetings, missed deadlines, and did not produce either a satisfactory level or amount of contributions to the project. The student generally was uncooperative and offered no leadership.

Instructions for Peer Evaluation Sheet

1. List group members' names in space provided (last, first).
DO NOT LIST YOUR NAME!!!!!
2. The number of the line corresponds to the number of the column. The student listed on line one is graded in column one, student listed on line two is graded in column two, etc.
For each area listed, apply one of the above ratings that best represents your view of the student's performance in that area.
3. Total each column for each student's overall performance rating.
4. You are required to give a short written description of each student's performance on the back of the score sheet. Each evaluation sheet *MUST* have comments or ten points will be deducted from the evaluator's score. The description is to be *neatly* and *legibly* handwritten in ink.
5. These ratings are, and will remain, *confidential*. Each group member will be provided only with an average overall score given by each group member. Your frank and honest evaluation is required in order to provide fair grades to all students.
6. Please return the forms to your instructor by the time and date requested. If the form is late, a penalty of ten points will be deducted from the evaluator's score. If not turned in at all, 20 points will be deducted from the evaluator's score.

3

ORIGINATION AND PROGRESSION

LEARNING OBJECTIVES—CHAPTER THREE

1. Describe the growth of visual merchandising during the twentieth century.
2. Identify factors that affect current display planning.
3. Discuss the philosophy of visual merchandising.
4. Explain the primary responsibilities of the visual merchandising staff.

"Curtain going up. Places, everyone."

With an air of excitement the little group moved behind the backdrop. This was like opening night on their own private Broadway stage.

A tall, thin man standing against the wall looked questioningly at another man who stood just a step in front of the group. After hesitating a moment, the second man nodded, and the thin man reached up and pulled a rope. Slowly the curtains parted to open the scene to the audience.

Outside in the snow, the spectators gasped with pleasure and awe at the colorful, animated scene that was revealed. Children were lifted up so that they could see over the crowd.

Inside the store, the people sighed with relief. The man who had signaled the curtain raising nodded his head in satisfaction and turned away.

"Going to get some rest?" someone asked.

The man stopped. "No," he said with a smile. "I'm going to start planning next year's Christmas display."

The viewers outside started to move slowly along the windows, stopping to exclaim as they came to each new scene. Coming downtown to see the Christmas

window displays at Putnam's was as much a part of holiday activities as shopping in the store would be later on. The extra budget allowance for these magnificent scenes would more than pay for itself.

<p style="text-align:center">* * *</p>

This excitement characterizes every Christmas season, as well as other occasions when effective, well-planned displays are created. A great deal of attention has been given to display and its artistic and profit-making function.

Where did it start? And how has display changed since then?

THE HISTORY OF DISPLAY

Display at Its Inception

The idea of display is as old as history itself. It can be traced back to people's first inclination to decorate their bodies or in a new way to indulge their desires to gain status in their environments.

However, display as we know it was almost nonexistent until early in the twentieth century. Before then, purchasing power was limited, and there was no pressure to present the public with the full range of goods offered for sale by an establishment. Spending was mostly for staples, leaving few, if any, dollars for goods whose purchase might be triggered by the emotional excitement of a compelling display.

Later, as the middle class began to emerge, merchants tried to show their wares by cramming as many items as possible into the window display area. Or, if the store catered to the "carriage trade," the windows might contain, instead, large vases filled with flowers and placed against a background of wood paneling or velvet draperies. In the spring, forsythia would appear in the vases, and in the fall, oak leaves. By about 1922, every merchant who could afford it had gleaming backgrounds of mahogany or walnut paneling in his windows. But still no attempt was made to glamorize or enhance the product itself, or to place it in such a position in the window as to promote its sales appeal.

If the establishment was a large one, the constant cramming of display areas and shuffling or merchandise became an unhappy, time-consuming task in the eyes of both the merchant and the person responsible for filling and emptying the window.

Development of Display Personnel

The first display person appeared on the scene in the early 1900s to maintain the crowded window area. His job was primarily custodial, and his major responsibility was to keep the merchandise clean and the window area free from debris. Merchandise was selected for the window only in terms of how much the display person could fit into the given space.

This person, who was known as a window trimmer, had no training in artistic principles, merchandising goals, or the profit motive. His greatest expression of creativity was occasionally to place a vase of flowers in some vacant corner of the window.

Also at this time, mannequins appeared as display props. They were constructed of wax and tipped the scales at about 300 pounds. Not only were they heavy and difficult to move, they often melted in the sun-heated windows, making it necessary to remove them on hot summer days. Needless to say, these dummies left much to be desired in the way of functional display props.

Display Enters the World of Art

As art forms, window and other displays may never be exhibited in our more conservative museums; but displays can be imaginative and artistic, an idea that developed in Europe soon after the end of World War I.

European artists, especially in Germany, became interested in proving that art has a functional form; that is, that good design could be used commercially. However, as display progressed from infancy to adolescence, it was significantly affected by the Exposition of Decorative Arts in Paris in 1926. Those interested in the art of display for the purpose of merchandising set out to emulate in the marketplace the type of art that was exhibited at the exposition for totally esthetic purposes.

Odd and varied art objects, many of them made of plaster of paris, were constructed for display windows and had no possible use other than their questionable presence there. Merchandise was once again forgotten, this time for the sake of a new art form.

In the 1930s, the application of psychological dream analysis to merchandising interrupted the growth of display for one mad period. Surrealism—the art form of that decade—as expressed in display windows, did stop people as they passed, but only long enough for them to laugh. Few display people used the theme to advantage.

However, during this period several people gained status as professional display artists, and they developed individual styles and techniques of display that have left indelible marks on the pages of display history. Hence the idea had developed that a window could be used to frame an artistic arrangement that would interest passersby.

After the interruption of World War II, retailers gradually began to hire artists to create their window displays. Stores set up display departments and staffed them with people who were trained in art, design, and interior decoration, and who also understood merchandising. These people had the courage and the ability to develop original ideas and make use of modern art forms. Using lifelike mannequins in natural poses added interest and realism to displays.

CURRENT STATUS OF DISPLAY

Today, retailers have discovered the power of attractive displays to bring people into their stores, to interest customers in their merchandise, and to create a desire for the items displayed. Through displays, especially in their store windows, they tell you what they have that is new and different and suggest ways to make you and your home more attractive. All stores, large and small, use displays to catch the attention of passersby and help sell merchandise. The best displays are designed to make you think, to appeal to your emotions, and to persuade you to buy. Table 3–1 contrasts past and present displays. Table 3–2 outlines the considerations that were most relevant in the 1980s.

Visual display in the 1990s will continue to reflect the social, political, environmental and economic issues of the day. Demographics are changing and effective displays will have to mirror company image and direction while appealing to a specific market niche.

Display has now become a profession, an integral part of the promotion and sale of merchandise. Across the country today, there are many groups of resourceful and imaginative men and women working against deadlines that would defeat less inventive designers. They combine artistic understanding—some, even genius—with the profit motive and pragmatism of the merchandiser. Our society looks upon them with respect and admiration, and they are amply rewarded, financially and otherwise, for their efforts. Display personnel maintain a weekly level of excellence that would be hard to equal in other fields, their windows having an esthetic cleverness that seems to reach through the glass to catch the window shopper's attention.

It is difficult to estimate the number of employees in the field. Anyone who arranges a few objects in a store window or on a counter may be considered a display person. Reliable industry sources indicate, however that the number of professional, full-time display workers in the United States range between 60,000 and 70,000.

TABLE 3–1 Past and Present Displays

Characteristics of Displays of the Distant Past	*Positive Characteristics of Displays Today*
Unorganized charlatanism (unprepared person practicing display)	Planned, professional, up-to-date business methods
Show window part of the storage space	Spacious display of selected merchandise
Disorderly	Systematic
Unplanned	Methodical
Poor display techniques	Artistic value
Dull and careless	Bright and careful
Bad taste	Attractive, tasteful
Negative effect	Positive effect
No selling factor	Sales promoting

TABLE 3–2 Today's Displays: A Guide to What's "In"

Emphasis on and depiction of current social, political, and economic trends.

Recognition and adoption of those techniques used by the industry's influential display artists.

Use of mannequins in unconventional ways—and use of unconventional mannequins.

Introduction of "movement" in display (fixturing with fans, strobe lights, etc.).

Adoption of computers to direct movement in theatrical displays.

Use of low-cost, untreated materials and "found" articles (e.g., making mannequins out of craft paper).

Recognition of the sexual confidence that characterizes the 1980s.

Introduction of imaginative lighting and lighting fixtures.

Recognition that displays should echo the philosophy of the store and should coordinate with all other relevant displays in the store.

SOURCE: Linda Cahan and Joseph Robinson, *A Practical Guide to Visual Merchandising* (New York: John Wiley, 1984), p. 341

Display today is a competitive, calculating, psychoanalytic profession of visual selling.

THE PHILOSOPHY OF VISUAL MERCHANDISING

Visual merchandising is part of our popular culture. It adds to a pleasurable environment and has a welcome usefulness as a constant, constructive stimulus to better living that promotes the products of a healthy industrial economy.

Display is a handicraft as well as an artistic occupation, designed to promote the sales and further the prestige of the business it serves. It is a specialized branch of commercial art, faced perhaps with more problems than some other branches because of the constant pressure for both creativity and performance.

Improvisation makes display fresh, spontaneous, and bright and is the core of its vitality. Display serves its purpose briefly and then vanishes. Its creativity must run on a timetable, and much of the work's potential value is never realized, owing to the brief existence of the display and the limited audience it serves.

Visual merchandising personnel constantly seek new concepts and fresh formulas. Rather than copy what has been used by others, they develop new ideas, realizing that originality must be one of their cardinal rules.

Display is art first, handicraft second. It is commercial art because it serves commerce; it is art in that it is creative, imaginative, and truly versatile. The display person must master both two- and three-dimensional techniques; use color, form, movement, lighting, and the properties of different materials to obtain the desired effects; work only for the present, although the past and the future will be featured in his or her creations; and combine the inspiration of an artist with the hands of a craftsman and the mind of a salesperson.

Some of the visual merchandiser's problems lie in the duty to marry art to sales promotion and evolve these two into a harmonious entity. Sales appeal and

taste must form a perfect match, free from constraint. The display person is the creator of the final, all-important phase of advertising, the one who ultimately transforms the potential customer's semiconscious interest into desire for possession, breaking down inhibiting barriers and directing the customer's final steps toward the sales counter.

SUGGESTED ACTIVITIES

1. Make this test: Stand outside your favorite store, count the number of people stopping in front of a window, and listen to what they are saying about the display; absorb the feeling given by the audience, then draw your own conclusions and bring them back to discuss with your classmates.
2. Interview display personnel representing various types and sizes of stores in your community and attempt to determine how display has changed in the community.

Portfolio Project Two: Fieldwork

Arrange a tour to one or more of the following places

A display supply house
A large department store's central display department
A small store's prop room
An industrial advertising department where trade-show displays may be planned, constructed, and so on.

where you will observe

The preservation and care of display props
Seasonal display props
Prop ideas appealing to individual students
The construction of specific props
Procedures in utilizing props
Point-of-purchase materials provided by manufacturers

Each student will submit a written report. A class discussion will follow.

4

THE
FRAMEWORK
OF VISUAL
MERCHANDISING

LEARNING OBJECTIVES—CHAPTER FOUR

1. Define the five principles of design: balance, harmony, proportion, emphasis and rhythm.
2. List and be able to identify the three types of store fronts.
3. List and be able to identify the eleven types of window display areas.
4. List and be able to identify the twelve types of interior display areas.

THE PRINCIPLES OF DESIGN

The principles of design are used in all art forms. When knowledgeably applied, they combine to create purposeful, effective, esthetically-pleasing entities, whether in the fine arts, commercial art, or visual merchandising. In display, they appropriately coordinate all the parts of the display in varying degrees. A knowledge of these principles is imperative for the person seeking to become skilled in display. Therefore, after discussing the steps of a sale as applied in display, it seems natural to analyze a display in terms of these principles—the coordinators.

The five principles—*balance, emphasis, harmony, proportion,* and *rhythm*—will be defined and presented here briefly; their use and application will be examined more thoroughly in later chapters.

Balance

Balance may be defined artistically as the state of equipoise between the two sides of an entity. It involves itself with the equilibrium and weight of the different elements or opposing forces of each side.

Balance refers to the displaying of merchandise "in such a manner that a pleasing distribution of weight occurs. Weighing, to determine balance, involves estimating and comparing the values and importance of the two sides of the display."[1]

Emphasis

Emphasis simply refers to the point that appears to be most dominant in any particular and bounded display area. It is the place at which the eye makes contact with the total display field. The several methods by which a point of eye contact or a point of emphasis may be created will be discussed in depth in Chapter 5, The Design Principles of Balance and Emphasis.

Harmony

Harmony pertains to the agreement among the various elements of the design that are unified to obtain a pleasing effect. Merchandise, lighting, props, shelf space, and showcards are combined through balance, emphasis, rhythm, proportion, the correct use of color, and the use of texture to create an aura of visual, artistic, and commercial agreement and correctness.

Proportion

Proportion is concerned with the ratio of one aspect of the display to any other. The relationship or ratio of merchandise to total space must be considered. One piece of merchandise must be considered in relationship to the others. The ratio of various props and showcards to the total arrangement of merchandise on display is also important. One particular object should not seem too large, too heavy, or too small in proportion to others in a display area.

Rhythm

Rhythm involves the measurement of motion; motion and proportion culminate in the eventual flow that occurs in the entity.

Rhythm pertains to the path the eye takes after making initial contact with the display. It is important that the eyes of the customer are led throughout the entire display area and do not leave the display until all parts of it have been seen.

[1]Jimmy G. Koeninger, *You Be the Judge: Display* (Columbus: Ohio Distributive Education Materials Lab, 1974), p. 10.

THE DISPLAY'S HOUSE—THE STORE

A store's personality is clearly shown by the way it chooses to display itself—from the bargain basement to the top floor, from the front door to the rear entrance, and all along the way. We will now discuss how the principles of design and arrangement are applied to various types of display windows in a variety of stores.

Outside the Store

There are all types of retailing establishments: the suburban store, the self-service store, the dealer, the exclusive shop, and so on. But whatever the type of store, its sidewalk appearance, or front, will fall into one of three general categories: arcade, straight, or angled.

The Arcade Front. Aracde fronts are usually spacious. They allow the window shopper to amble around the outside of the store, off the sidewalk, and scrutinize merchandise closely. Arcade fronts may be open in sweep or more complex, with island-type windows. They seem to be more relaxing to the shopper and often take on highly surrealistic shapes, with concave or slanted panes of glass and beautifully decorated windows. (See Figure 4–1.) Windows are the promise of the store, and they deserve careful consideration.

The Straight Front. This type of front parallels the sidewalk, with its monotony broken only by entrances. The entrances may be recessed into the main floor area, but all the lines are identical. (See Figure 4–2.)

The Angled Front. The angled front is much like the straight front in that it follows a true line, but the monotony is relieved by angles away from the sidewalk contour. (See Figure 4–3.)

FIGURE 4–1
The arcade front.

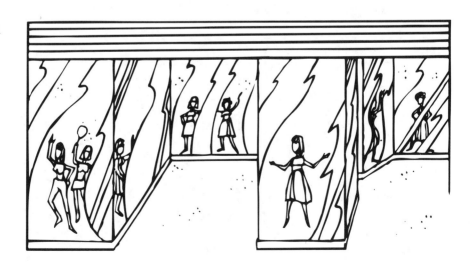

FIGURE 4–2
The straight
front.

The design of the doors or windows in an angled-front store may be asymmetrical or symmetrical. Angled store fronts tend to lead the passerby toward the entrance. Often these entrances have deep lobbies to allow traffic to slow down without being pushed or pressured by other pedestrians.

Display Window Types

Various types of window display areas are used in planning and building a store front. They are elevated, elevator, raised or ramped, lobby, shadow-box, corner, island or kiosk, open-back, semiclosed-back, and closed-back. (See Chapter 7 for some applications.)

Almost all types of windows have the drawback of glare and reflections that detract from the merchandise. Many stores use tinted glass to reduce reflection

FIGURE 4–3
The angled
front.

and sun damage. However, tinted glass has the effect of distorting the true color of the merchandise. Lighter backgrounds tend to play down the glare. Windows that are set in, angled, or curved also reduce glare; however, space is often lost when these techniques are used. A nice touch to reduce glare is the exterior awning, which can present the store name as well as lend color and atmosphere to the store or the shopping area.

Elevated Windows. These windows have a usual floor height of 12 to 14 inches above the sidewalk level. This is mostly a safety measure, to protect the expensive glass panes from damage by shuffling feet, cleanup crews, and vibration caused by passing vehicles. A floor of this height also helps get the displayed merchandise closer to eye level, where it can be seen more easily. Some stores have elevated windows with floors 24 to 36 inches above the sidewalk to accommodate the type of merchandise sold. Jewelry stores, bookshops, eyeglass stores, and bakeries fall into this category. (See Figure 4–4).

Elevator Windows. In these windows floor level may be raised or lowered at will, but they are very expensive to install, since they require a complicated hydraulic system. With this type of window setup, display departments are usually located in the basement; for changing the display, the window is lowered one floor, trimmed, and then raised to the desired elevation. These are used very little today.

Raised or Ramped Floors. The floors in this arrangement are slanted, elevated in the back to form a ramplike display area. Such windows facilitate showing merchandise attached to a panel. Any window may be made a ramp window merely by installing a false floor with its back edge higher than the front. Many bakeries, banks, utility buildings, shoe shops, and drugstores employ this type of window for their displays.

FIGURE 4–4
Elevated windows.

Lobby Windows. Just as its name implies, this kind of display area follows the lines of deeply recessed entrances to buildings. Lobby windows are usually slightly angled to help lead the customer right into the store. They present a display problem because people must be attracted coming and going as well as straight on.

Shadow-Box Windows. These may be small and an entity in themselves, or they may be segments of a larger window that has lost space to a structural block. Grillwork, unsightly pipes, posts, and doorways are camouflaged very nicely in frontage layouts by the placement of shadow-box windows. They also afford a display area for small merchandise such as jewelry, toys, cosmetics, notions, books, handkerchiefs, infant shoes, and so on.

Corner Windows. These are often considered the most important areas of any store frontage. They are the central viewing point of converging traffic and, consequently, the best merchandising areas. The average pedestrian will notice a corner window and its contents much more readily than a side street window.

Island or Kiosk Windows. These are usually found in arcade fronts and are isolated from the rest of the building. This type of window offers many display problems because it can be seen from all angles, and merchandise must be placed so as to appear attractive from all sides.

Open-Back Windows. Since the end of World War II, there has been a trend, both in remodeling and in new building, toward opening the store to full view of the sidewalk traffic. Thus far, the trend has mostly been confined to the small stores, and whether there is to be a definite swing toward open-back windows remains to be seen.

Problems with open-back windows include the merchant's lack of ability to create a complete atmosphere by using a decorative background. The customer is easily seen in the store and may distract the person viewing the display. Also, there is a lack of storage space that is normally provided by putting shelves or racks on the other side of the solid or closed-back window.

Many retailers have found that this type of window stimulates. It invites the passerby to come in and look around. Properly handled, open-back windows become quite effective. Replacing the lost stock and storage areas and maintaining effective displays without blocking a clear view of the store are but two of the problems that arise here and require added ingenuity on the part of the display the store; they are found inperson.

Semiclosed-Back Windows. These windows, having a partition extending to a height below the line of vision, are sometimes found in drugstores and hardware stores. They offer a display challenge because they must be constructed giving consideration to the store interior.

Closed-Back Windows. These windows completely isolate the display area from the store; they are found in the majority of department stores and in specialty

stores handling men's and women's wearing apparel. A display may be constructed in them without the additional considerations of lighting and merchandise arrangement within the store.

If several windows are constructed in a line, or if the area of the window is too large for the amount of merchandise that has been selected, or if a special effect is needed, the concepts of proscenia and masking might be used. Proscenia are simply decorative borders which continue around the outside of the window. Masking makes use of wide borders and can reduce the inside space that the viewer sees. Therefore, it can actually change the inside dimensions of the display area as well as lend a special feeling to the area. Both proscenia and masking serve to define the borders of a display area, thus containing the eye. Masking of a display area can reduce a large window to a mere peephole, taken to the extreme.

Stores with off-the-street parking lots are giving less attention to display windows along their frontage, because their shoppers park in the first vacant space and seek the nearest entrance. Stores in some malls also emphasize inside displays rather than outside windows. Many stores overcome this inability to influence with window displays by placing huge display areas directly inside the entrances or wherever there is heavy traffic, such as near elevators or escalators.

The shopping center mall, often with partially covered walkways, fountains, benches, and meandering courts, contributes a most influential setting for displays and windows as it affords the passerby a haven in which to select a store to patronize.

Inside the Store

All furnishings of the store should be placed to enhance the visual impression each floor presents. They should be arranged both to sell the most merchandise and to be pleasing to the customer.

Corner Shops. These shops, as well as other marked-off areas with distinctive decor, are employed by store engineers to relieve the monotony of departmental furnishings.

Shelves. Obviously, shelves are necessary to store stocked merchandise. They are poor display areas, however, and should be hidden whenever possible by walls, curtains, and so on.

Counter and Table Displays. These sell merchandise more readily than do shelf displays, because they are located in front of the stock areas, bringing the goods nearer to the customer and allowing the customer to touch the merchandise. Square and rectangular shapes are the usual design for counters and cases. However, rounded, oval, and surrealistically-shaped counters not only ease the flow of traffic through a store, they appear less regimented and do not present hazardous sharp edges to the customer. They are a pleasant change from the square design.

Placing store furnishings at an angle to the structural lines of the interior is an arrangement that will increase sales at no added expense to the store. If all aisles are straight from front to back, the customer moves too quickly through the store. Even a slight deviation from the usual parallel placement will lead people in a more comfortable and leisurely path, slowing them down and inviting them to take notice of the surroundings. Likewise, when customers are leaving, counters carefully arranged at angles to the wall will seem to hold them back, to delay their departure. Each hesitation on the part of the passerby is an opportunity for interior displays to make a sale.

Shadow Boxes. A shadow-box display is often located behind the counter area. This location makes it easy to display and maintain an arrangement of merchandise that is beyond the reach of anyone who might otherwise remove it from the store without paying for it. A more dramatic presentation of merchandise is required, however, to compensate for the customer's inability to handle and examine the goods. What a customer could not comprehend except by touching the merchandise must now be shown vividly.

Shadow boxes are often larger than their name would imply; in many instances, they are enclosed with glass, and they are often cleverly designed. Shadow boxes are illuminated with side, ceiling, or indirect lighting of greater intensity than their surrounding areas, so that they will attract attention immediately.

Ledges. The tops of shelves sometimes serve as areas for display. They necessarily follow the set structural lines of a department. Ledge areas may be made very attractive with the addition of decorative pieces for seasonal promotions. Because ledges with shelf space below them are above the comfortable range of vision, constant care must be exercised in the placement of merchandise. Unsightly portions of it, such as chair seats, shoe soles, wrong sides of materials, or unfinished backs of stoves or refrigerators, should not be visible to the customer's eye and must be camouflaged with decorative effects.

Kiosks or Island Areas. As their name implies, these are isolated display places amid the pattern of shelves and counters that constitute the principal selling spaces of a store. They are forceful merchandising agents when placed strategically near elevators, by entrances to departments, and at stairway landings. Island displays catch the customer's fancy and attract the eye. They are not stock areas, nor should they be crowded with boxes and signs. They are concerned exclusively with showing merchandise and items related to that merchandise.

Kiosks may be built from 5 to 28 inches above the floor, may or may not have a background, and are often finished with carpet, grass, linoleum, or wood. They are well-lit and allow space for figures, forms, and other fixtures necessary to the merchandise.

Gondolas (end-of-aisle displays). Often called T-walls, they are areas at the end of two back-to-back shelving or standing units.

Platform Displays. These are usually used to raise mannequins off of the floor at the side of an aisle. Light is usually from above.

Museum Cases. These are display cases with flat surfaces on top. They are usually a rectangle with the top part made of glass and lighted. Expensive and special merchandise is secured in museum cases.

Demonstration Cubes. These are cubes made of many different materials and in many different sizes. The display props are inexpensive, versatile, and extremely flexible. They can be clustered to form island-type displays in traffic aisles.

Fascia. These are boards approximately 7 feet above the selling floor that hide lighting fixtures and provide space for flat pinned displays, which help tie an area together and/or define a particular department. The lighting that is covered by fascia is used to emphasize merchandise and is lower than normal ceiling lights

Structural Columns. These columns hold up the ceilings and roofs of buildings. They must be a part of a structure. You can make them work for the store through attaching ledges, using a variety of wall coverings, and attaching flexible signage, thereby helping to define the beginning and ending of a department. You also can use them to carry out a simple "all-store" theme as is often done at Christmas.

All store furnishings, of whatever description, should complement the impression desired for a certain section of a store. Plush-covered poufs would be out of place in a toy or camp equipment department. Glass shelves are much more practical for jewelry or handbags than they are for heavy cans of paint. Island display areas are desirable for children's apparel departments, but sectional room displays are far more useful in furniture departments. As the needs of a department change, the store furnishing should be converted to meet these needs whether they are sectional or seasonal.

The importance of store furnishings cannot be overemphasized in regard to the impression a store and its wares make upon the public. Furnishings lead the customer through all departments; they provide the clerk with areas for stocking, showing, and selling merchandise; they serve as feature display areas to attract the customer. Furnishings—their type and placement—play a leading role in the dramatic presentation of merchandise.

SUMMARY

Display has been analyzed in terms of principles of design and the display's house—the store. First, we looked at the definitions and important points about the five principles of design, which are balance, emphasis, harmony, proportion, and rhythm. Second, we looked at these principles applied to numerous types of display windows in different types of stores.

SUGGESTED ACTIVITIES

1. Evaluate some mall or suburban shopping-center windows, using the five steps of the sale through display (Chapter 1 and the Display Evaluation Form in Chapter 2). Determine if the displays you observe entice you to buy (or want to buy) the merchandise. If possible, evaluate the same windows that your classmates do, so that the evaluated windows can be discussed by most of the class, thereby providing a deeper understanding of the steps of the sale through display.

2. Select a two- or three-block section of the business district and note the various types of store fronts used. Attempt to interview the manager or display person of these businesses on why particular fronts were used.

5

THE DESIGN PRINCIPLES OF BALANCE AND EMPHASIS

LEARNING OBJECTIVES—CHAPTER FIVE

1. Define *balance*.
2. Discuss how balance can be achieved in a display.
3. Define and be able to identify formal and informal balance in a display.
4. Define *symmetry*.
5. Define *emphasis*.
6. Explain how emphasis can be achieved in a display.
7. Define *optical center*.

BALANCE

Balance is a state of equilibrium—the equality of two things in weight, force, and quantity. To balance is to compare as to relative importance, value, and weight.

In merchandise display, balance is the drawing of an imaginary line down the center of a display to get two equal sides of a display area's shapes, colors, and object placement.

The following are ways in which display components might be different, but in balance:

1. Use exact objects in both parts of the display.
2. In the two parts of the display, use different-sized objects that, by their place-

FIGURE 5–1 One kind of informal balance.

ment, will appear in balance. For example, a small item placed in the foreground will balance a larger item placed in the background. (See Figure 5–1.)

3. Balance objects of a brighter hue (color) with larger objects that have less intensity of color.
4. Balance smaller objects with larger objects by the frequency with which they appear. For example, one large item can be balanced with two or more smaller items. (See Figure 5–2.)

Types of Balance

Generally, there are two types of balance: formal and informal. *Formal balance* occurs when each object on the right side has an exact counterpart on the left side relative to size, placement, shape, and color. Therefore, each side has equal power to attract attention and is equally forceful in demanding the customer's action. Formal balance produces a feeling by the total unit of dignity, restraint, and conservatism. This type of balance is usually used to depict tradition, store image (or other institutional examples), and so on and denotes less activity than the informal type.

FIGURE 5–2 Another kind of informal balance.

Informal balance in display also achieves component equality to the viewer's eye, but it does so by using varieties of color, placement, size, and shape of the objects on opposite sides of the display. Using this type of balance to create a display can result in more subtle and imaginative arrangements. It is used in merchandising when the designer wishes to provide activity, excitement, and variety.

Determination of Balance

To determine balance in any display,

1. Draw an imaginary line down the center of the display.
 a. To achieve formal balance, place objects, weight for weight, on either side of the line.
 b. To achieve informal balance, place merchandise and props so that more weight occurs on one side than on the other. Usually the side weighting the most will be on the left side, since the upper right side is the end of the eyes' path and often has little merchandise in it.
2. Place heavier objects and stronger colors closer to the floor or base of the display to avoid top-heaviness.

Balance and Symmetry in Display

A symmetrically-balanced composition must consist of a dominant centerpiece and subsidiary motifs forming the flanks, suitably reduced in size. Motifs consist of "themes" or subjects to be elaborated on and developed. Any prominent lettering, such as signs or banners, should also be symmetrically distributed in a formal display. Smaller items such as small showcards can well be placed asymmetrically without disturbing effects. The need for symmetry is greatest when a large

FIGURE 5–3 Informal balance in display using color, merchandise, and props.
Courtesy of Prange's, Sheboygan, Wis. Photo by Jim Theodoroff, Sheboygan, Wis.

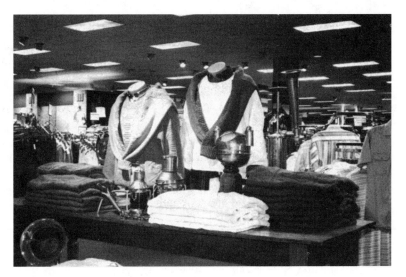

number of different articles are to be displayed in one composition. It is also used when displaying exclusive, expensive merchandise, such as a single designer dress. Symmetry implies strict correspondence in the form, size, arrangement, and so on, of parts on either side of that median line referred to above.

In asymmetrically arranged (informal) displays (Figure 5–3), one side is more dominant than the other, and the areas on either side of an imaginary line down the middle do not "weigh" the same. Asymmetrical displays lend themselves to a great deal of originality and are frequently considered to be more "creative" than the symmetrical or formal display. Smaller objects with a brighter hue (color) will balance with larger objects that have less intensity of color.

When planning a display area, the first thing to determine is whether to balance it formally or informally. This planning can be done on paper rather than by trial and error in the display area itself. Without effective balance, the display would not usually be functional.

EMPHASIS

The Second College Edition of *Webster's New World Dictionary* defines *emphasis* as "a force of expression, thought, feeling, action... special attention given to something."[1]

In a merchandise display, emphasis is the point of initial eye contact. It is from this point that all other eye movements emanate and flow; therefore, it is the center of attraction. It begins the flow of the eye throughout the entire display area that contains the merchandise.

Placement of the Point of Emphasis

The point of emphasis may be appropriately placed in one of two positions as the viewer faces the display.

It may occur in or very near the optical center of the display. This is halfway from either side and slightly above the bottom half. With this type of emphasis placement, the eye will flow evenly on all sides of the point of emphasis, eventually covering the entire area.

The point of emphasis may also be placed in the upper left corner of the display area as it is viewed from the front. This type of placement assumes that the eye of the viewer will proceed like that of a person reading a page—from upper left to lower right—thereby covering the entire display area.

When a display is approached from either side rather than from front and center, it is advisable to place a secondary emphasis point on each wing of the area. The passerby will then be halted visually, pausing so that the primary point of emphasis will come into view, and the eye will once again, proceed throughout the entire display.

[1] *Webster's New World Dictionary of the American Language*, 2nd College Edition (Cleveland: William Collins Publishers, 1980), p. 458.

Methods of Creating Emphasis Points

The display person must keep in mind that the eye must have a point of beginning and that this point has to be planned and created.

A point of emphasis may occur through use of one of the following devices:

A contrast of a visually projecting color, such as a red dot on a neutral background.

A contrasting shape, such as a circular object in a field of horizontal and vertical lines.

A contrasting texture, such as a velvet object on a smooth and dull surface, or a highly reflective metallic item on a background of nonreflective woods.

A particularly large object that, although it is in proportion to the total field, is clearly dominant in terms of its importance in the display area.

See Figure 5–4 for some examples.

FIGURE 5–4 Emphasis.

Size

Intensity

Optical Center

Left to Right Movement

Size

Texture

FIGURE 5–4 Emphasis (continued).

SUGGESTED ACTIVITIES

1. Evaluate, in terms of balance and emphasis, downtown business windows, or interior store displays, with your classmates and report on your findings to the class.
2. Find magazine articles (as recent as possible) pertaining to the use of emphasis and formal and informal balance in display.
3. Make sketches applying to the principles of design and arrangement that were explained in this chapter.

Portfolio Project Three: Preparation and Presentation of Display Slides

The purpose of this project is to prepare a selection of photography slides, which you will make from a minimum of ten displays found in suburban shopping centers, urban retail areas, nests of boutiques, or industrial trade shows. You will then write a commentary (script) describing and analyzing each display and, at a time specified by your instructor, present your slide program to the class.

The following procedure is recommended for collecting and analyzing the data your require.

1. Visit the area selected and photograph ten different displays in a variety of display facilities, including as many different types of contours, kiosks, windows, and shelf areas as possible.
2. Then script the slides for presentation in class. This script will include an analysis of each display according to the elements of display and the principles of design and arrangement, thus giving you a review of both areas.
3. Present the slides and script to the class; they will be evaluated by the instructor.
4. Submit the slides and script to the display instructor; they will remain in the department and/or will become part of your display portfolio, explained in Chapter 1, Introduction to Visual Merchandising.

6

THE DESIGN PRINCIPLES OF HARMONY, PROPORTION, AND RHYTHM

LEARNING OBJECTIVES—CHAPTER SIX

1. Define *harmony*.
2. Explain how harmony can be achieved in a display.
3. Describe the visual effect vertical lines, horizontal lines, diagonal lines, and curved lines create in a display.
4. Describe how shape, line, texture, and idea are used to create harmony in a display.
5. Define *proportion*.
6. Discuss how the following types of space division are used in a display to achieve proportion: pyramid, step, zigzag, and repetition.
7. Define *rhythm*.
8. Discuss how the following aspects of design are used in a display to create rhythm: repetition of shapes, progression of sizes, continuous line movement, and radiation.

FIVE ASPECTS OF HARMONY

As we discussed in Chapter 4, harmony concerns the agreement among the elements of a display. The elements we refer to are merchandise, lighting, props, shelf space, and showcards.

Let us now inspect harmony in display, in terms of its application to effective production.

Harmony may be achieved through use of the artistic devices of *line, shape, size, texture,* and *idea.* Each of these devices will be discussed in terms of definition and application.

Line

There are four basic types of *lines* to be used in design creation (see Figure 6–1).

Vertical Lines. The vertical line is one whose direction is from the top to the bottom of a given area. This is a straight, upright line and gives a rigid, severe, and masculine quality to an area. *It expresses strength and stability and is inherent in many types of merchandise constructed of rigid materials.* Its application naturally gives the viewer an up-and-down eye movement.

Vertical lines may appear in the center of a display, to either side, or throughout the area in varying degrees to achieve an effect. Not all vertical lines need extend all the way from the bottom to the top of the area; they may terminate at any point in between. The points at which vertical lines terminate lend aspects of height and proportion to a display.

Dominant use of vertical lines in a display tends to heighten the area, giving the illusion of increased space in this direction.

Horizontal Lines. Horizontal lines extend across the surface of an area from one side to the other, terminating at any point in between. *They tend to widen the surface on which they are used and seemingly decrease the height of the area.*

FIGURE 6–1 Line harmony.

Curved Lines Vertical Lines Horizontal Lines

Left to Right Diagonal Right to Left Diagonal

Horizontal lines create a feeling of rest, relaxation, and repose, as in the restful line of the horizon. Merchandise that connotes rest and relaxation by its nature and use may be displayed aptly through the use of horizontal lines. These lines may be created by props or by the merchandise itself.

Although horizontal and vertical lines may both appear in a display area, a feeling of either the vertical or horizontal is usually dominant.

Diagonal Lines. Diagonal lines direct the eye in one of two ways. They may extend from the upper left to the lower right side of a display, thus creating and inducing action. The eye will follow this line direction with active force. This type of diagonal line especially connotes action and movement to the viewer and is quite effective in the informal display arrangement.

The diagonal line that moves from upper right to lower left is used less frequently. It tends to give the illusion of instability. It must be used with care and precision and by an expert.

Curved Lines. Curved lines add flowing movement and excellent eye direction to a display. They also tend to give a display a feminine atmosphere.

When any of the four types of lines are repeated throughout a display area, they emphasize themselves and create the simplest kind of harmony. Used in opposition to one another, they can create contrast and visual transitions. (Technically, any line that cuts across from one opposing line to another is transitional.) These transitional lines lead easily from one line to another, thus leading the eye throughout the display if used correctly. If too many lines oppose each other and the eye is asked to make a large number of transitions within a limited space, confusion results. Therefore, opposing lines should be used carefully and with expertise. Line harmony is the most important aspect of harmony in display, especially in background treatments and the control of eye movement.

Shape

The *shape* of an object refers to the visual form of that object. For our purpose, shapes are discussed not in their variations, but as being similar or dissimilar. For the creation of perfect harmony in a display, shapes that correspond exactly to one another are used exclusively.

Inharmonious or dissimilar shapes may be used in a display to create contrast and, in some instances, a point of emphasis.

Size

Size refers to the physical magnitude, extent, bulk, and dimension of something. To achieve harmony within a display, sizes should be kept consistent. Objects of the sizes in which they appear in reality should constitute an entire area rather than being used in conjunction with objects that are miniatures.

Sizes should also be kept in proportion, so that large objects do not minimize smaller ones that appear with them in a display.

Texture

Texture is the aspect of harmony that relates to the sense of touch. This sense may be stimulated either physically or visually, as when one senses the roughness of sandpaper without feeling it or the softness of satin without handling it.

Textures may be divided into two categories: (1) *those materials that appear rough or smooth to the touch* and (2) *those textures that reflect light as opposed to those that absorb light.*

When a majority of the textures in a display area tend to be smooth, rough, reflective, or absorbent, we may consider the display to have consistency and harmony.

When a combination of visual impressions prevails, the display will have contrast. If all textures are of one type with the exception of one item of a different texture, a point of contrast, or emphasis, has been created.

Idea

In the area of merchandise display, one basic rule is to allow one *idea* to dominate. This tends to enhance the selling message of the window. Here, more than in other areas of design, we emphasize the importance of the display area as a selling tool. A display is not an artistic creation stimulating speculation and interpretation concerning its intent. The idea of a window must be clearly and quickly received by the viewer. Its details must be in keeping with the central idea or theme in order to enhance and immediately clarify the idea that prevails.

Guidelines in Creating Harmony

The effective use of the aspects of harmony will produce a display that is concise in its message and pleasing to the eye of the all-important customer. In addition, keep in mind these guidelines.

1. Avoid overcrowding the space with too many shapes, whether they occur in lines, surfaces, or bodies.
2. Remember that the window or display area has to hold the merchandise and present a sales message.
3. Use converging lines (lines that come together) and diverging lines (lines that seem to separate) as an aid in producing the illusion of depth through the use of perspective.
4. Use of the curved line can be effective with the various types of straight lines.
5. Give all components equal optical weight or allow one component to dominate over the others. For example, combine several vertical lines compactly with fine horizontal lines.

ELEMENTS OF PROPORTION

As you will recall from Chapter 4, proportion refers to the ratio of merchandise to the total display area and the effective handling of the space intervals between objects. These space intervals govern the appearance of a display.

There are four commonly used space divisions or types of arrangements by which the display person achieves proportion: *pyramid, step, zigzag,* and *repetition.* (See Figure 6–2.)

Pyramid

The *pyramid* is a triangular arrangement with a broad base rising to a center peak. It is a common device to achieve proportion and may be used with any type of merchandise. It tends to give a display a stiff and formal feeling. (See Figure 6–3.)

FIGURE 6–2 Proportion.

Pyramid

Step

Zigzag Line

Repetition

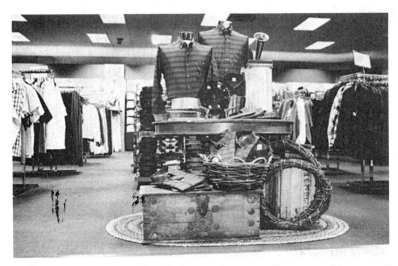

FIGURE 6–3 Does this display make use of a pyramid type of arrangement?
Courtesy of Prange's, Sheboygan, Wis. Photo by Jim Theodoroff, Sheboygan, Wis.

Step

The *step* is a level elevation within the display area. It is effectively used as a side unit facing the center of attraction. It is more informal than the pyramid and is most effective when only three steps are used. When steps extend evenly from either side to a midpoint within the display, the appearance is of an inverted pyramid. This aspect of proportion may therefore be easily combined with the illusion of the pyramid.

Zigzag

The *zigzag* is based on the principle of the double reverse curve and is particularly adaptable to wearing apparel, owing to the flexibility and ease of draping most fabrics. The zigzag requires equidistant spacing and precision. It may be especially effective when small accessory steps are used, thereby eliminating vacant areas. An easily achieved zigzag effect is created by using material like yarn, rope, or ribbon to lead the eye throughout the zigzag line.

Repetition

Repetition, as a type of proportion, is simple in form. It makes use of steps of the same general nature. It aligns all items in the same manner by height, spacing, and the angle at which they are placed. This type of repetitive arrangement requires deviations to break the monotonous effect that may evolve.

FIGURE 7-1 Lego Imagination Center

FIGURE 7-2 Knott's Camp Snoopy

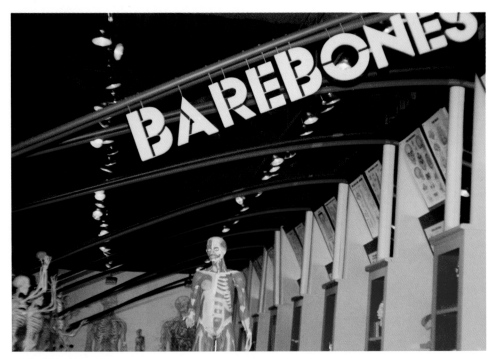

FIGURE 7-3 Bare Bones.

FIGURE 7-4 Wilsons.

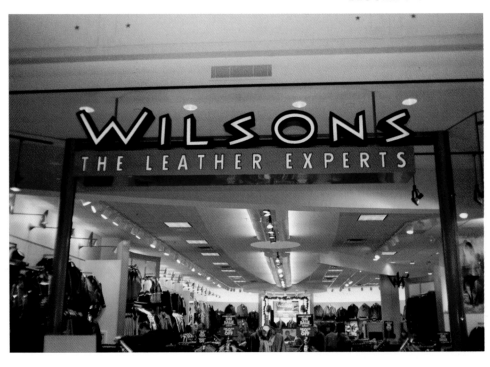

RHYTHM

Rhythm is concerned with the devices employed in merchandise display that guide the eye from its point of contact throughout the remainder of the display area. Whether or not the viewer's eye comes in contact with the merchandise on display is contingent upon how successfully the following aspects of rhythm are applied. Any one of these four aspects will guide eye movement in the desired direction. (See Figure 6–4.)

Repetition of Shapes

This self-explanatory principle makes use of similar shapes at regular intervals throughout the display. Separate units within the display should not be apparent when this technique is employed.

FIGURE 6–4 Rhythm.

Repetition of Shape

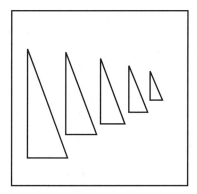

Progression of Sizes

Continuous Line Movement

Radiation

Progression of Sizes

Progression of sizes refers to using similar shapes and varying their sizes by consistently increasing or decreasing them along the visual path. The eye is made to move rapidly over the display, and this swift eye movement is in keeping with the immediate, quick viewing that is essential to the successful display of merchandise.

Continuous Line Movement

This aspect of rhythm makes wide use of curves in their varying forms. One curved line is seen leading into the next, creating a graceful, swinging movement easily followed by the onlooker's eye. Props such as ribbon lend easy eye movement by connecting curved lines. Background draping and merchandise that is easily draped can be successfully employed in achieving the effect of continuous line movement.

Radiation

Radiation can be described as having a sunburst effect. It often appears as an inherent part of the merchandise, as in the spokes that radiate from the center of a wheel. The movement of radiation grows out of a central point and is most effectively placed at the optical center of the display. The movement may lead the eye away from the central point of contact, or it may bound the eye movement by employing an outer encircling band.

SUGGESTED ACTIVITIES

1. Photograph several current displays in the area. Then, with the assistance of the audiovisual department or your instructor, construct a combination slide/overhead presentation so that the displays (by drawing on the projection through the use of the overhead) may be analyzed visually in terms of the principles of design and arrangement.
2. Discuss how the following exist in the home, school, place of work, and local newspaper, and their effect on us:
 Five aspects of harmony
 Elements of proportion
 Rhythm

Portfolio Project Four: Construction of Open Shadow-Box or Shelf Displays

The purpose of this project is to gain experience in combining the elements of display through the use of design principles by the construction of a small, five-sided or shelf display. It is an individual effort in applying knowledge of display.

You will construct a display using merchandise and props approved by the instructor. The display may be constructed in any five-sided area or shelf that is, optimally, visible only from the front. A sketch of the display plan should be presented to the instructor (see Chapter 2).

You will select and furnish the merchandise for the shadow box. It may be borrowed from a retail store or may be brought from home. The unit value of the merchandise should be kept in mind when determining the amount of merchandise to use. The less expensive the merchandise, the more items of it need to appear in the display area to make it economically feasible.

The display area may be lighted from above or from the front.

When the elements of the display are combined successfully using the principles of design, you should view the display from directly in front of the display area, then from both the left and the right sides by passing in front of it approximately 3 feet away, as a pedestrian or store customer would.

If, at this point, you are satisfied with the display, you are ready for oral and written evaluation by the instructor.

7

VISUAL MERCHANDISING AND THE SHOPPING MALL

LEARNING OBJECTIVES—CHAPTER SEVEN

1. Discuss the impact that shopping malls have had on visual merchandising presentations.
2. Define *face-outs*.
3. Define *grid*.
4. Define *plan-o-gram*.
5. List and be able to distinguish among the different types of hardware used when creating merchandise wall displays.
6. Discuss the five objectives of a wall display area.
7. Explain the guidelines used when creating a merchandise presentation on the selling floor.
8. Define and be able to recognize the different types of floor fixtures used in creating a merchandise presentation.

This evolution of shopping malls has been accompanied by an evolution in visual merchandising. That is, taken together, stores in malls now resemble one giant display case that, it is hoped, will attract al types and ages of customers who shop there—whether they are hurrying from one store to another, picking up their children in the arcade, lingering over the entries in an arts and craft show, or racing to an exercise class. Displays in all the store windows are created to entice—to lure the consumer into the retailer's establishment—and to keep the shopper at the mall.

In this chapter, we will discuss how retailers use displays effectively in the store setting, employing the entire store and mall environment. The most effective way to discuss visual presentation is to examine the largest retail and family entertainment complex in the United States—the Mall of America.

THE MALL OF AMERICA

The Mall of America, which is located in Bloomington, Minnesota, is the nation's largest retail and entertainment center. The Mall of America was created to serve as a one-stop destination for shopping, dining, entertainment, and family fun. The 4.2-million sq. ft. center is home to the LEGO Imagination Center (Figure 7–1), 360 specialty stores, four department stores (Macy's, Bloomingdale's, Nordstrom, and Sears), cart retailers, restaurants, nightclubs, Golf Mountain, and a seven-acre theme park, Knott's Camp Snoopy (Figure 7–2).[1]

The Mall of America houses four "avenues" that are placed in a square around the entertainment park, Knott's Camp Snoopy. These four avenues are: South Avenue, which is upscale and sophisticated; East Broadway, which has a high-tech, trendy look of the future; North Garden, which conveys a natural, park-like atmosphere; and West Market, which has a European motif.[2]

Each of the avenues has a distinct theme. Retail establishments convey each theme through store fronts, displays, merchandise selection and presentation, lighting, and signage—the elements of display and visual presentation. (Figures 7–3 & 7–4)

A visit to Knott's Camp Snoopy or the LEGO Imagination Center is entertaining and educational. Businesses compete to woo customers into their stores, and the "let-us-entertain-you" format may very well be the trend of the future for retail merchandising. It allows the customer to experience a shopping adventure and new merchandising formats.[3]

The Mall of America continues to attract customers with businesses that present fresh merchandising concepts. Retail establishments that have opened recently and utilize this concept are, Children's Place, and children's clothing store that features a play area, and Scientific Revolution, a hands-on store that features interactive, science-related merchandise. Consumers want new and innovative presentations that not only show the goods but provide additional services. The concept has proved to be successful for the Mall of America; first-year attendance and sales were very strong. John Wheeler, General Manager of Mall of America attributes the strength of the Mall of America to the combination of retail and entertainment.[4]

[1]Mall of America Inc., 60 East Broadway, Bloomington, Minnesota, September, 1993.
[2]*Ibid.*
[3]"Megastores That Entertain and Educate May Signal the Future of Merchandising," *The Wall Street Journal Marketplace*, 11 March 1993, sec. B1, p. 1.
[4]Mall of America Inc., 60 East Broadway, Bloomington, Minnesota, September, 1993.

USING STORE STRUCTURE AS MERCHANDISE SPACE

Merchandise Walls

Imagine a customer standing in the entrance to a store, taking in the "view." Wherever that customer looks the background will be a *merchandise wall.* Merchandise walls form the total background of the store.

There are only two types of merchandise walls: (1) those that house merchandise and display that merchandise using face-outs (Figure 7–5), and (2) those that house merchandise and display that merchandise using grids (Figure 7–6). (Face-outs show apparel hanging from the display with the front of it facing the viewer.) But these walls can be treated in many ways to create a strong store "look" and provide an interesting, colorful background for the store's other fixtures and displays.

In addition, there are two purposes of merchandise walls: (1) to house and display basic as well as nonbasic merchandise (e.g., exceptionally long items such as nightgowns and jumpsuits), and (2) to help backup merchandise "stories" that are being featured on the selling floor.

Housing (stocking) all the merchandise walls will be something of an adventure—you will learn about the hardware, facing directions, balancing of merchandise, and so on. Your efforts will be rewarded, though, by the shopper who stops short to look at your display and becomes a customer.

While they vary in size, construction, and name, there are certain basic fixtures and hardware that are used on all merchandise walls. They are (1) bars and hardware, (2) waterfall face-outs, (3) straight-arm face-outs, (4) shelving (on brackets), (5) slatboard, and (6) display grid and adjustable rod. (See Figure 7–7.)

All face-outs should be above the level of any racks and totally visible to the customer. The presentations on barred walls should never be blocked by store fixtures or display cases, for example.

The presentation on a merchandise wall should always reflect a consideration of (1) the merchandise layout already existing on the floor, (2) the merchandise stocks, (3) the merchandise to go on the wall, (4) the proper hardware

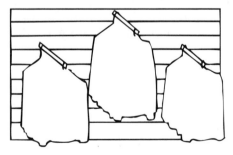

FIGURE 7–5 Merchandise wall with face-outs.

FIGURE 7–6 Merchandise wall with grid.

for the amount and type of merchandise to be housed, and (5) the design plan for the walls.

With regard to the design plan for the walls, there are four different ways to present merchandise walls, each depending on the stock level:

1. Totally faced out (Figure 7–5)
2. Faced out with barred
3. Barred with faced-out merchandise
4. Heavily barred (Figure 7–11)

Each of these alternatives is discussed in the paragraphs that follow.

FIGURE 7–7

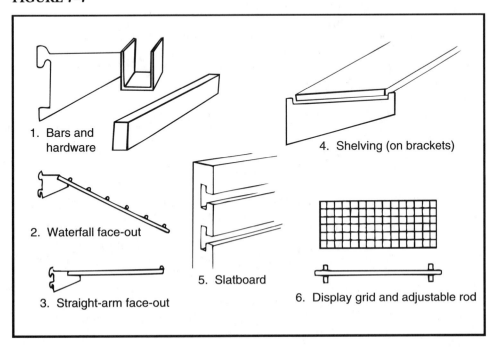

1. Bars and hardware
2. Waterfall face-out
3. Straight-arm face-out
4. Shelving (on brackets)
5. Slatboard
6. Display grid and adjustable rod

Totally faced-out walls should, whenever possible, exhibit a formal balance; that is, if a line is drawn in the middle of the wall, the placement/presentation of merchandise on the right should be exactly like the placement/presentation of the merchandise on the left.

A *faced-out wall with barred merchandise* (predominantly faced-out) has the position face-outs on primary visual areas of the wall—the area the customer sees first. As noted earlier, all face-outs should be above the level of the racks and totally visible to the customer.

1. Use a face-out of the best style to lead into barred merchandise.
2. Whenever possible, choose a face-out style of the same color as the barred merchandise it leads into.
3. Vary height and type of face-outs for visual interest.

Barred walls with faced-out merchandise (more merchandise needs more bars) should be arranged as follows:

1. Place face-out-related merchandise on primary visual area before you bar.
2. Make the face-outs your best-selling items that attract customers to the wall.
3. Use a face-out of the best style to lead into barred merchandise.
4. Barred merchandise should be grouped according to store directives, which can be based on:
 a. Merchandise classifications.
 b. Color or colors within each classification.
 c. Sleeve or garment length.
 d. Fabrication.
5. Use shelf over long barred areas to tie in related merchandise.

Heavily barred walls should be put in using these basic guidelines. (See Figures 7–9 & 7–11.)

1. Plan for heavy barring with very large stock quantities.
2. Use a face-out of the best style to lead into barred merchandise.
3. Vary the height and length of bars to create a visually interesting presentation.
4. Bar regular-price merchandise.
 a. By classification.
 b. By color within classification.
 c. By sleeve length (sleeveless, short sleeve, long sleeve).
 d. By fabrication.
5. Hang all merchandise on bars facing the front of the store.
6. Arrange top hooks of hangers over the bar in the same direction. (See Figure 7–8.)
7. If quantity of sale merchandise is insufficient to make proper colorized presentation, have it sized.
8. Keep merchandise 8 to 12 inches from ceiling to allow better visibility and easier access to customer.

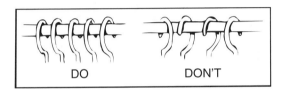

FIGURE 7–8 Do's and don'ts for top hooks of hangers.

9. Provide a visual "break" from one classification to another in heavily barred wall with face-outs. Always face out the best style of the barred classification.
10. Use different length bars (24 inches, 30 inches, 48 inches, 60 inches) to provide breaks and variety when wall is heavily barred. (See Figure 7–11.)
11. Wherever possible, use same-length face-outs in one section of a wall.

Wall Display

Wall displays can take several different forms: face-outs above barred merchandise, merchandise displayed on a grid (Figure 7–6) or a ledge display above barred merchandise with face-outs on either side (optional).

Guidelines for Merchandise Walls. Sales associates who will be involved in setting up a wall or floor display should have certain criteria to follow to insure a proper merchandise presentation.

1. Follow the company plan-o-gram for proper placement of merchandise.
2. Colorize merchandise according to the store's color chart.
3. Make certain that proper signage or toppers are used.
4. Hang all barred merchandise facing the front of the store.
5. If double-hanging two different classifications of merchandise, colorize classifications in the same color order, top and bottom (Figure 7–10).
6. If double-hanging pants, do not fold and clip with pant hangers. Neatly fold pants over the pants hanger (Figure 7–12).
7. A T-stand or four-way fixture should lead into merchandise featured on a merchandise wall.

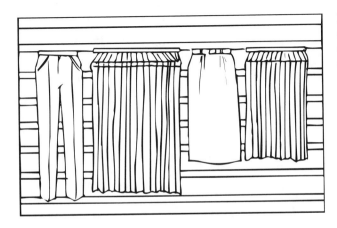

FIGURE 7–9 Barred merchandise wall utilizing face-outs as a break from one classification to another.

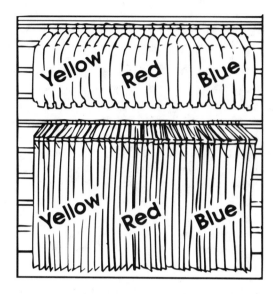

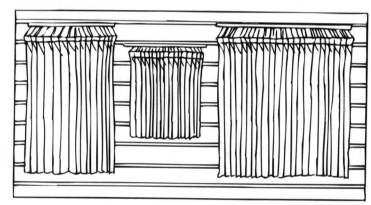

FIGURE 7–10 Double-hanging merchandise wall colorized the same in top and bottom.

FIGURE 7–11 Heavily barred wall utilizing different bar lengths to provide "visual breaks."

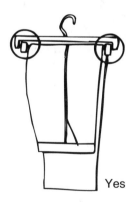

Yes

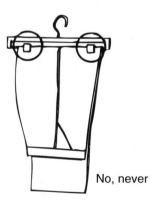

No, never

FIGURE 7–12 Do's and don'ts for double-hanging pants.

The Selling Floor

The type of merchandise that will be located on the selling floor is based on the type of retail institution and who their customer is. The merchandise selection will vary with seasonal and promotional changes within a store. But sale merchandise as well as regular price merchandise needs a specific location on the selling floor. The following points can serve as a guide for merchandising the selling floor:

1. Use fixtures to house one classification of merchandise on the selling floor.
2. Large quantities of merchandise will require a straight rack or a rounder.
3. Categorize, colorize, sign, and size merchandise based on plan-o-gram information or management directives.
4. Face all merchandise toward the front of the store.
5. Keep your clearance merchandise on a rounder or straight rack—the floor will usually outsell the walls.
6. Properly sign all clearance merchandise; keep the merchandise neat and orderly.
7. Use the selling floor to create departments within the store (i.e., outerwear, suits, or sweaters).

FIXTURES

Selecting the correct fixture will not only enhance the merchandise but will allow the customer to shop the store comfortably. In using any fixturing element, consider the following points:

1. Don't overload a fixture; allow the merchandise to "breathe" and hang correctly. If the customer has to fight with the merchandise, you may lose the customer and a sale.
2. If a four-way or T-stand is located on an aisle, slope the arm(s) toward the aisle.
3. Keep all fixtures clean and in top condition.
4. The fixture should "fit" the merchandise. Are you using the merchandise to highlight goods or to present a large quantity of a particular item?

Some of the most commonly used fixtures are:

1. *T-stand.* Used primarily to highlight and display merchandise; it may have straight arms or waterfalls to create more interest (Figure 7–13).
2. *Four-way or Four-arm.* May be used to carry a heavier volume of merchandise; straight arms may be used alone or with waterfalls (Figure 7–14).
3. *Rounder.* A circular rack that is used to house a higher volume of merchandise; merchandise may be classified according to color, size, and silhouette (Figure 7–15).
4. *Trilevel rack.* A rounder with adjustable levels; may be used to highlight merchandise (Figure 7–16).

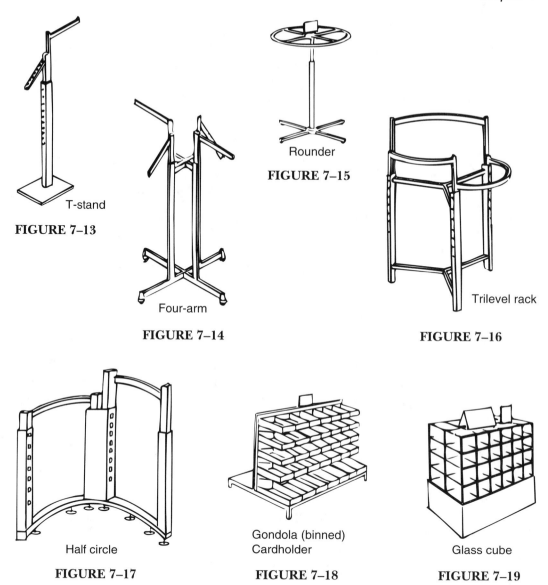

FIGURE 7–13
T-stand

FIGURE 7–14
Four-arm

Rounder
FIGURE 7–15

FIGURE 7–16
Trilevel rack

Half circle
FIGURE 7–17

Gondola (binned)
Cardholder
FIGURE 7–18

Glass cube
FIGURE 7–19

5. *Half-circle rack.* Half of a rounder that usually has adjustable levels; used to highlight merchandise (Figure 7–17).
6. *Straight rack.* Used primarily for regular priced merchandise; also may be used for clearance merchandise.
7. *Gondola.* Used for a variety of nonhanging merchandise (i.e., packaged shirts or small items) (Figure 7–18).
8. *Glass cubes.* Use to store folded merchandise such as sweaters; also may be used to highlight featured items (Figure 7–19).

PLAN-O-GRAMS

Retailing is a business that requires all associates to be trained in the basics of giving proper customer service and creating merchandise presentations and displays. In order to insure uniformity in merchandise presentation and visual display, many retail operations use plan-o-grams. With this type of a system the planning is usually done at the corporate office and the set-up takes place at each store under the supervision of the store manager or a department manager.

The plan-o-gram is a detailed plan that gives a store guidelines for:

1. Store front, window display or department setup.
2. The quantities of merchandise to be used and how they are to be presented on a shelf or fixture (i.e., by color, size, vendor, or style).
3. The type of fixture to use and its placement.
4. Price and description of the merchandise.
5. The date that the merchandise should be "in house" as well as beginning and completion dates for the plan-o-gram.
6. Signs and sign holders that are to be used.

Using this type of planning system provides continuity from the store front to the display and fixture positioning in the store; the customer will recognize the store by its uniform merchandise presentations and visual displays.

SUMMARY

When deciding on a merchandise presentation that will attract the customer's attention and direct the flow of traffic through the store, use these six points to enhance your merchandise presentation and increase sales:

1. *Create a strong entrance.* The first four feet inside the store are the most important. Appropriate fixtures will give customers the opportunity to stop and decide if they want to shop in the store.
2. *Allow front-to-back sightlines.* Customers should be able to see the back of the store or the department from the entrance. Effective lighting and bright colors, as well as a center aisle, will pull customers through the store.
3. *Take advantage of your highest profile location.* Most customers will move from the front of the store walking right at a 45-degree angle. The best-selling merchandise should be placed in this area.
4. *Direct and redirect common customer traffic patterns.* Shoppers usually walk down one side, across the back, and up the other side of the store. The use of color, angles and motion will encourage them to zigzag through the store.
5. *Wrap it all up at the cash-wrap stand.* The cash-wrap station should be located in the front left-hand corner of the store so customers can reach it after seeing all the merchandise.
6. *Maintain an active feeling in your store.* Customers are less likely to go into a static store. Sales associates should not congregate in one location.[1]

[1]Kathleen O'Connor, "Location, Location, Location—Merchandise in the Right Place BOOSTS Sales Opportunities," *The Retail Challenge* Vol. 5, no. 2 (1993): p. 7.

SUGGESTED ACTIVITIES

1. Using the guidelines provided in Chapter 7, visit a mall in your area and compare a store's interior display approaches and terminologies with those of the text. Report back to the class on your observations and the responses you received from store management personnel.

2. Compare a small mall store interior display approach with that of a large mall store. Include your observations in your portfolio, and be prepared to share with your class members.

Portfolio Project Five: Optional Display Construction

The purpose of this project is to individualize instruction so that next you may concentrate on your own areas of interest and gain display experience and skill that will be of benefit in a career choice.

Consulting with the instructor, select from the following list the type of display with which you wish to gain experience. Then, construction time and evaluation criteria (in addition to the usual element and principle analysis) will be determined through conference with the instructor.

Case and counter displays
In-store P.O.P. displays
Closed-back window
Open-back window
Semiclosed-back window
Corner displays
Kiosks
Pinned display story (several such displays in an area with a central theme)
Hard-line store front

Displays may be constructed in the school using its display lab, bulletin-board surfaces, display-case areas, or other central locations for displays. This display assignment may also be done in a retail store or commercial institution, according to student-instructor agreement.

After a display site has been agreed upon, determine whether the message will be institutional or promotional, and whether merchandise will be selected. Prepare signs and showcards, assemble props, and consider display lighting.

The display is to be evaluated according to display principles as well as the criteria agreed upon by you and instructor. The display evaluation may take place as part of the class period (if an in-school display area is used) or by appointment (if an outside institution provides the display space). The time allowed for construction and evaluation will depend on the type of display and display area selected.

8

COMMON ERRORS
IN DISPLAY

LEARNING OBJECTIVES—CHAPTER EIGHT

1. Discuss the relationship between selecting a theme and planning a display or merchandise presentation.

2. List and discuss ten common display errors that decrease the effectiveness of a merchandise presentation.

3. Explain how the principles of design, when used properly, will increase the aesthetics of a merchandise display.

Many display areas—exterior or interior, windows or showcases, tabletops or shadow boxes—can be improved if you simply avoid a few obvious errors that decrease their effectiveness. This chapter highlights some of the common display errors that can be sidestepped with relative ease.

Lack of Underlying Theme

Whether a display is in a window or a store interior, part of the storewide promotional effort or an independent entity, it should have a strong message or underlying theme. (See Chapter 2 for a review of themes.)

The viewer should be able to understand the idea presented by a display in a matter of seconds. Too often, merchandise is simply placed in a given space without a selling message or motif of any kind, or too many ideas or themes are presented simultaneously, making each of them ineffective.

The importance of having a theme becomes even more apparent when several types of merchandise are combined in a display area, as when soft goods, wood carvings, toiletries, eating utensils, and so on are all displayed in the same space. Many stores embark on great storewide themes and motifs by having foreign fairs and other central theme efforts.

MERCHANDISE DISPLAY

Too Much

As we have seen, display areas have tended to be overcrowded for two reasons. Early in the history of display, before the true value of display space was realized, the "pitchfork" method of showing everything in the store created very crowded windows. And, then, as display space began to be considered valuable, merchants seemed to think that the more items they put in the display area at one time, the more beneficial this area became. Both these reasons lead to ineffective merchandise display.

There is no hard and fast rule on how much merchandise should appear in a display area. One consideration, however, concerns the price of the merchandise to be displayed. Because each display area is valuable and costs the store money for lighting, space not used for merchandise, fixtures, and so on must be made to pay for itself. If an item costs several hundred dollars, it may very well be the only item in a space, as in the case of the designer dress in the window of an exclusive women's shop. The profit on this one item will easily make up the cost of the window display. For the low-priced variety store, however, where most items are of low cost and yield a small percentage of profit per unit, more units and combinations of merchandise are presented at one time, because it will take several sales to pay for the display space.

Caution must be exercised that a window or an interior display area does not appear to be crammed with many similar items, does not have so many different items as to lose any selling message that it might have conveyed, and does not appear esthetically offensive to the viewer.

Too Little

On the other hand, bare or half-empty windows, interior racks, and cases can be just as bad. The bare look makes a business establishment appear to be going out of business, or in other ways indicates to the customer that the establishment is less than prosperous.

The usual reason for insufficient merchandise in a display is that the merchandise was sold out of the display area and not replaced. But also contributing to the bare look is failure to add props, lights, and other elements that enhance the total appearance of the display. Poor planning of what merchandise is to be available for display during a certain period may also cause an area to appear bare, particularly when the display is following a theme. This problem arises most frequently when merchandise is to be borrowed, since the desired items may not be available. If merchandise cannot be obtained for a display, it is best to change the dimensions of the display area, making it appear smaller in relation to the merchandise and props.

PROPS

Too Many

No exact amount of merchandise must appear in a display area; neither is there a given number of props that should accompany an item of merchandise or appear in a given area.

Props enhance the selling message. But a window or display area should not be so heavily propped as to disturb the selling message and confuse the customer. The viewer should know immediately what items in the area are for sale and what items are props. Salable items should be in full view.

Overpropping is often more serious than is using too few props. Some merchandise, such as a priceless antique dining set, may need few props to complete its message. Other merchandise, especially when grouped, needs propping to elevate it, direct the eye to it, and otherwise tell the customer about it. Always use props to enhance merchandise.

Inappropriate Use

The use of props that do not *enhance* the merchandise is a common error, for instance, selecting a favorite such as an antiqued orange crate and finding a use for it in almost every display, even, say, a lingerie display. Or an area may be propped and then only the merchandise is changed. This creates monotony, which leads people to think that the area is never changed and therefore discourages them from viewing. Props must be evaluated as to whether they are seasonal, masculine or feminine, rustic or modern, and whether they will appeal to the proper age and income groups, according to the merchandise they are to enhance.

Also, because props play an important part in presenting a theme clearly, they must be in harmony with the merchandise. Therefore, background props, although expensive, cannot be used effectively from season to season, even though merchandise may be changed. What would you think of a display of summer clothes against the red velvet and fireplace that accompany a Christmas display?

ERRORS IN APPLYING THE PRINCIPLES OF DISPLAY

Many of the functional errors that appear in displays concern application of the principles of design discussed earlier.

One error has to do with the *point of emphasis*. Each display should have a point at which the viewer's eye can start easily. Often, a display has no definite point of emphasis, or it has the emphasis point in the wrong place, such as the upper right-hand corner.

Another error affecting the esthetics of a display is that of poor *balance*. A display that is neither formally nor informally balanced but merely too full on one side and empty on the other will not be as effective.

A common error concerned with *rhythm* is observed when many objects, some of them quite small, are displayed in a single area and no attempt at continuous eye movement is made. These displays appear to be scattered and spotty, and a special effort must be made to tie them together visually.

Another error occurs when props and merchandise are not in *proportion* to each other, or when items in a display are not in proper proportion. A miniature usually should not be combined with something of actual size. If a display is to be done in miniature, it should be miniaturized throughout. Also, extremely large objects of real size can dwarf small objects of real size.

RELEVANCE OF DISPLAYS

Changed Too Seldom

There are several timetables for the changing of displays. Many interior displays are changed daily, because they are effective and merchandise sold directly from them must be replaced. Most large windows will be changed anywhere from twice a week to every other week, depending upon the season of the year and the extensiveness of a current store theme. An example of a window that might remain on display longer than usual would be a large department store's Christmas window.

One guideline for changing displays might be the consideration of the expense and extensiveness of the display effort. Special windows and internal promotions have a longer life. No set of props or group of merchandise should remain in an area until it literally collects dust and all possible viewers in the community have seen it several times. Frequently-changed display areas present more merchandise, more messages, and more opportunities to purchase to the consuming public. Displays must be kept fresh.

Changed Too Slowly

The time that a display area is vacant (or covered) is time that it is not selling. The longer it takes to remove a display from an area, clean the area, and put in a new display, the more profits are reduced from that area.

Those working in the field of display must learn to plan a new layout so that all props, merchandise, signs, and lighting equipment are prepared and assembled before the old display is taken down or removed. Only then is the display area quickly cleaned and prepared, and the organized materials for the new display are put in place immediately.

Displays should be changed at the time when traffic in front of and in the store is at its lowest. This may entail late evening or early morning work. Peak customer traffic hours are to be avoided.

The greatest contributor to slow display changes, however, remains poor planning of materials, props, and merchandise for the new display.

Lack of Attention to Detail

Probably nothing is less professional than a display that is incomplete. Items often left unfinished include the following:

Pins are not removed from garments or are allowed to show.
Dirt and dust are not removed from surfaces.
Glass is not clean.
Signs are not dry or complete, or have ink stains or soil on them.
Signs do not have borders.
Items that are flown or suspended are not secured to stay affixed to the ceiling and walls for the duration of the display.
Dummies or mannequins are not appropriately accessorized.
Tools are left in the display area.
Floor coverings are not cleaned.
Floodlights are not hidden from view.
The display area is not checked from all angles.

Nothing will destroy the selling message of a display like dirt.

BUDGET

Adequate funds for display materials are important, but you can learn to avoid the low-budget look by reducing the use of obvious prop items like crepe paper or construction paper or perishable items like grass, weeds, and other things from nature. Too many posterboard signs (used to fill up space) should also be avoided.

A low budget for the purpose of props in a store or a display laboratory should lead to ingenious use of merchandise and creative prop production. Good theme development without elaborate background materials is possible. Techniques such as using large bath towels hanging on a clothesline to back up a towel display, instead of trying to tile the back of a window, add to both motif and merchandise exposure without adding expense. Often, packing boxes with interesting wood textures, such as orange or fruit crates, may be antiqued and used as props, especially for imports. Furniture is growing in popularity as display props and often can be purchased inexpensively or borrowed for the occasion.

Not Asking the Right Question

What really counts in visual merchandising is how the presentation affects the customer. When a display has been completed, the critical question remains: Does this display sell? Does it make a person want to own the merchandise that

is on sale or does it make a person want to buy the products or service it promotes?

Even though the elements of display are present and the design principles have been used correctly, the bottom line in visual merchandising is whether or not the customer is moved to act.

SPECIAL PROBLEMS

Interior displays must be set up carefully, with traffic patterns in mind, If, as in a supermarket, outsiders are allowed to display their company's point-of-purchase materials anywhere in the store, aisles get crowded, customer traffic becomes jammed, and the shopper experiences loss of time and inconvenience. The appearance of the store also suffers when it appears overcrowded. A display person or merchant must resist the temptation to use all display materials available regardless of space, quality, and timeliness of the materials.

SUMMARY

Common errors in display to avoid are: lack of an underlying theme, too much merchandise, too little merchandise, too many props, inappropriate props, errors in applying the principles of design, displays that are changed too seldom, displays that are changed too slowly, lack of attention to detail, a low-budget look, and confused customer traffic patterns due to too many point-of-purchase displays and a poorly-planned store layout. Ask yourself the following questions to make certain that you are avoiding the most common display errors:

1. Will the display stop passersby?
2. Is the theme understandable within ten seconds?
3. Does the display reflect the store's image, targeted customer, and price range?
4. Is there enough merchandise in-house to support the display or merchandise presentation?
5. Are the elements of display in harmony with the principles of design?

SUGGESTED ACTIVITIES

1. Evaluate four local store windows according to the effectiveness with which the common errors of display, described in this chapter, have been avoided. Use the evaluation sheet at the end of Chapter 2.
2. List and describe at least five low-budget props. Include detailed directions on how to create and use them. Provide each class member with a copy.
3. Using the errors of display discussed in the text, submit a written evaluation, or present an oral report, on how these errors either harmed your classroom display this week or were carefully avoided in it. Emphasize the error that you had to try hardest to avoid.

9

COLOR:
THE LIFE
OF A DISPLAY

LEARNING OBJECTIVES—CHAPTER NINE

1. Define *color* (hue).
2. Define *intensity* (chroma).
3. Distinguish between tints and shades.
4. List the three primary colors.
5. List the three secondary colors.
6. Describe which colors would be classified as chromatic colors and which colors would be classified as achromatic colors.
7. Define and be able to recognize the following color schemes: monochromatic, analogous, triadic, complementary, split complementary, double complementary, and tone-on-tone.
8. Explain the difference between warm colors and cool colors.
9. Discuss the psychological impact of color.

The average pedestrian sees a window display as a flashing picture that is approached, observed, and responded to all in less than 11 seconds. This picture must be magnetic to bring customers into the store. A window display should represent the store, and it should help sell goods. To do this, it must attract the eye and turn walkers into *stoppers*—people who stop to examine the goods.

One of the strongest forces in stopping the pedestrian and making him or her want an item is the effective use of color *in a display*. It is an invaluable selling tool, because people are color-conscious. Newspapers, magazines, radio, and television promote color constantly. Color helps to create interest in new merchandise and the desire for it. (Note the color photographs in the insert.)

COLOR DEFINED

We define color here as *the presence or absence of light as it is reflected or not reflected from a surface.* Those that we see as light colors—yellow, say, or orange—reflect a great deal of light, and an object that reflects light completely appears to be white. Objects that absorb a great deal of light appear to have dark colors, such as purple, and complete absorption of light on a surface makes that surface appear to be black.

Colors are wavelengths of light. At one end of the spectrum of radiant energy are radio waves and infrared waves (waves of heat that are very long and invisible). At the opposite end of the spectrum are the invisible, very short, ultraviolet waves, followed by even shorter cosmic-ray waves. Between the very long and invisible sound and infrared waves at one end of the spectrum and the very short and invisible ultraviolet and cosmic waves at the other end are the waves of radiant energy that are visible. These waves are the components of visible light that we call *color.*

COLOR SYSTEMS

When describing a color, we refer to its *hue* (color and hue will be used here interchangeably), to its *chroma* or *intensity*, and to its *value*. *Hue* is the name of the color: red, yellow, blue, and so on. *Chroma*, or *intensity*, is the degree of saturation. *Value* refers to the range of grays from white through black. (*Tints* are those hues closest to white, and *shades* those hues closest to black.)

Color systems, when not applied, provide little practical knowledge or value. Display people should familiarize themselves with their essentials, but real knowledge comes from actually working with color. We soon learn that each color system is based on a limited conception. For example, the *color wheel* will indicate the approximate color that will result from mixing adjacent hues, but it bears little relationship to prismatic color or that which results from the mixture of colored light.

Many theories have been developed on color. One of the best known is the Munsell Color Designation System. Munsell recognized a total of 100 different hues around a wheel, starting with a basic 5: yellow, red, purple, blue, and green mixture of two adjacent hues results in an *intermediate* hue.

Another well-known system—the Oswald System—recognizes 24 colors around a wheel. Supporters of this system argue that its 4 basic colors—yellow, red, blue and green—are arranged more exactly opposite their true complements than in other systems.[1]

The Munsell and Ostwald systems differ from the well-known color wheel for color mixing that we may recall from our earliest school years. That wheel has three *primary* colors—red, yellow, and blue—and three *secondary* colors—orange,

[1]Marian L. Davis, *Visual Design in Dress* (Englewood Cliffs, N.J.: Prentice Hall, 1980), p. 20.

violet, and green—that result from mixing two primaries. Orange results from red and yellow, violet results from red and blue, and green results from blue and yellow.

Chromatic colors are colors such as red, yellow, and blue. They are considered as having color, or hue, because of reflective properties. *Achromatic hues* are in essence neutrals, such as black, white or grays. They are either totally reflective (unsaturated) or totally absorbent (saturated) in regard to their light properties. In a sense, they have no visual color.

All hues are created by the three (primary) original colors: red, blue, and yellow. These three colors, combined with one another in various proportions, complete the entire spectrum and produce all chromatic colors. Illustrations of their placement on the color wheel, and the other hues that their combination produces, follow.

COLOR SCHEMES

Through the use of a color wheel (such as those appearing in the color insert), colors may be combined according to their position on the wheel and may then evolve as *color schemes*. These schemes are simply calculated ways that colors may be combined successfully through the use of a formula.

As each color scheme is discussed, it will be considered in terms of how many colors are involved in the scheme, where these colors are positioned on the color wheel, and what changes in value and intensity might be expected in any one color scheme.

Monochromatic

This color scheme consists of one basic hue. This hue may appear at any point on the color wheel. It appears in from three to five different values and therefore runs the gamut from the full hue to varying tints (pastels) of this hue. Five colors ranging from red to pale pink would constitute a monochromatic color scheme.

Analogous

An *analogous color scheme* consists of from three to five or more different hues that are placed consecutively on the color wheel and must include no more than one-third of the wheel. There are few noticeable gaps in the colors represented. Therefore, if an analogous color scheme uses the colors from blue to green varying values and intensities of all the hues between blue and green are represented. The changes in these hues in regard to value and intensity may be many and varied and give this color scheme great versatility, yet continuity. Five colors ranging from blue to blue green to pale green and perhaps a yellow green or yellow would constitute an analogous color scheme.

Triadic

A *triadic color scheme* involves three colors. These colors may be any three that are equidistant from one another on the color wheel. Thus, red, blue, and yellow constitute a triadic color scheme. Owing to the wide separation of these colors on the wheel and the fact that they essentially cover the entire range of the wheel, one or more of the colors may undergo changes in value or in intensity to decrease the contrast represented. These changes, however, are not essential.

Complementary

A *complementary color scheme* consists of two colors or hues that are exactly opposite one another on the color wheel. Because of their wide contrast, when used together they tend to intensify one another. Thus, when red is used with green, the green appears greener than when it is combined with blue. One or both of the colors may be changed in either value or intensity to avoid too much contrast and color intensification. Green and red could thus be changed in value and intensity, respectively, and appear pale green and dark red.

Split Complementary

The *split-complementary scheme* consists of three hues. One is determined as being the basic hue in the scheme; the other two are those that appear on either side of the basic hue's complement. The distances between the basic hue's complement and the split complement on either side must be exactly equal. Again, value and intensity changes of any or all of these three colors may be used. Yellow, red violet, and blue violet would constitute a split-complementary color scheme. The split-complementary scheme offers a bit more variety than does the complementary scheme.

Double Complementary

A *double-complementary color scheme* consists of four hues, which are any two sets of complementary colors. They may be four colors that are widely separated and appear on each of the four sides of the color wheel, or they may be four colors of which two oppose two others, as in the case of red and orange—red being used as the complement of green and orange as the complement of blue. Because of the wide variety of colors that may be used, changes in both value and intensity give the scheme more continuity and viewing ease.

Tone on Tone

A Tone-on-tone color scheme consists of two hues that are next to one another on the color wheel with very little space between them, such as green and blue green. The blue green is so close to the green on the blue side of the wheel that almost no hue difference is readily apparent when the viewer glances at the two

colors. There is usually no change in either intensity or in value in the use of this scheme. It is used as a subtle device in fashion merchandising with great care and skill.

These schemes may be varied and innovations in them made as you become more skilled in the use of color combination techniques.

AMOUNT AND USE OF COLOR

As a display person you cannot satisfy the color tastes of everyone all the time, but you can cultivate the taste of customers gradually and purposefully. Keep in mind that the colors people say they prefer and the ones they actually buy are often entirely different. Tests conducted by a color research institute revealed the following: (1) Of those asked to choose a favorite coffee offered them because of taste, over two-thirds made their differentiation on the basis of container color. The contents of all three cups were the same, yet the green cup won most acclaim. (2) Over 90 percent of women tasting in a margarine–butter study chose the yellow pat as butter by taste when actually the white pat was butter.

Display workers should learn a few simple rules and study numerous practical examples, keeping records as they go along. The more scientific *facts* you know about color, the better—but do not expect them to tech you taste. Observations of nature and fashion are the most important sources of inspiration in teaching color know-how.

Now that information on color terminology and color schemes has been presented, the impact of the basic chromas will be given as well as an outline of rules that the display person may use in combining colors in their respective values and intensities within a display. Also presented in Table 9-1 is a chart of suggested background colors that might be employed in a display and the subsequent effects that these backgrounds might have.

THE IMPACT OF COLOR

Color can convey and induce a variety of emotions. It has long been known that warm colors, colors that are located in the red area of the color wheel such as red, yellow, and orange, project a feeling of warmth and tend to increase mental alertness and stimulate us. The colors we classify as cool colors, those colors in the blue and green range, are associated with cooling and calming qualities and tend to sedate us. The effects of color can also be applied to merchandise presentations and displays. A bright color may attract a customer into the store, but warm colors in general make customers feel uneasy; cool colors in a display create a calm atmosphere and may prolong the customer's stay in the store.[2] Proper

[2]Paul Zelanski and Mary Pat Fisher, *Color* (Englewood Cliffs, NJ: Prentice Hall, 1989), pp. 28–30 and pp. 127–128.

TABLE 9-1 Effects of Background Color

Color of Merchandise	Black Background	White Background	Beige Background	Dark Gray Background
Yellow	Enhanced in richness	Lightly duller	Warmer	Brighter
Red	Far more brilliant	Darker, purer	Bright, but less intense	Brighter, but loses saturation
Blue	More luminous	Richer and darker	Little more luminous	Brighter
Green	Paler, sharpened	Deepens in value	Takes on yellowish cast	Brightens, gray becomes reddish
Orange	More luminous	Darker and redder	Lighter and yellowish	Increases brilliancy
Purple	Loses strength and brilliancy	Darker	Brighter, gray becomes greenish	Gray becomes green

use of color in displays, floor presentations, and store layout should accurately reflect the image of retail establishment and the product or service they are selling.

GUIDELINES REGARDING COLOR IN DISPLAY

1. Use strong contrasts and loud color with care:
 a. Although very bright hues command attention at first, they disturb immediately afterward and distract attention from the merchandise.
 b. The more intense a hue, the smaller the area it should cover.
 c. The more intense a hue, the softer should be the second hue used in combination with it. Do not combine two or more strong colors that have not been changed in value or intensity.
 d. Do not paint large surfaces in strong colors.
2. Make your color scheme suit the merchandise on display:
 a. The color of floors, walls, and background should be either one of the main colors in the merchandise or a neutral shade.
 b. Generally, soft tints should be given preference over saturated hues.
3. The type of merchandise displayed has a bearing on the selection of colors:
 a. Low-priced goods are usually displayed in a color scheme of vivid hue.
 b. The more exclusive types of merchandise, on the other hand, are usually displayed in a refined color scheme and in color combinations used in the current fashion. (Exceptions may be found in some areas of the country, e.g., New York City.)
4. Light tints are always a treat for the eye:
 a. They appear to deepen the window space.
 b. Therefore, they seemingly increase the size of the window.
5. The opposite is true of dark shades
 a. They seem to bring the background closer.
 b. Therefore, they shorten the window space in the eyes of the spectator.

6. Most colors can be classified as warm or cool:
 a. Warm colors include yellow, orange, red, and their combinations with white or black. All these hues impress the eye, enhance the appearance of the merchandise, and optically push it to the front of the display.
 b. Cool colors include blue and green. They appear calm, soothing, and balanced, and they create the illusion of enlarging the window.
7. Contrasts are welcome but dangerous:
 a. Beware of clashes.
 b. Confine strong contrasts to small accessories.
 c. Audacious combinations are permissible if taste is preserved.
8. More than two principal colors can be grouped in one display, but proportionately; more care must be taken to achieve harmony:
 a. Most pastels go well together.

SUMMARY

Realizing the importance of color in display, the beginning display person should study color schemes created by leading display artists and fashion designers. Remember that when implementing the effective use of color, it is better to create a simply display in a becoming color scheme than a sophisticated display in a poor color scheme.

Practice in creating displays is the only way to become an effective display person.

SUGGESTED ACTIVITIES

1. Visit your local paint store and discuss the mixing of paints with the manager. A demonstration of how paint colors are mixed well enhance your understanding of the color wheel and its applications.
2. A review of color use in the local display departments by direct observation will give you some appreciation for and knowledge of color and its application.
3. Using Table 9-1 as a reference, test the various guidelines listed with various kinds of material. Described the experiment in writing and be prepared to explain and, if possible, demonstrate it.

Portfolio Project Six: Color-Wheel and Color-Scheme Analysis

The objectives of this project are to make (1) a color wheel containing the primary colors, the secondary colors, and the tertiary colors, and (2) a showcard illustrating each of the seven color schemes (including various shades and tints of the hues used).

The project is designed to give you a practical understanding of how the various hues, tints, and shades of the color wheel emerge from the chromatics of red, blue, and yellow (the primary colors) and the achromatics of black and white. In addition, it is intended to provide experience in combining colors in

such a way as to illustrate how each of the seven color schemes mentioned in the text can evolve.

You will need:

Eight 12 × 12-inch showcards
Red, blue, yellow, black, and white tempera paint
Mixing pans

The showcards are to include the following information:

Name of the color scheme
Hues present
An illustration of where they are placed on the color wheel
A chart indicating whether or not each hue used has been changed in value or intensity
Whether the total effect off the scheme is warm or cool

10

GUIDELINES
TO LIGHTING

LEARNING OBJECTIVES—CHAPTER TEN

1. Discuss the purpose of proper lighting in a merchandise presentation or display.
2. Explain the difference between primary and secondary lighting.
3. Define *fluorescent lighting.*
4. Define *incandescent lighting.*
5. Define *high-intensity discharge lighting.*
6. Discuss proper lighting guidelines for interior displays and windows.

INTRODUCTION

Proper display lighting is vital to selling. It calls attention to merchandise. It pulls customers' eyes to the merchandise and encourages them to buy. Moreover, it can be used to direct shoppers through the store, urging them to pause and examine displays of featured goods. People buy because they see.

There is no magic about the attraction of proper display lighting. To a great extent, buying decisions are the result of seeing. The shopper's eye is drawn automatically to the brightest thing in its field. Therefore, the lighting on a display should be two to five times stronger than the room lighting.

Consider brightness of detail. Bold checks on white cloth, for example, stand out even in semidarkness. But put the same checks on a piece of black cloth, and what happens? You may have trouble seeing them in the sunlight.

A good rule of thumb is: *The more difficult it is to see detail, the greater the display light that is needed.* Yet strong lighting alone will not necessarily tempt customers to buy. Lighting should also have the quality and color that bring out the best features of the merchandise.

Expert display people use light in the same way a musician uses sound. A musician varies the volume to attract attention and manipulates tones to create a mood. Similarly, a display expert varies the amount of light to pull shoppers over to a display, using colored lamps, soft light, and so on, to create a buying mood.

The principles behind the art of light in the home, the store, or the theater are highly technical. However, for display purposes, the analysis of lighting patterns in their simplest form will suffice. The reader should understand that *light is radiant energy reflecting from an object and acting on the retina of the eye to make that object visible. Intensity*, in lighting, *is the degree or amount of that reflection.*

The lighting must be considered in planning a store—beginning with the sign out front that identifies the store and going right up the stairways, down the aisles, to the elevators, and back to the front door.

There are two phases of lighting to consider in a discussion of store illumination: primary lighting and secondary lighting. (See Figure 10-1.)

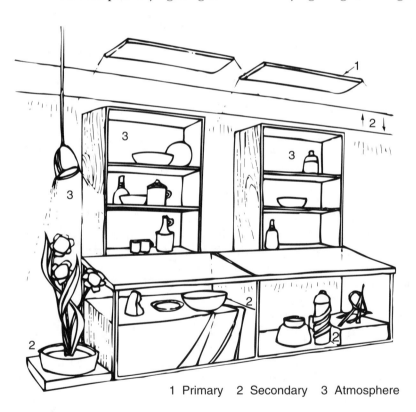

FIGURE 10-1 Store lighting.

1 Primary 2 Secondary 3 Atmosphere

Primary Lighting

Primary lighting supplies the bare essentials of store illumination. Outside, it includes the 150-watt bulbs used as basic window lighting, the marquee lights illuminating the sidewalk for the window shopper, and the lobby ceiling lights. Inside, primary lighting provides general illumination for the store, including lights along the aisles, an indicator of an elevator, the light in a stairway, and a directional sign at the fire exit, the office, or the down escalator. This general illumination is the minimum adequate store illumination.

Secondary Lighting

Primary lighting is inadequate for the specialized showing of merchandise. For this purpose, secondary lighting should be added: Spot- and floodlights augment basic window lighting, brightening the shelves, the cases, the counters, and the merchandise. In this phase of store illumination, lighting begins to function as a selling force. Even dresses hanging in stock areas, or aprons on a counter, become more appealing to the customer when illuminated. Besides selling the store, lighting is now selling the contents of the store. Secondary store illumination includes *downlighting* from the ceiling, *showcase lighting*, and *valance lighting.*

Secondary lighting may also be used for *atmosphere* lighting, the final element in store lighting. This is the phase that plays light against shadow to create the distinctive effect in specific displays. It is atmosphere lighting that concerns the display person most directly. In the windows, color filters, pinpoint spotlights, and black lighting may be used to create dramatic effects. Inside the store, atmosphere lighting is used in featured displays.[1]

LIGHT SOURCES AS SELLING TOOLS

Color means little unless it is considered in relation to the type of light in which the color is seen. It is light that makes things visible. All colors depend on light. There's natural daylight and there's artificial light, which can be incandescent, fluorescent, or high-intensity discharge lighting (HID).[2]

The judicious use of lamps is also encouraged. Present-day lamps are economical and offer variety for effective display.

Fluorescent Lighting

Fluorescent lighting is electrical energy causing phosphors to glow in a tube. It is very economical and provides shadowless light that is valuable for general back-

[1]Emily Mauger, *Modern Display Techniques* (New York: Fairchild Publications, 1964). p. 53.
[2]Martin M. Plegler, *Visual Merchandising and Display* (New York: Fairchild Publications, 1983), p. 37.

ground or ceiling illumination. It is cool and produces little heat, making it good for small, enclosed areas. However, it tends to make some objects look unpleasant and cannot be focused or projected. Maximum efficiency is obtained when the tube is placed next to a flat white surface that reflects the light beams.

Fluorescent lamps come in various wattages and sizes and are used for general room lighting, large-area display lighting, and specialized lighting on shelves and showcases. A wide range of shades is available for enhancing the colors of merchandise and the atmosphere of the store.

> Warm white and deluxe warm white fluorescent lamps create a *warm* atmosphere and blend well with incandescent lamps.
>
> Deluxe cool white fluorescent lamps produce a *cool* or neutral environment that blends with daylight. They give colors a bright, clear natural appearance and flatter customers, employees, and store decor.
>
> Colored fluorescent lamps—blue, green cool green, gold, pink and red—produce dramatic effects and colored backgrounds.
>
> Ultraviolet fluorescent lamps can be used in areas of reduced general light level to create unusual *black-light* displays.

Fluorescent fixtures and lighting can be shielded, filtered, or softened with grids, baffles, or diffusing panels. a baffle is any device used to dissect, divert, or disseminate light. It can be a louver over a light, an egg crate grid, or even an angled panel that dissects the stream of light.[3]

Caution: Fluorescent lighting alone results in a dull and uninteresting store atmosphere. To avoid this combine fluorescent and incandescent light, testing and then selecting an agreeable mix of tubes in number and color.

Incandescent Lamps

In the incandescent, electric energy flows through a very thin wire (filament) that resists the flow of energy. This causes the filament to heat up and, consequently, to glow. The heat that is produced can, in confined, unventilated areas, be a fire hazard. Incandescent light is flexible and therefore very useful in special effects. It is always used with a fitting or reflector, unless it is used in lines or with batteries. Incandescent lamps give a warm effect but are less diffused and much less economical than are fluorescent.

Incandescent lamps have sharply defined beams that are easily directed to emphasize merchandise. They come in a great variety of types, shapes, beams, wattages, and colors.

Reflector lamps are most widely used for spotlighting interior displays. The reflectors are sealed in and never need cleaning. They are available in 75, 100, 150, and 200 watts and in spot and flood beams. For higher intensities, 300-watt lamps produce spot, medium flood, and wide flood patterns.

[3]Ibid.

COLOR WHEEL

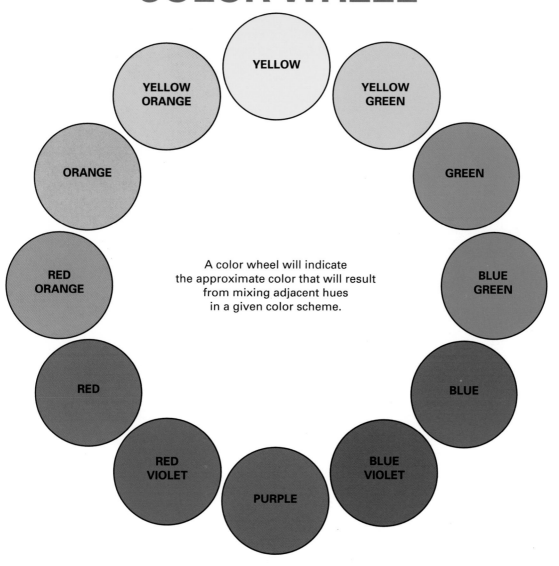

YELLOW

YELLOW
ORANGE

YELLOW
GREEN

ORANGE

GREEN

RED
ORANGE

BLUE
GREEN

A color wheel will indicate
the approximate color that will result
from mixing adjacent hues
in a given color scheme.

RED

BLUE

RED
VIOLET

BLUE
VIOLET

PURPLE

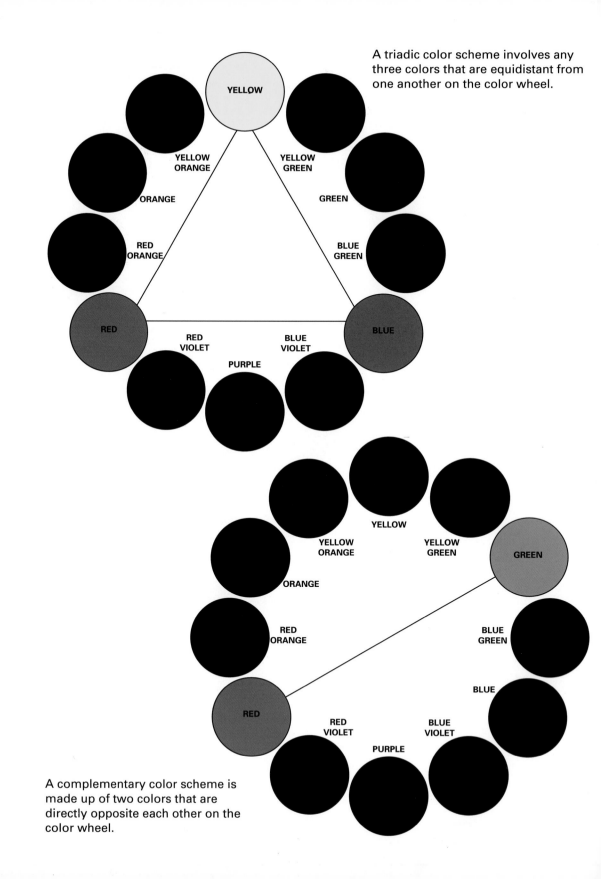

A triadic color scheme involves any three colors that are equidistant from one another on the color wheel.

YELLOW

YELLOW ORANGE

YELLOW GREEN

ORANGE

GREEN

RED ORANGE

BLUE GREEN

RED

BLUE

RED VIOLET

BLUE VIOLET

PURPLE

YELLOW

YELLOW ORANGE

YELLOW GREEN

GREEN

ORANGE

BLUE GREEN

RED ORANGE

BLUE

RED

RED VIOLET

BLUE VIOLET

PURPLE

A complementary color scheme is made up of two colors that are directly opposite each other on the color wheel.

A split-complementary color scheme consists of three hues: the basic hue and the two hues on either side of the basic hue's complement.

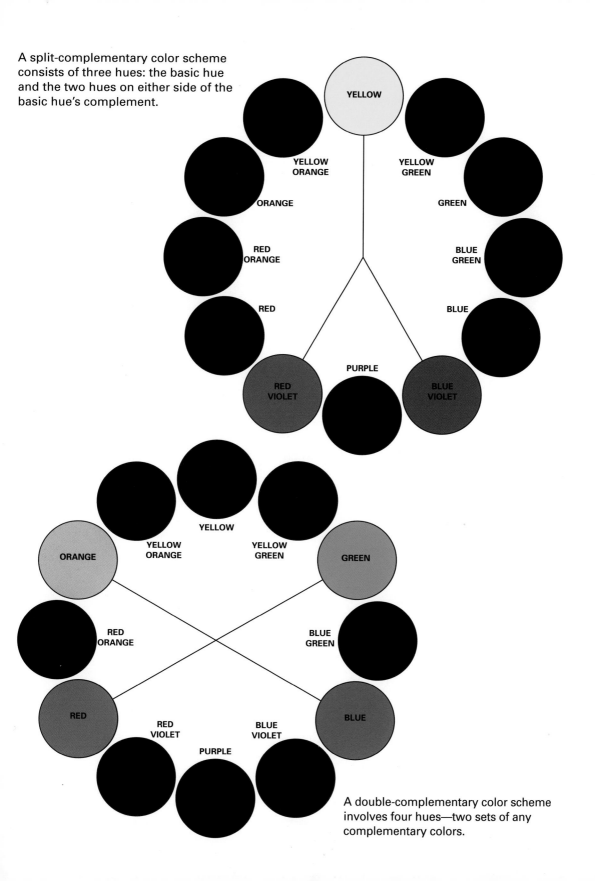

YELLOW

YELLOW ORANGE

YELLOW GREEN

ORANGE

GREEN

RED ORANGE

BLUE GREEN

RED

BLUE

PURPLE

RED VIOLET

BLUE VIOLET

YELLOW

YELLOW ORANGE

YELLOW GREEN

ORANGE

GREEN

RED ORANGE

BLUE GREEN

RED

BLUE

RED VIOLET

BLUE VIOLET

PURPLE

A double-complementary color scheme involves four hues—two sets of any complementary colors.

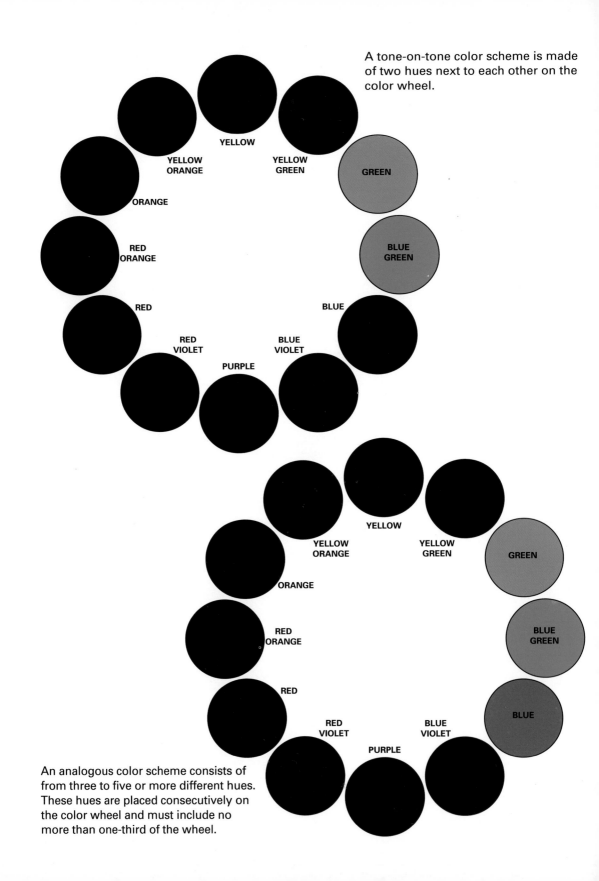

A tone-on-tone color scheme is made of two hues next to each other on the color wheel.

YELLOW

YELLOW
ORANGE

YELLOW
GREEN

ORANGE

GREEN

RED
ORANGE

BLUE
GREEN

RED

BLUE

RED
VIOLET

BLUE
VIOLET

PURPLE

YELLOW

YELLOW
ORANGE

YELLOW
GREEN

ORANGE

GREEN

RED
ORANGE

BLUE
GREEN

RED

BLUE

RED
VIOLET

BLUE
VIOLET

PURPLE

An analogous color scheme consists of from three to five or more different hues. These hues are placed consecutively on the color wheel and must include no more than one-third of the wheel.

Color spot lamps of 150 watts produce concentrated beams of amber, green, blue, yellow, and red light that can be used at increased distances from the merchandise. They can be used as primary lighting, but they are generally used as secondary lighting.

Cool reflector lamps reduce deterioration of perishable displays and fading or discoloration of merchandise, as well as boost customer and clerk comfort. A dichroic coating on the built-in reflector removes most of the heat from the light beam yet retains high light output and good beam control. Smart, decorative lamps—in 10- to 100-watt sizes and in a variety of finishes, shapes, and colors—can add sparkle to your displays. For example, early-American chimney lamps lend colonial charm to a display of wigs.

More and more stores are combining incandescent lighting with fluorescent lights to create their primary lighting. The incandescents are used for warmth, for emphasis, and for highlighting as well as on the merchandise beneath them.

Because of their lower lamp efficiency, shorter lift, and high heat load, incandescent lamps are not recommended for general lighting where cost is an important factor.

High-Intensity Discharge Lighting

HIDs are relatively small in size (compared to fluorescents) and, like the incandescent, provide shadows and highlighting.

Mercury-type HIDs may be too green, the metal halide type may appear too blue, and the sodium type is quite yellow, but research is producing warmer and more flattering types of light.

General Electric's Multi–Vapor II is an improved metal halide–type lamp that produces a light similar to a standard cool white fluorescent that is satisfactory in some areas. It is however, still cooler and bluer than an incandescent lamp.

Westinghouse has a high-pressure sodium (HPS) lamp Ceramalux 4 that works well at that warm end of the color wheel but is still yellower than an incandescent lamp.[4]

Since HID lamps do provide so much light, they are best in areas where the ceiling is at least 15 feet high.

LIGHTING TIPS FOR SPECIFIC MERCHANDISE

1. Use large-area lighting fixtures plus incandescent downlighting to avoid heavy shadows when displaying major appliances and furniture.
2. Use general diffuse or overall lighting, accented with point-type spotlights to emphasize the beauty of china, glass, home accessories, and giftware.
3. Bring out the sparkle and luster of hardware, toys, auto accessories, highly-

[4]Ibid.

polished silver, and other metalware by using a blend of general light and concentrated light sources—spotlights.

4. Use concentrated beams of high-brightness incandescent sources to add brilliant highlights to jewelry, gold and silver, or cut glass.

5. Highlight the colors, patterns and textures of rugs, carpets, upholstery, heavy drapes, and bedspreads by using oblique directional lighting plus general low-intensity overhead lighting.

6. Heighten the appeal of men's wear by using a cool blend of fluorescent and incandescent, with fluorescent predominating.

7. Highlight women's wear, especially the bright, cheerful colors and patterns, by using natural white fluorescents blended with tungsten-halogen.

8. Bring out the tempting colors of meats, fruits, and vegetables by using fluorescent lamps rich in red energy, including the deluxe cool white type. Cool reflector incandescent lamps may also be used for direct-type lighting.

COMMON LIGHTING DEFINITIONS

Accent: Lighting that highlights or emphasizes merchandise on display; incandescent spotlights are frequently used as accent lighting.[5]

Baffle: Any device used to dissect, divert, or disseminate light. It can be a louver over a light, an egg crate grid, or even an angled panel that dissects the stream or light.

Ballast: The electrical device that supplies the proper voltage and currency necessary to start and operate a discharge lamp. The most common is the electromagnetic type, which is typically the "little black box" mounted inside the luminaire. Certain lamps are equipped with "solid-state" ballasts. See *Luminaire.*

Barn Door: An accessory used with spotlights to control the spread of a beam of light. It usually attaches in front of the spotlight in the color frame guide and has four adjustable flaps or "doors" (one to either side, one on top, and one on the bottom) that can be maneuvered to control the direction of the light or completely block off the light in any direction. Sheets of colored frosted gelatin or plastic and spun-glass diffusers can be used with this device.

Bee Lights: Miniature screw base electric bulbs of very low wattage, such as those used in strings of 20 or 36 for Christmas decorating; tiny tubular or globe-shaped replaceable bulbs.

Black Light: A special ultraviolet light bulb; incandescent or fluorescent, that will cause surfaces treated with ultraviolet paint to glow in the dark. The black light

[5]Pegler, Martin M., *Visual Merchandise and Display,*(New York, NY: Fairchild Fashion and Merchandising Group, 1991, p. 54.

is directed onto the treated surfaces, and the darker the area, the more intense and more brilliant the treated objects or surfaces appear. A theatrical device.

Border Light: A striplight hanging from an overhead pattern, pipe, or ceiling grid and used to produce general overall lighting in a window or on a stage. See *striplights.*

Canopy: An enclosure or cap, placed between the stem of the fixture and the outlet box in the ceiling, that conceals the wire connections in this gap.

Chase Lights: A series of lamps that flash on and off in a set pattern, reminiscent of the lights that seem to "run" around theater marquees. It usually comes with its own timing device that sets and controls the flashing or "chase" pattern.

Cove Lighting: A form of indirect lighting. The lighting source in the area is concealed from below by a recess, cove, cornice, or baffles, and sometimes by a partially dropped ceiling. The light is reflected by the ceiling or wall. A soft, subtle way of lighting an area or a wall.

Dimmer: A mechanism for changing the intensity of light in a given area by means of cutting down the amount of electrical current passing through the electrical wires to lamps. The resistance dimmer is the only one that will work on direct current (D.C.) whereas autotransformer electronic resistance, electronic, and magnetic amplifier dimmers will work on alternating currents (A.C.).

Downlight: A light fixture with a reflecting surface, shade, or shield that directs the beam or spread of light downward toward the floor area rather than toward the ceiling.

Flasher: A device that screws into a light-bulb socket before the lamp is inserted and causes the light bulb to flash on and off by interfering with the flow of electric current. Sometimes a set of miniature light bulbs will come with a flasher bulb that causes the current breaks.

Flicker Bulb: A candle-shaped bulb with a filament that flickers and spurts, mechanically simulating a candle flame.

Floodlight: An electric lamp or bulb that throws light over a wide area. Floodlights are available in varying wattages, starting from 75.

High-Intensity Discharge Light: An electric lamp relatively small in size that, like the incandescent, provides shadows and highlighting. The color and makeup varies depending on the manufacturer.

Indirect Lighting: A lighting arrangement in which the light is directed to the ceiling or any other reflective surface, from which it is bounced back to illumi-

nate the general area rather than being directed straight down to the area below. See *Cove Lighting*.

Insulator: A nonconductor of electricity, like rubber, porcelain, asbestos, and some plastics. The insulator is used around electrical conductors (copper wire) as a protective coating.

Lamp: The complete light source unit, which usually consists of a light-generating element (a filament or arc tube), the accessory hardware, the enclosure or envelope (usually glass) for the assorted parts, and the base that fits into the socket; an electric light bulb.

Light: Radiant energy reflecting from an object and acting on the retina of the eye to make that object visible. Intensity in lighting is the amount of that reflection.

Luminaire: The complete lighting unit (from the French word for "light" or "lamp"). It includes the lamp socket, housing, frame, holder, reflector, shield and so on.

Par Bulbs: Incandescent spotlights that are usually used as secondary lighting, but may also be used as primary lighting.[6]

Primary Lighting: The basic, most elementary lighting of a store or selling area. Usually does not include special lighting effects—spots, floods, filters, washes, and so on—and is almost devoid of any sort of atmosphere or mood.

Projectors: The projection process consists of a light source, objects or slides to be projected, and the surface or screen upon which the image is projected. The projector is the light source, and the image may be projected by lens, for a sharper effect, or by shadow, which is less complicated. Front projection places the projector in front of an opaque screen (downstage); rear projection places the projector behind a translucent screen (backstage). In either case, a certain amount of space is required between the projector and the screen.

Reflector: Polished or mirrored surface that is used to redirect light in a desired direction, or onto a specific area; a baffle or screen used to reflect heated air.

Secondary Lighting: The spots, floods, filters, washes, and so on, that add depth, dimension, and atmosphere to a lighting plan; the lighting beyond the basic or primary lighting plan. See *Primary Lighting*.

[6]Ibid, p. 50

Showcase Lamps: Long, thin, sausage-shaped incandescent lamps that are available in 25-, 40-, and 60-watt strengths.

Specific Illumination: Form-revealing, highlighting, and attention-getting lighting that focuses the viewer's attention on a specific object or area. This form of lighting is usually accomplished with spotlights and/or concentrated beams of light, sometimes through a color filter.

Strip Lighting: Long lines of exposed fluorescent fixtures on a ceiling.

Striplights: A general term that includes border lights, footlights, cyclorama, border, and backing striplights. Striplights usually consist of rows of individual reflectors, each containing one lamp and a round glass color medium that covers the entire mouth of the reflector. They are often wired in three of four circuits for the primary colors (red, blue, green), and possibly one for white.

Switchboard: A portable or fixed panel with switches, dimmers, and so on that controls all the lamps and outlets in a window or group of windows, or for a stage. By means of the switchboard, it is possible to turn specific lights on or off without having to climb or reach for them.

Swivel Socket: A socket with a 360-degree swivel joint between the screw-in socket end and the receptacle that receives the lamp or bulb. It is possible, when the lamp is screwed into the socket, to rotate and direct that lamp or bulb to any direction—up or down and to all sides. The swivel socket sometimes comes with an extension pipe before the swivel device.

Track Lighting: A channel or track, usually attached to a ceiling or ledge, that is electrically wired and plugged into a source of electric current. The 4-, 6-, 8-foot lengths of channel will receive assorted spotlights and floodlights,in decorative holders or housings. This is selective lighting, since it is possible to move these lamps about on the length of channel, turn the individual lamps on and off as needed, and direct the light where one wants it, thus making changes in light emphasis.

INTERIOR FEATURE DISPLAYS

Extra lighting is the key in building feature displays—ones that sell news items, remind customers of products that carry a high markup, or help to move close-outs quickly. Feature displays can be made with regular merchandising fixtures, such as wall cases, or with movable merchandise fixtures, such as tables. The secret is using light that is from two to two and a half times stronger than the light you use on your regular displays.

In using such spots of brightness, it is important to vary their location from time to time to give customers something new to look at.

Thought should be given to using your wall fixtures for promotional displays. Shelves niches, and wall showcases can be made to do an extra selling job by the judicious use of extra lighting.

Start by locating lighting fixtures far enough in front of the merchandise to provide effective brightness on all vertical surfaces. Vary the lamp wattage or the quantity of lighting fixtures to project two to two and a half times the light used for a regular wall display.

An example would be display of summer dresses in a wall case. One store uses deluxe natural white reflector-type fluorescent lamps for regular display in the wall case. By the addition of 250-watt tungsten-halogen lamps, the case becomes a promotional display, producing a sunshine effect that reminds customers of the season. In addition, these lamps bring out color in a way that appeals to shoppers.

In another store, the bottom row of suits in a double-tiered rack is highlighted by aperture-type fluorescent lamps that throw a beam of light on the coat sleeves on the lower tier.

If you want customers to look into showcases, light them internally. Small-diameter fluorescent lamps bring out merchandise quality and produce a minimum of heat. Reflectorized tubular incandescent lamps may also be used in smaller showcases.

SHOW–WINDOW LIGHTING

Display lighting in show windows of open-front stores is fairly simple. The lights in such windows—and store interiors—should be strong enough to overcome the reflections from outside objects such as parked cars and buildings. At night, additional light on overhead marquees and projecting cornices can make the window area look larger.

A high-level general illumination is the first requirement for a closed-backed window. An exception would be the attempt to achieve dramatic effects, perhaps by using some spotlights in a darkened window.

Massed window displays are often lighted with overhead fluorescents that are supplemented by closely-spaced clear incandescent lamps. Metal halide lamps can also be used. They give a highly contrasting light with many of the best display features of combination fluorescent-incandescent systems. Certain phosphor-coated mercury lamps that flatter red colors may also be used.

The more direct lighting of tungsten-halogen lamps is especially effective on high-style displays. Dichroic and other color filters may be used to produce colored light from lamps with white beams. Eye-catching mobile color effects can be provided by automatic dimming of switching cycles. Center each principal dis-

play between two or more adjustable lights and have extra illumination for emphasizing the display and for overcoming reflections on the glass.

Use miniature portable spotlights to accent small display areas, price cards, and specific items in a massed display. Compact footlights help relieve shadows near the bottom of vertical displays.

Fixtures for special display lighting can take many forms. Some downlights can be almost completely hidden in the ceiling. Other exposed, bullet-type units are available in attractive geometric shapes that flatter a store's architectural decor. Flexibility is the feature of many fixtures. They will accept a wide variety of lamp wattages and beam patterns. For rapid rearrangement, some fixtures can be plugged directly into an electric track. Other units contain built-in silicon rectifiers or special ballasts that allow wide-range dimming of light output.

Display windows act like mirrors. A mirror has a dark backing material, a layer of silvering, and a pane of clear glass. The interior of the window area acts as a dark background and the glass as the silvering with the sun reflecting. To overcome reflections, more light must come from inside the window than is hitting the window from the outside.

Lighting of the mannequin in a show window must appear natural. The main spot should come from overhead. (From below, it would give an unreal, unflattering appearance.) It should be as far from the mannequin as possible and as close to the glass line as can be managed. One spotlight is not enough to light one mannequin. (A spotlight concentrates the light. It has more sparkle and punch in the center of its rays. The face of the lamp is of clear glass.) The main spot should be a white light. Aim it to cover the main part of the mannequin, which is usually at an angle to the window. Next, use a pink pinspot to highlight the face with color. Also, on the ceiling, a side spot is very effective. It fills in deep, dark shadows and often can be used as a color spot in a complementary color on merchandise. To achieve back-wall color lighting, or to hit accessories or a showcard, or to fill in shadows, a spot on the side wall of the display is very handy.

Many stores fill show windows with merchandise where it is necessary to light these large amounts of merchandise effectively yet interestingly. This calls for the use of floodlights that wash the light over a broad area through a frosted, pebbled glass. The wash lighting technique completely covers every nook and cranny with light, and no merchandise is lost in shadows. The common fault in wash lighting is the roller-coaster effect that is due to poor spacing of lamps. This creates shadows between highlights. It is a mountain-and-valley type of light. To overcome this, overlapping reflector lights must be spaced correctly. (See Figure 10-2).

In determining the proper placement of lamps, consider the merchandise to be displayed. Stores promoting many items in one window, where the merchandise is generally on a flat plane and there is a lot of it, use floodlights and the wash lighting technique. An occasional spotlight can be used to pick out spe-

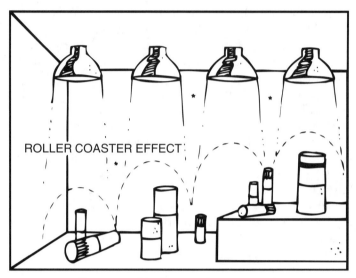

ROLLER COASTER EFFECT

*Incorrect: Shadow gaps not covered
by lighting beams.

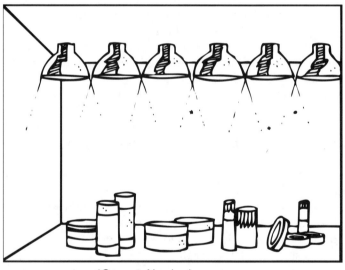

*Correct: No shadow gaps.

Figure 10-2 Correct and incorrect "wash" technique.

cial items. Vertical display, using mannequins with both back and side walls covered with merchandise, calls for floods and spots from the ceiling at the glass line. (See Figure 10-3.)

Lighting is the most important factor in display. Without it, the merchandise cannot be seen. Its function is to highlight the merchandise so that it will sell.

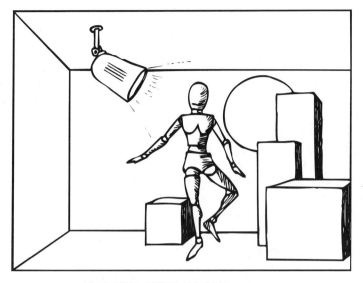

VERTICAL DISPLAY All items are
covered with lighting from one side
or the other.

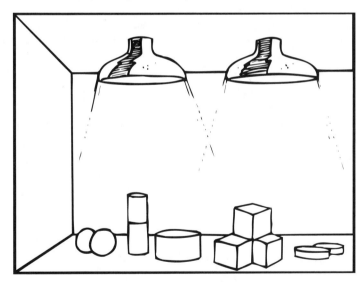

HORIZONTAL DISPLAY All items are
covered with lighting from the top view.

Figure 10-3 "Wash" in vertical and horizontal displays.

SUMMARY

The objective of proper lighting is to ensure that a shopper sees the merchandise.

Colored lights emphasize the color of merchandise, create atmosphere, attract attention, or emphasize desirable undertones. When colored lights are used, they should be more intense, because darker colors tend to "swallow" light. The most versatile colored light fixture is an ordinary lamp with a filter wheel that can be turned to show a desired color.

Lighting methods include pinpointing, spotlighting, floodlighting, diffused lighting, and indirect lighting.

Directional control will improve displays by eliminating glare, bringing out textures and patterns, concentrating light for emphasis, producing effective shadows, and eliminating unwanted shadows.

SUGGESTED ACTIVITIES

1. Conduct a survey of various types of local stores to determine the types of lighting used and the reasons for their use.
2. Gather information on two types of lighting. Then experiment with the lighting on merchandise and present the results to the instructor and/or the class, orally or in writing.
3. Contact lighting manufacturing companies and/or retail outlets orally or in writing to obtain information on the current trends and the future of lighting.

11

SIGN LAYOUT

LEARNING OBJECTIVES—CHAPTER ELEVEN

1. Discuss the importance of using proper signage techniques in merchandise presentations and displays.
2. List and explain the proper margin guidelines that are used in creating effective signs.
3. Discuss the relationship between the optical center and the focal point in a sign layout.
4. List the six steps used in creating a sign or a showcard.
5. Explain how balance, proportion, dominance, and subordination relate to the principles of sign layout.
6. Discuss how lines can add movement to a sign or showcard.
7. Explain how formal or informal balance might be used when creating a sign or showcard.

INTRODUCTION

Retailing is an ever-changing business; each day presents new challenges and opportunities to serve the customer in the most effective and profitable manner. An integral part of customer service is proper signage. Signs provide the customer with information to make buying decisions. The information could include vendor name, price (regular or promotional), size, or in-store promotion data. The type of signs that are present in a retail establishment will vary depending on the type of operation (specialty, off-price, discount, or department store) and the market that is being targeted.

The type of procedures used for producing signs will again vary by store operation; signs may be designed and created at a central location or the respon-

sibility may be given to the individual store. Signs can be created in a number of ways: computer-generated programs, sign machines, stencils, or hand/coit lettering procedures (outlined in Appendix A).

Whatever signing procedure and method a store chooses, the retailer should keep in minds that signs are the silent salesperson, and an extension of customer service.[1]

Guidelines that might be discussed concerning effective sign layout are many and varied. A few of the most common principles are covered in this chapter. You will master variations on the principles and additional techniques as you progress in signing and layout skills.

Special attention should be given to sign and showcard margins. The left and right margins should be exactly equal and usually should not exceed 2 to 3 inches. The top margin should be approximately one to one and a half times the size of the side margins. The bottom margin should be the largest, twice the size of the side margins and one and a half times the size of the top margin.

The focal point of a sign should appear near the optical center of the sign, which is exactly halfway between the left and right margins and slightly above the top-to-bottom midpoint. Letters and words will obviously be seen and read from left to right. The same principles of proportion, balance, and emphasis discussed in the preceding chapters should be used when laying out a sign.

In producing a showcard, line borders are often used to contain the eye. These lines, which may extend completely around the sign or appear only in defining its corners, should stay within the prescribed margins just suggested. They often contribute a completed and professional appearance to the sign and may be added to balance the contents of the sign if necessary.

Showcards, a necessary part of any display area, are most impressive and effective when produced individually by the person creating the display, so that their layout, lettering style, and total effect are in keeping with the mood of the display.

As your lettering skill increases, your showcards will reflect creativity and imagination. Therefore, more restrictive rules of lettering will not be set forth here.

SIGN LAYOUT

Principles of Layout

In lettering, *layout* means the arrangement of copy, designs, or illustrations on a showcard.[2] Layout is very important to the success of a showcard. Even though

[1]Tom Reynolds, "Four Retailers Discuss Their Signage Programs," *Visual Merchandise and Store Design*, 123 (August 1992): 78.

[2]This section is adapted from "Principles of Layout," *Lettering & Layout Techniques* (Madison, Wis.: Board of Vocational, Technical & Adult Education, 1963), p. 24.

the lettering may be perfect, if your layout is not harmonious, your card will lack *visual impact.*

The two usual types of layout are formal (symmetrical) and informal (off-centered or asymmetrical). If a line were drawn through the center of a formal layout, both sides would be equal. If this were done to an informal layout, the sides would not be equal in amount or size of copy, design, or illustrations. But the informal layout would balance visually, owing to the placement of contrasting sizes, shapes, colors, lines, and so on.

To understand why this balance would exist, imagine a seesaw, with a child at each end. If the children are of the same weight (formal layout), the seesaw will balance. If they are not of the same weight (informal layout), one child must move closer to or farther from the center of the seesaw to achieve a balanced position. The same principle applies to the placement of elements within an informal layout.

Formal layout is the easier of the two to master. Before undertaking a formal layout, however, we must consider the rules for margins and optical centers.

Margin Rules. The margin numbers represent units or proportions. For example, if you used 1/4 inch as the unit, the sides would be 1 inch (four units), the top 1 1/4 inches (five units), and the bottom 1 3/4 inches (seven units), as in Figure 11-1. Try to maintain as much white space as possible around the copy.

The Optical Center. The optical center is one-tenth the distance above the true center (Figure 11-2). The eye will usually make contact with this portion of the card first. Therefore, use this center to good advantage. Place in this area the important heading that will catch the viewer's attention.

Steps in Layout

Let's assume a local grocer has asked you to make card, 11 × 14 inches, vertical. The copy reads as follows: Homogenized Milk, 1 gallon, $1.87.

Step 1: The copy is received. At this point, valuable information can be obtained from the copy writer, such as preferred colors, where the copy is to be

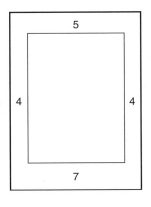

Figure 11-1
Margin numbers represent units or proportions.

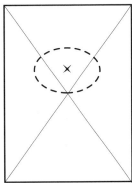

Figure 11-2
Determining the optical center.

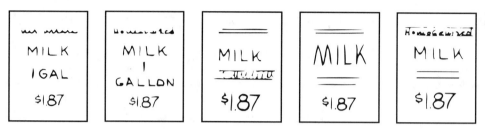

Figure 11-3 Thumbnail sketches allow you to try several layouts before inking.

placed, what are felt to be the most important elements, and if the card requires an easel.

Step 2: Rank the importance of words or elements by numbers or letters:
(4) Homogenized
(1) Milk
(3) 1 gallon
(2) $1.87

Step 3: Make thumbnail sketches of these elements, and choose the best layout for transfer to the showcard. These sketches should be made in proportion to the finished card. In each sketch, attempt a different approach, until an effective layout is created. See Figure 11-3.

Step 4: Begin drawing guidelines for the best sketch on your card.

Step 5: Begin inking, starting at the top line to the left. Working to the right, move down to the second line of copy, and repeat the process. Use a variety of sizes to give the card contrast in weights of words. Avoid the monotony of using the same size of pen all the way through.

Step 6: When the sign is thoroughly dry, clean off pencil marks with an art gum eraser (optional if guidelines are light, since erasers streak some showcards). See Figure 11-4.

Figure 11-4
Completion of sign. Note that the penciled guidelines and "X" have been erased in the final sign on the right.

Layout Principles as Related to Design Principles

The principles of layout, as noted, are directly related to the general principles of design: balance, proportion, dominance (contrast), and the direction of attention through suggested movement.

Balance. The two kinds of balance are *formal* and *informal.* Figure 11-5 illustrates them and shows examples.

Proportion. *Proportion* refers to the relation of the parts to each other. It is achieved through *variety, color, line,* and *type.* Proportion is essential to attractive cards. See Figure 11-6.

Dominance and Subordination. Some parts of the layout should stand out on the card. This can be achieved by giving a larger area to some particular part of the

Figure 11-5

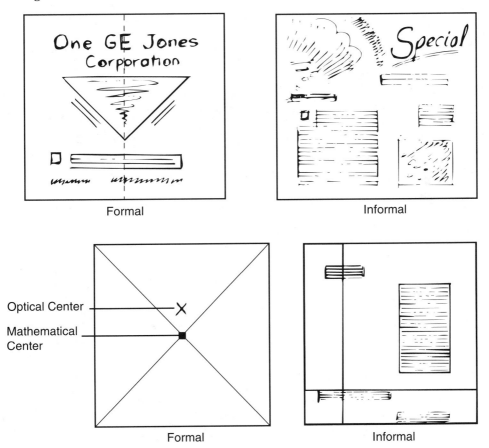

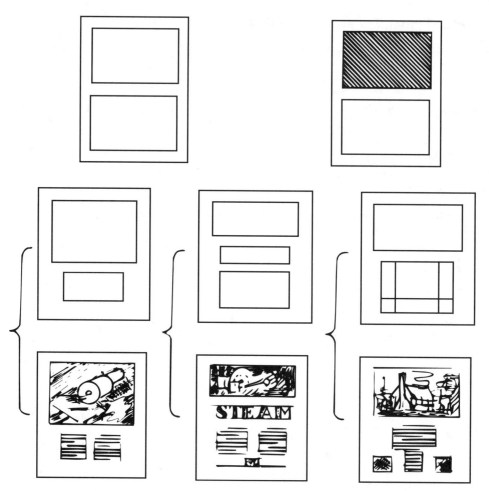

Figure 11-6 Proportion refers to the relation of the parts to each other.

copy. Dominance may also be obtained through interesting lines, strong contrasts, white space, odd shapes, or colors. See Figure 11-7 for examples.

Lines of Direction (Suggested Movement). Figure 11-8 illustrates some of the ways movement can be suggested to lead the eye in the desired direction.

Informal Layout Examples

Informal layouts are most effective in attracting attention, directing eye flow, and providing variety to your showcards. The examples, Figure 11-9 illustrate several techniques in achieving such layouts.

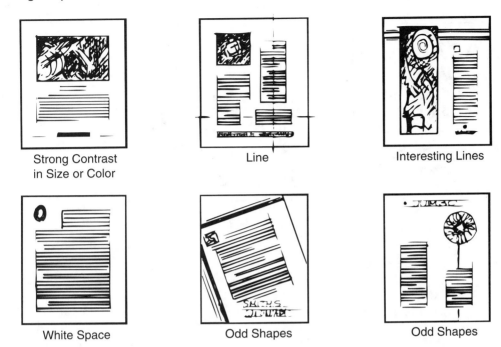

Strong Contrast
in Size or Color Line Interesting Lines

White Space Odd Shapes Odd Shapes

Figure 11-7 Examples of dominance and subordination.

Figure 11-8 Lines can lead the eye in the desired direction.

"Cabbage today only" balances
"2 pounds 39 cents"

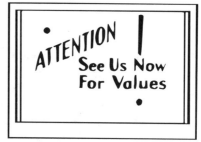

"Attention" and the dot above
it balance the rest of the layout

Diagonal balance – "Rugs" balances
the rest of the copy

Another diagonal balance

Figure 11-9 Informal layouts attract attention.

Conclusions

As you can see, there are no set rules in layout beyond the basic principles of design. Your best approach is to study many forms of layout to see what seems to work best, making sketches along the way. Keep in mind that you must have a reason for what you do; then analyze what you have done to determine whether you have accomplished that goal.

Portfolio Project Seven: Sign Layout

Using the guidelines discussed in Chapter 11, create 3 posters for your portfolio (one of which should be institutional). You will be evaluated according to the guidelines discussed in the chapter. Attach a brief typed description to each sign, explaining why and how you prioritized the items on the sign.

12

VISUAL MERCHANDISING AIDS & AREAS

LEARNING OBJECTIVES—CHAPTER TWELVE

1. Define and explain *P.O.P.* (point-of-purchase) displays and how they are used in merchandise presentations.
2. Explain what type of visual merchandising aids supermarkets and drugstores use in merchandise presentations.
3. Discuss the role mannequins play in fashion displays.
4. List the steps for dressing a mannequin.
5. Explain the difference between hard-line and soft-line merchandise presentations and displays.
6. Discuss the type of props and display areas that are used for hard-line and soft-line merchandise presentations and displays.

Our discussion of visual merchandising up to this point has focused largely on fashion displays—those found most often in main-line department stores and general-merchandise retailing establishments. Here we expand our framework and consider other retailing establishments that employ visual merchandising aids, namely, drugstores and supermarkets, which rely to a large extent on point-of-purchase displays; boutiques, small shops that feature an abbreviated line of goods, such as sunglasses or swimwear; and hard-line merchandisers, such as hardware and furniture stores, where the products to be sold are often large and difficult to move.

Common to all these retailers is their use of point of purchase displays, and it is with this visual merchandising aid that we begin Chapter 12. We then consider the use of signs and, finally, the use of mannequins, which are used largely by soft-goods merchandises to display fashion apparel.

VISUAL MERCHANDISING AIDS

Point-of-Purchase Displays

With the growth of self-service retailing during the past two decades, and the increased competition for the consumer's dollar, point-of-purchase (or P.O.P.) displays—where merchandise is presented to the customer at the point of purchase (usually near the checkout counter)—have proliferated. Given the broader spectrum of merchandise carried by many retailers, P.O.P.displays offer a means of segmenting the merchandise into identifiable categories.

Besides the benefit that P.O.P. displays offer the consumer—namely, those of easy identification and accessibility—point-of-purchase materials often represent a great accommodation to the retailer.

For example, P.O.P. advertising links the retailer with a product manufacturer that can afford to advertise the produce on television and radio and in national magazines, thereby reducing the retailer's outlays for advertising while broadening consumers' recognition of that product. Moreover, to standardize product identification, it is the manufacturer of the product being displayed who supplies the display materials to the retailer and often assists in developing a local advertising campaign. This assistance is often provided free of charge as an inducement to the retailer to stock the manufacturer's full product line.

Point-of-purchase materials range from counter cards to free-standing displays using light and motion as attention-getters, to blow-ups of the product package that can be suspended from the ceiling of the store. The type of P.O.P. materials provided to the retailer depends on the budget of the product manufacturer and the ability which the product or product line lends itself to such a display.

Some of the goals of P.O.P. displays are to

1. Increase impulse purchases.
2. Tie in the product to promotional and advertising programs.
3. Attract attention.
4. Distribute samples of the product.
5. Provide a place for storing the product (shelving).
6. Introduce a new product.
7. Distribute coupons.
8. Elevate a product eye level.

Some guidelines in the use of P.O.P. materials are to

1. Inspect all incoming P.O.P. materials furnished by a manufacturer so as not to overlook good promotional opportunities.
2. Not order or try to use every available "freebee" as too many P.O.P. entries in a store can downgrade or distort its image.
3. Coordinate P.O.P. materials with other promotional efforts in the store.
4. Not accept and then discard P.O.P. materials. They cost the product manufacturer a lot of money and should be used and then stored carefully for use as props in future promotions.

Types of P.O.P. Displays *Outdoor displays* are used to attract the potential customer and to inform him or her that these manufacturers and their products are represented and available inside.

Counter displays and fixtures, which are window displays compacted and brought inside, are used to introduce a new product; show merchandise range; and supply testers, samples, and coupons.

Floor fixtures are large P.O.P. units that are free-standing on the selling floor.

Accessories (banners, pennants, ledge signs, dump bins, lapel pins, demonstration setups, food tasting) are added to a P.O.P. display concept to enhance the promotion of a product inside a store.

Media tie-in links product to other media promotions (TV, newspapers, magazines, store mailings).

Important P.O.P. Design Considerations Counter space must be light and easily portable, low enough so the salesperson can see/reach over it, narrow enough not to impede selling action on surface.

Production identification must attract and quickly inform the shopper what the product is, what it does, and who makes it.

Customer involvement through the use of samplers increases interaction with the actual product and stimulates impulse sales.

Shipping and assembly should send as completely assembled as possible, parts should be prescored, tag or number all parts, include a diagram with instructions.

Light and motion attract shoppers and increase the likelihood that they'll remember the product's name.[1]

Signs

Signs and a store signature are important. A special type of lettering may be used to represent a store and carried through on bags, matchbooks, delivery trucks, and advertisements. The more unusual the artwork, the more effective it will be in distinguishing the merchant from its competitors. (Signs were discussed in Chapter 11.)

SIGNING

At the least, signs keep the store's presentations consistent and uniform and help the customer to make informed buying decisions. At the most, signs can increase sales by being displayed attractively (in a plexiglas holder, for example), and by containing information that adds to the customer's knowledge of the product or services being offered.

[1]Martin M. Pegler, *Visual Merchandising and Display* (New York: Fairchild, 1983), p. 76.

At J.C. Penney, signs are used to highlight

1. New and innovative products
2. Advertised specials
3. J. C. Penney corporate goods
4. Closeouts
5. Sale items
6. Special-purpose goods
7. Major brand-name goods
8. Recommended loss leader promotions—LLPs[2]—(when a promotion is built around an item at a sale price, which will not net a profit but will attract customers)

Displays Using Mannequins

The use of mannequins in the display of apparel tells customers that fashionable merchandise is available to them, by painting a picture of the garment on them. The display of mannequins creates a fashion atmosphere in the store, through fashion coordination, and helps to sell complete coordinated outfits. For non-fashion merchandise, mannequins also show the viewer samples of merchandise being sold and "set" a store atmosphere.

Department stores may use mannequins to display certain lines of upscale, trendy merchandise. Specialty stores will highlight certain items of merchandise or tell a silhouette story by displaying merchandise on mannequins. Due to the nature of the business in a discount or off-price store, and the way goods are merchandised there, you are less likely to see mannequins used as props in a visual presentation.

Before the mannequin is assembled and dressed, it is necessary to have a display theme. Next, the clothing to be used must be selected and pressed. It must, of course, be fashionable merchandise. Accessories should be chosen carefully to complete the costume; often, the use of accessories will be in a vital sale of all the merchandise in the display.

Steps in Dressing a Mannequin

Follow the same steps whether dressing a male or female mannequin. For both, your job will be easier if you arrange for clothing of the correct size—this will keep pinning (and taping) to a minimum. Finally, make sure that when more than one mannequin is used in a display, the clothing being shown is coordinated. In this case, coordination can be either rigorous, ensuring that all clothing colors, shapes, hemlines are compatible; or more flexible, using alternating colors for separates—navy blazer and white slacks for one model, white blazer and navy slacks for another.

[2]The authors wish to thank the J. C. Penney Co., Inc. for providing the information presented in this discussion, which was part of a survey conducted by the authors in 1984–1986.

Once you have chosen (or have been assigned) the mannequins' wardrobes, arrange for a clothing rack to be set up adjacent to the mannequins so that the clothing can be organized before fitting.

For all mannequins,

1. Separate arms, hands, waist, and legs (if it is cross-legged mannequin).
2. Turn bottom half upside down and put on hose, trousers, and shoes.
3. Carefully split pants along seam in the seat to make room for the mannequin's stem.
4. Attach torso; put on blouse, shirt, and vest.
5. Put on jacket. Put arms back in by way of blouse.
6. Accessorize.
7. Apply makeup; position wig and hat.
8. Cut off garment tags and place in garment pockets or pin inside the garment.
9. Coordinate mannequin's pose with that of other mannequins in display.

To illustrate how these steps are followed in practice, here is an example of how to dress a man's suit form:

1. Put shirt on form. Button. Turn up color so tie will go on easily later.
2. Fold excess shirt material into center back of form; flip shirttail under and pin in place.
3. Turn up front shirttails into the sides of the form and pin in place.
4. Tuck shirt sleeves into armholes of the form.
5. Wrap tie around upturned collar and tie. Pin tips of collar to form and clip off pin heads.
6. Add vest and jacket. Button vest. Do not button jacket unless displaying a suit with no vest.
7. Align buttonholes with buttons.
8. Place pin inside jacket sleeve and attach sleeve to side of form.
9. Fold slacks in half and pin or wire into side of suit form.
10. Accessorize with pocket handkerchief.

If clothing is the correct size, a minimum of pinning will be required (as we've noted). However, if it is necessary, the following areas may be pinned: neck of shirt by top button, jacket vent, under jacket collar at back, and under jacket lapels. It may also be necessary to pin on shoulder pads before jacket is put on and insert cuff blocks into jacket sleeves after sleeve has been pinned to the form.

When dressing is completed, polish any exposed chrome.

Change a mannequin as often as possible. Surveys show that customers return to shop every ten days. On each of their visits, show them something new to stimulate their interest. Some experts say that displays in small towns should be changed every four to five days because of the high number of repeat customers providing the store traffic.

The next step is to select a background to create the proper atmosphere for the merchandise. It must enhance, not overshadow the merchandise or in any way present an opposing message. It is often a temptation to simply change the clothes on a mannequin, leaving in the same tired background week after week. The display then becomes out of season, and gives the passerby the impression that it has not been changed at all. The background provides the proper setting for the merchandise and should be considered each time the display is changed.

Mannequin are of different kinds: standing, kneeling, reclining, and frozen in action. There are mannequins with and without arms. Bust forms also may be used.

Most mannequins have "breaking points" at the shoulder, wrist, waist, and thigh. Because the mannequin is not flexible like the human body, it is often necessary to "break" it at these points.

Mannequins, as we have stressed, are the most important element in a fashion display. They must be maintained impeccably, and their styling must be in keeping with current fashion trends. Up-to-date accessorizing ideas can be found in fashion magazines, media presentations, and displays developed by your competition.

Mannequins can and should be used in (1) theme areas, (2) main aisle presentations, (3) window displays, and (4) entrances. Keep in mind that wherever mannequins are used, they should be appropriate for the segment of the population they are meant to represent: junior, preteen, and women's, for example.

With these general guidelines in mind, let's now consider the finer points of posing and dressing mannequins.

Posing Mannequins

Mannequins should be posed in natural positions. They should show off the merchandise in which they are dressed—for example, if you want to show off a garment's sleeves, be sure that the mannequin's arms are extended. To achieve this coordination, choose the merchandise first, then choose the mannequin.

If you are using more than one mannequin in a display, be certain to make their positions compatible.

When you pose your mannequins, consider one of the following basic positions:

1. Back relaxed (positioning mannequins back to back in neutral poses).
2. Interlocked (positioning mannequins with hands, arms, etc., interlocked).
3. Repeated (positioning mannequins in identical poses moving in same direction).

In the case of three or more mannequins, you can cluster them in a pyramid form by placing them at various levels on platforms, with the central mannequin posed at the highest point. A cluster of five mannequins is used only in a major theme area.

Particularly when designing an in-store display, do not separate mannequins with props, and be sure that you place the mannequins in positions that can be viewed from all angles.

HOW THE BROAD SPECTRUM OF RETAILERS USE VISUAL MERCHANDISING AIDS

Supermarkets and Drugstores

Nowhere is good display more important to profits than in the American supermarket and, more recently, the health care and beauty and (drug) store. Because these merchants operate on such a small percentage of profit, it is imperative that all items appear as tempting or necessary as possible.

Props used in supermarkets are usually confined to shelves, racks, and merchandise pyramids and fixtures, which are provided by the total store decor. In displaying food items, two considerations are imperative: *absolute cleanliness* and *placement of the food items where they will be seen* by the customer. Impulse items are often placed next to the checkout stand to entice the customer who is waiting to check out. Most food items are accessible to the customer, because food stores are generally self-service, and most are at eye level to provide for easy visual and physical accessibility. Also, the same product may be displayed at several points in the store, so that it is next to other items that it might accompany at a meal.

One exception to the "well-displayed" supermarket is the growing trend toward "discount" supermarkets, also discount drugstores where the P.O.P. merchandise remains in shipping containers, giving the "lower overhead-lowest price" look. Very little attention is given to effective merchandise displays in these stores.

Signs are extremely important in supermarkets. Outside, signs announcing specials are sometimes presented in almost a shorthand, understood only by the consumer who wants to know about as many sale items as possible for the weekend. These signs are often used against the front window and must be easily read, colorful, and informative. Interior signs include aisle information signs as well as special-sale signs.

Color is important—bright, clear, clean colors should prevail.

Pharmacy stores or drugstores also use props such as shelves, racks, merchandise pyramids, and other fixtures, which make up the total store decor. These are relied on even more so as most drugstores do not make extensive use of exterior window displays. Interior displays are generally located between the front of the store and the drug counter at the rear, so the customer must pass them when entering, leaving, or picking up a prescription. The point of purchase at the entrance(s) or point-of-prescription service, postal needs, and so on are all places where the customer may easily view especially "small items" (such as small gifts, housewares, toys) when walking by or standing on line for service.

Many drugstores also carry quality boxed candy and moderately-priced seasonal gift items,such as stuffed animals at Christmastime.

Boutiques

A *boutique* is a small shop selling separates and accessories. Our current interpretation of *boutique* includes a concept of a specialty store, selling unusual, high-style, high-priced merchandise. In fact, today, a boutique is nearly any small shop, whether it is located on Carnaby Street in London, in SoHo or on Columbus Avenue in Manhattan, on the main street of an American midwestern town, or in a part of a large department store with a small-shop look.

Boutiques encourage the customer to browse. Whereas large stores use special display techniques and special props to set aside a particular line of merchandise in order to achieve a boutique effect, boutiques use antique furniture or other unique props to provide that special kind of atmosphere apparently so pleasing to today's customer.

Several factors have created the need for a new look and new technique of merchandising and display: greater quantities of merchandise available; increased imports in soft goods, fashion areas, and hard lines; new and increasing awareness of changing fashions; and a huge new teenage market. A boutique may specialize in one merchandising line, such as junior dresses; one price line; one merchandise source, such as French imports; or one market, such as the children's market; or it may include several of these ideas.

The props in a boutique are an important consideration. many items of furniture and antiques that are used to enhance merchandise in the boutique are themselves for sale. Great care must be exercised to accumulate props in accordance with the look of the merchandise, whether it is a look of imported goods, the Old West, American antique, or youth. The props must not overshadow the merchandise as salable items and turn the fashion store into an antique shop. However, usable furnishings are probably the most popular and important of the boutique display props.

Important features of boutiques, in addition to special merchandise and unique props, are the interesting permanent architectural details and intriguing graphics that frequently accompany them. Large spaces are divided into small, intimate areas. Special store fronts are used to set the small boutique apart from its often drab surroundings in an out-of-the-way location. In some instances, the merchant's creativity reaches outside the boutique, and the store front is painted, and its motif and color are changed with the change of the seasons and changes in the merchandise selection. Many boutiques are located in atmospheric brownstone houses or old frame houses.

Hard-Line Retailers

Hard-line retailers specialize in merchandise that is nonflexible. Many of these items are small, such as those found in hardware stores—tools, light fixtures,

paints, and so on. Also included in hard lines are many gift and accessory items that are small and need special fixturing and shelves to make them appear as a unit. Hard lines also include china, silver, glassware, pottery, and cookware for the home, along with dozens of home gift items. Each of these merchandise categories presents special display problems. Radiation, progression of sizes, and repetition of shapes are used to give these displays rhythm.

Props that are easily used to unify hard-line displays include shelves, counter tops, steps, and so forth, which help the items appear as display units.

If hard-line goods are large, like furniture and appliances, they require a setting, such as room. They appear within the prop area rather than upon props. Appliance departments and stores, hardware stores, and hard-line gift areas have a tendency to appear spotty and cluttered if the goods are not displayed properly. This is due to the fact that many items must be visible to the customer simultaneously for a proper selection to be made.

Soft–Goods Merchants

Fashion merchandise falls under the heading of soft goods, which include men's, women's, and children's ready-to-wear and accessories. These merchandise lines are easily draped and folded and lend themselves well to displays using continuous line eye movement as a method of creating rhythm in display.

Common props used in soft-goods displays include mannequins, T-stands, racks, pinned surfaces, and furniture fixtures. Displays may range from one-mannequin displays to those using mannequins, shelving fixtures, and other combinations of soft-goods props; and from single items where the merchandise is of substantial value to complete, accessorized units displaying many items, such as several coats accessorized by hats, boots, scarves, handbags, and jewelry.

One technique of arranging soft goods of all types is called flying the merchandise, suspending it from walls and ceilings through the use of spool thread or other invisible wires so that is appears to be in motion. Using this technique, fashion items can be shown in their entirety, without the use of mannequins and as they would be seen in motion. It is important never to fly merchandise in a way that contradicts natural body movement, such as bending forward at the knee.

Much is being done today with home furnishings like towels, sheets, and other linens. These are often put in a setting that implies their use in a home. Bath towels are shown with hampers, towel racks, soaps, wastebaskets, and even toilet seats of a corresponding pattern. Sometimes entire environments are created to show where merchandise would occur and how it would be used in the home, office, and so on.

SUGGESTED ACTIVITIES

1. Visit four boutiques or specialty stores in your community and list the features of the windows or interior displays you find to be unusual. Discuss how

each provides reinforcement for the overall theme of the boutique. Submit a written report on your findings. Include snapshots if you wish.

2. Sketch or describe in detail how you would decorate and display a clothing boutique's exterior to set it apart from other store fronts surrounding it. Include comments on the role of the store front in merchandise display.

3. List all the considerations you feel make supermarket display effective. How is it different from other types of store display?

4. Using the same theme, the same props, and the same space or shelf, create a soft-line and then a hard-line display, changing only the merchandise, the lighting, and the arrangement of the merchandise according to display principles. Create these displays in class as a demonstration of the differences between soft-line and hard-line displays.

Portfolio Project Eight: Optional Display Construction

The purpose of this project is to individualize instruction so that, during the ensuing four weeks, the display student may concentrate on his or her own special areas of interest and gain display experience and skill that will be of benefit in a career choice.

Consulting with the instructor, you will select from the accompanying list the type of display with which you wish to gain experience. Construction time and evaluation criteria (in addition to the usual element and principal analysis) will be determined through a conference with your instructor.

Displays may be constructed in the school through use of its display lab, bulletin-board surfaces, display-case areas, or other central locations for displays. This display assignment may also be done in a retail store or commercial institution, according to your agreement with the instructor.

After a display site has been agreed upon, it must be determined whether the message will be institutional or promotional and whether merchandise will be selected. Signs and showcards will be prepared, props assembled, and the display lighting considered.

The display is to be evaluated according to display principles as well as the special criteria agreed upon. The display evaluation may take place as part of the class period if an in-school display area is used or by appointment if an outside institution provides the display space. The time allowed for construction and evaluation will depend on the type of display and display area selected:

Corner displays
Kiosks
Pinned display story (several such displays in an area with a central theme)
Hard-line window display
Soft-line window display
Institutional trade-show exhibit
Institutional window
Total boutique (classroom or actual small boutique)

13

LANDS' END
DIRECT
MERCHANTS

LEARNING OBJECTIVES—CHAPTER THIRTEEN

1. Discuss the unique merchandising and display challenges that face a direct merchant (or direct marketer).
2. Explain the purpose of a floor plan.
3. List and discuss the criteria for developing an effective floor plan at Lands' End.
4. Explain how seasonal changes affect merchandising strategies at Lands' End.
5. Discuss the steps that are followed when merchandising for an ad setup at Lands' End.

DIRECT-MAIL MERCHANTS

Lands' End, located in Dodgeville, Wisconsin, is a mail-order catalogue company. Founded in 1963 by Gary Comer, it started out as a catalogue supplier of hardware and other equipment for sailboats. Customer. demand for the apparel items continued to increase and in 1977 the emphasis shifted to apparel.

Being a direct merchant presents special challenges and opportunities for servicing the customer. Since catalogues do the talking (or the merchandise presentation) for Lands' End, it is very important to advertise great prices for classic value-priced merchandise in an appealing format. And just as important as the direct-mail piece, is the helpful and polite operator who takes the order.[1]

[1]Susan Caminiti, "Romance: Lands' End Courts Unseen Customers," *Fortune*, March 1989, p. 44.

Customers and operators have access to "specialty shoppers." Sharon Kostuch, Specialty Shopper Supervisor at Lands' End, explains the role of the Specialty Shopper: "Individualized attention is what we give our customers. We can answer questions that a customer may have regarding size, color, construction or fit; we have access to the merchandising staff if there are questions that we cannot answer. We also coordinate wardrobes for customers who are taking a trip and don't have time to shop for the proper articles of clothing or luggage. A size and color range of the items that appear in the catalogue are accessed easily by the shoppers; this pertains to soft line and hard line items."[2]

In a traditional department store or specialty store the merchandise is displayed so the customer can see items coordinated together either by style, silhouette, size, or color; Lands' End must address this merchandising challenge over the phone. Dotty Quinn, Display Specialist at Lands' End, discusses how this is done: "Each month new displays are created in the buildings where our employees work. The most current and new products are used in these displays. In this manner, we keep our associates up-to-date with what we are selling. I try to do this in the most visually exciting manner possible. I coordinate all items with color, and try to give suggestions in combinations that make people take notice of the products. Once I get their attention, they will touch and feel the merchandise and it will register in their minds. Knowing our goods and being impressed and excited by our product, translates into the voices of our operators and staff. Thus, we can satisfy our customers with descriptions coming through confident, knowledgeable voices."[3]

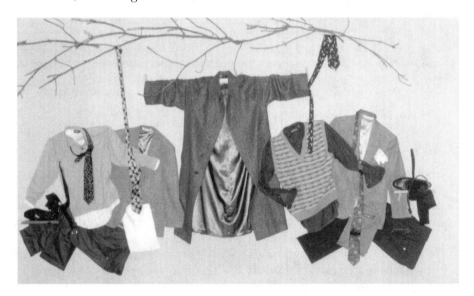

[2]Sharon Kostuch, Specialty Shopper Supervisor, *Lands' End Inc.*, Dodgeville, WI, August 1993.

[3]Dotty Quinn, Display Specialist, *Lands' End Inc.*, Dodgeville, WI, August 1993.

RETAIL OUTLETS

In addition to being direct merchants, Lands' End also operates retail establishments. The specifics of merchandising a Lands' End store will be discussed in the following manner: display creation, planning and preparation, floor plans, fixtures, color, lighting, props, seasonal changes, ad set-up and the final checklist.[4]

Display Creation

An effective display will attract the customer's attention and produce a sale. As discussed earlier in this text an effective display also conveys the company image and is targeted to a specific market niche. Lands' End believes that a display should set them apart from the competition. It should inform the customers of the type of merchandise sold, and assist with suggestive selling and multiple sales.

Planning and Preparation

At Lands' End the primary goal is to service the customer and sell merchandise. Consequently, merchandising a store involves preparing the store front, walls, ceiling, and the selling floor to highlight and display merchandise in the most effective manner possible. A floor plan, or an outline of the store, is an integral part of display and merchandise planning. It gives direction in terms of space allocation for displays, fixtures, ad set-ups, where and how to highlight best-selling categories of new merchandise, and clearance merchandise.

Floor Plans

When preparing a floor plan Lands' End follows the following criteria:

1. Floor walk-through, develop an overall picture of the selling floor and surrounding areas (sketch the selling floor if necessary).
2. Decide what needs to be changed and/or condensed.
3. Check merchandise on feature racks to see if they need to be rotated.
4. Review stockroom availability.
5. Review incoming shipments and upcoming ads (will there be sufficient merchandise to support the floor change?)
6. Decide on fixture placement and type.
7. Schedule sufficient staff to cover the floor and to do a floor move; make sure that the floor move does not conflict with peak customer traffic patterns.

A good floor plan should also take the following points into consideration:

1. Do the fixtures and merchandise create balance? Fixtures, merchandise, colors, sizes, and silhouettes all affect balance.

[4]Materials furnished by Lands' End Inc., Dodgeville, WI; the authors wish to thank Lands' End Inc., for their support and cooperation in preparing this chapter.

2. Create categories of like merchandise; departmentalize the selling floor (i.e., men's pants, shirts, and sweaters).
3. Highlight and merchandise the type of items your customer prefers (style, price, and quality).
4. Use a central color theme or story.
5. Make certain that all fixtures are in straight rows; they should be in balance with the floor plan.
6. Consider the height of the fixture; create an elevation, front to back, low to high.

Fixtures

Fixtures were discussed in detail in Chapter 7. Lands' End uses several different types of fixtures in their selling floor set-up. The types of fixtures used would include: a straight rack (used for regular-priced or clearance merchandise); rounders (work best for merchandising groups or related separates); four-way and T-stand (very effective for highlighting and featuring merchandise); cube units (used to house folded merchandise); pinwheel (floor fixture used to house accessories); reversible shelf (a floor fixture used to house domestics and/or shoes.

Color, Lighting, and Props

As discussed in Chapter 9, color can affect consumers when they are making buying decisions. Therefore it is necessary to apply color principles and concepts when creating a merchandise presentation or display. These concepts are: maintain one color theme, use only three colors in a display, colorize within sizes, colorize within groups of merchandise (i.e., prints, stripes), and colorize shelved goods from top to bottom, left to right.

Lighting calls attention to the merchandise and encourages the customer to buy; lighting can also direct a customer through the store. Lands' End uses spotlights to highlight displays and emphasize detail, since spotlights are more effective than floodlights. Lights that have burned out should be replaced as soon as possible so that the display will not lose its eye appeal.

Props will define, describe and support the merchandise that is being used in the display. When deciding on the type of prop to use, Lands' End selects props that reflect and blend with their classic merchandise. The props that are used should also tie in with the theme used and create a visual presentation that is in harmony with all the elements of display.

Seasonal Changes

The only constant in the retail environment is change. As the seasons evolve, the merchandise selection and presentations will reflect a change in the way the goods are displayed and promoted to meet customer demand. The four major

seasonal changes that take place at Lands' End, and how they affect floor setup and merchandising strategies, are discussed here.

Our biggest seasonal changes at Lands' End include:

Spring/Summer
Fall/Winter
Holidays
Clearance

A. *Spring/Summer:* It is up to the store to determine when spring and summer merchandise will arrive. Ideally, a good representation of spring merchandise should be shown in the front of the store in February. As more spring and summer items arrive, move fall and winter merchandise towards the back of the store. Do not try to make a statement with spring goods, unless there is a fair amount of merchandise to support it.

For a smoother transition, when doing spring displays early in the season, use heavier-weight cotton, long sleeve shirts, cotton sweaters, and lightweight outerwear. Spring colors help brighten the front of the store and will help give the store a new and exciting look.

Further into the season (ideally by March), all of the focal points in the store should incorporate spring and summer merchandise. This includes windows, walls, and displays. Do not forget to put key seasonal classifications up front and toward the center—shorts, knits, and swimwear.

B. *Fall/Winter:* A good portion of fall merchandise should include items that will be good for those shopping for the school year. The merchandise coming into the store should include domestics and children's clothing. Although August is still a strong selling month for spring and summer clearance, remember to make a strong back-to-school statement.

Fall and winter merchandise should be moved to the front of the store by the middle of August. For any easy transition, use light weight fall items in displays. Further into the fall season, all displays and feature racks should be heavily layered.

C. *Holiday:* From a merchandising standpoint, the most important holiday is Christmas. The Christmas decorations help put customers in the shopping mood. Also, have displays reflect gift-giving ideas.

A great way to put together a holiday look is by merchandising certain classifications prominently in the store. For example, at Easter, make a strong dressy statement with both adult and kids' merchandise. At Father's Day and Mother's Day, make a whole section of gift giving accessories and other items.

Use good taste in decorating. For the different holidays, paper cut outs and other inexpensive decorations are not encouraged. Be consistent with the Lands' End image.

D. Clearance: The clearance season can be one of the most frustrating times to merchandise. It is important to make a big impact with clearance goods. When there are odds and ends, consolidate them and then move the fixtures toward the back of the store.

All clearance fixtures should be sized so that it is easy for the customer to shop. Price point signs should not be used on a fixture unless all the items on the fixture are the same price. If you have more than one fixture price-pointed, the lowest priced fixture should be closest to the front of the store.

Ad Set-up

Advertised items need to be displayed properly so the customers will find the advertised items as soon as they walk in the door. Poorly-highlighted advertised specials will not allow the retailer to achieve a profitable return on their advertising dollars. At Lands' End the following criteria are followed to insure customer satisfaction and advertising success.

Associates must determine which merchandise is to be sold "as advertised" or "in-store special," to determine the placement of the merchandise on the selling floor. After the amount of "as advertised" merchandise has been determined the fixtures can be selected. The merchandise will be displayed on a T-stand or a four-way near the front of the store; the merchandise needs to be highlighted for easy customer access. Complementary merchandise should be placed near the advertised items—this is a good way to aid sales associates with suggestive selling. All racks should have appropriate signs so the customer will be able to locate advertised merchandise with relative ease.

Are You Ready to Service Your Customer?

A successful merchandise presentation is not complete until all the elements of a display have been examined and analyzed. At Lands' End a "finishing touches checklist" is used to make certain that Lands' End is ready to welcome and service the customer.

Your store will be visually complete if you can answer "YES" to the following questions:

Signing

_____ Are all sale fixtures signed?
_____ Are the proper toppers being used?
_____ Does kids' merchandise have a size chart?
_____ Are all bent or torn signs/toppers replaced?
_____ Are the signs visible from both sides?
_____ Are all handwritten/patched signs replaced?
_____ Are the proper size sign holders being used?

_____ Are chipped/damaged sign holders being replaced?

_____ Are all signs throughout the store the same height? (Hint: check your sign stems.)

Merchandising

_____ Is there a good representation of all categories?

_____ Do adjacent categories relate to each other?

_____ Is the store balanced: men's v. women's?

_____ Is colorizing consistent throughout the store?

_____ Are fixtures aligned in rows?

_____ Do fixtures increase in height from front to back?

_____ Are the sizes consistent in the store? Do they go from left to right?

_____ Are the proper hangers being used?

_____ Are foam grips being used on the hangers when necessary?

_____ Does the customer understand the way the floor is set up?

_____ Can the customer shop easily?

_____ Is there too much merchandise on the fixtures?

Displays

_____ Are there adequate inventory levels to support the merchandise being displayed?

_____ Are the displays complete and colorful?

_____ Have the displays been changed in the last week?

_____ Are the props appropriate?

_____ Are the spotlights focused on the display?

General Maintenance

_____ Are pants/shorts hung with all zippers facing toward the center of the fixture?

_____ Is the merchandise restocked and straightened daily?

_____ Is the store clean: swept, waxed, dusted, and vacuumed.

_____ Are the plants clean and healthy?

_____ Are all banners and pictures hung straight?

_____ Are the fixtures not only straightened, but colorized within each size?

_____ Is the lighting a consistent color?

_____ Are burned-out lightbulbs replaced?

Employee Appearance

_____ Are the associates fully dressed with Lands' End uniform, including name tag and apron?

_____ Are aprons in good condition?

_____ Does the management staff project a professional image?

14

INDUSTRIAL DISPLAY

LEARNING OBJECTIVES—CHAPTER FOURTEEN

1. Discuss how industrial products are merchandised and displayed.
2. Define the term *trade show*.
3. List the elements of display that are used in creating an industrial display.
4. Discuss the similarities and differences in creating a display or merchandise presentation for the industrial market and the consumer market.

INTRODUCTION

Institutions and companies producing and marketing industrial products use merchandise display in various ways. One type of display they prepare is known as an *industrial trade show exhibit*. These exhibits, which vary in size and expense, are used to promote the company and its products. They may be set up at a manufacturer's show, such as a national machine-tool, show, or they may be seen in the local junior high school as part of a career exhibit.

Manufacturers of both soft and hard goods exhibit at trade shows or trade fairs—renting a booth or an entire room or hotel suite. The exhibits may be product-oriented or institutional. This special type of display is an important aspect of industrial promotion and is a special challenge to the display creator.

There are several other patterns of displays used by industry. The following is an example of industrial display by a manufacturer of wrenches and

mechanics' tools for industrial production and maintenance, and automotive test equipment and repair tools—the Snap-on Tools Corporation of Kenosha, Wisconsin.[1]

INDUSTRIAL DISPLAY EXAMPLE—SNAP-ON TOOLS

Marketing more than 14,000 different products has presented many merchandising and display opportunities for Snap-on Tools Corporation over its more than 70-year existence.

The tools are produced at 13 manufacturing facilities in the U.S. and Canada. Approximately 80% of the total sales volume is provided by more than 5,000 dealers and over 600 industrial representatives, operating out of 81 sales offices worldwide. Additional volume is obtained through international sales distributors covering all remaining areas of the free world not serviced by the dealer or industrial organization.

Snap-on Tools Corporation has three distinct markets which require specialized displays. They are the dealer market, which services the automotive technician, the industrial market, and the international distributor market. Each of these markets utilize similar informational and display techniques, but the nature of selling done in these three areas requires different types of visual marketing.

The largest and most important area is the market serviced by the Snap-on dealer force. The dealer operates a specific territory through the use of a walk-in van. The van, or "mobile store," carries the dealer's inventory of hand tools and equipment directly to the automotive technician at the technician's place of business. Visiting the technician on a weekly basis, the dealer shows and sells tools and equipment to the technician, as well as servicing existing products previously purchased, if necessary (Figure 14-1).

Snap-on's major theme, carried throughout all of its visual merchandising, is "...there is a difference with Snap-on." This theme is incorporated into the many point-of-purchase displays, product packaging and dealer van shelf displays. Beginning with the tool sweep logo on the outside of the dealer vans, the company name is immediately identified with the manufactured product. Specific products and customer service programs are advertised on the vehicle with four-color van signs which fit into an aluminum frame located next to the entry door (Figures 14-2 and 14-3).

The interior of the dealer's mobile store, due to space restraints, utilizes point-of purchase displays, props, literature, and additional signs to demonstrate and tell the quality story to the customer. Many of the displays also act as inventory carriers such as the screwdriver display rack, tap and die display, punch and chisel display, and plastic trays which fit in tool chests for set display. Props

[1]The authors are indebted to the management of Snap-on Tools Corporation, Kenosha, Wisconsin, for providing the data and photos used in this discussion.

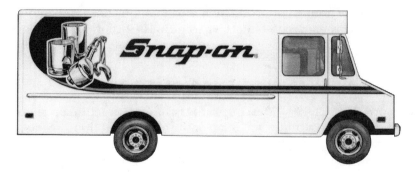

FIGURE 14-1(a) The Snap-on industrial demonstration coach is one of the ways the industrial sales representative can bring various tool displays directly to the customer. Harboring a cross section of the products available to the industry, the customer, through props and hands-on demonstrations, can see the quality difference with the Snap-on product.

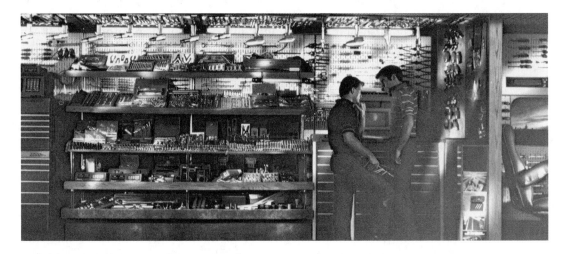

FIGURE 14-1(b) The interior of a typical dealer van. The "mobile store" carries a vast inventory of products ranging from tool storage units down to drill bits. All items are displayed with visual appeal in mind for point-of-purchase sales. Displays are usually rearranged on a weekly basis to keep the overall visual impact fresh for the customer.

demonstrating the advantages of Snap-on tools over competitive brands are used throughout the vehicle. The most common ones are the screwdriver turning props, wrench broaching props (demonstrating Snap-on's Flank Drive broaching system), tool storage unit cutaways, and engine simulators used to demonstrate diagnostic equipment. All are used with the customer to present the benefits of the product when explaining the Snap-on quality story (Figures 14-4 through 14-7).

FIGURE 14-2 These are two examples of dealer van signs which are placed next to the dealer van entry door. These signs are used to either highlight a particular product or for new product introduction.

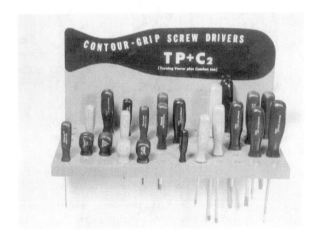

FIGURE 14-3 The screwdriver display rack enables the dealer to effectively display up to 72 different sizes and styles of screwdrivers in a confined area.

FIGURE 14-4 The tap and die display is able to stock both SAE and metric taps and dies. The top shelf is red for SAE sizes and the lower, removable shelf is blue, designating metric. A handle is attached for the dealer to carry it directly to the customer.

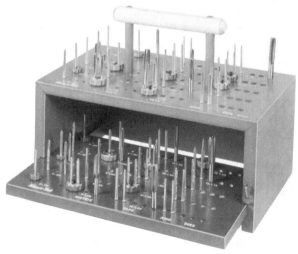

FIGURE 14-5 and FIGURE 14-6
Both these pieces of literature are used as customer handouts. Done in four-color, each is designed to help the dealer or industrial sales rep in presenting the Snap-on quality story.

Product packaging, for those products which will be displayed on the dealer van shelving, is developed with several goals in mind. The packaging must be attractive to show the product off in its best possible light and catch the customer's eye. It must tell the product story describing the product's features

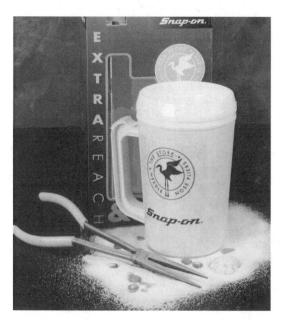

FIGURE 14-7 Many products are married to premium items for the customer. The packaging must display the tool product along with eye catching graphics explaining some product features. The premium item must also be of value to the customer. In this case, the grips of the pliers and the body of the mug are both the same color. Aimed at a spring/summer promotion, the beverage mug is a timely promotional item.

and customer benefits. The packaging must, where applicable, have the ability to have long-term use. For example, the tray in which the wrench set is sold can be used for a tool-control wrench tray in a tool storage unit. The packaging also must not be overly bulky, taking up too much shelf space.

Snap-on's industrial sales force utilizes much of the same types of product demonstration props as the dealer, but because of the way the industrial sales representative conducts business, many of the product line visuals are limited to what the salesperson can carry into a sales call. To accommodate this style of selling, Snap-on has developed two major alternatives for tool selling displays—the Snap-on industrial display coach, and product sales demonstration cases.

The industrial display coach has over 500 square feet used for product displays and demonstrations. The display coach enables the salesperson to show customers the vast product selection Snap-on offers, along with those larger tool items the industry uses on a daily basis. Pneumatic, electrical, and hydraulic power equipment all can be shown and demonstrated to the customers, with the coach's built-in power supply. This mobile product show also enables the Snap-on salesperson an opportunity to get the purchasing agent and/or maintenance foreman into a Snap-on environment conducive to Snap-on sales.

In lieu of having the industrial display coach, industrial salespeople utilize product demonstration cases. These cases display samples of the various product families, and when used in conjunction with sales literature and props, the salesperson can perform an effective product demonstration (Figures 14-8, 14-9, 14-10).

As described in the examples of the dealer and industrial sales representative, the key for the effective selling of Snap-on products is to get the product into the hands of the customer and let them experience the difference between Snap-on products and the competition. This concept is also carried throughout the many automotive and industrial trade shows Snap-on participates in yearly. Automotive shows utilize Snap-on dealer vans fully outfitted with inventory, props, and mini-displays. The focus of the exhibit is to inform the customer of

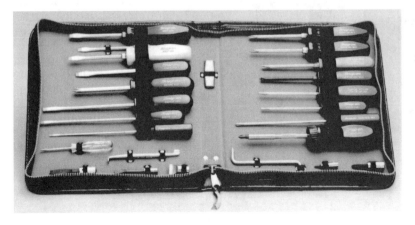

FIGURE 14-8 Product demonstration/display cases, such as the screwdriver case, enable the industrial sales representative an opportunity to present the various product families to the customer. Displaying the different styles and sizes of a product helps the sales rep identify the customer's needs.

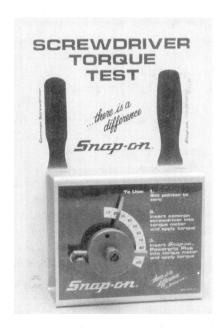

FIGURE 14-9 This is another example of customer hands-on demonstration. When used against competitive screwdrivers, it is obvious to the customer the extra turning power that can be developed with Snap-on's new screwdriver handle design.

the many services and products Snap-on has to offer the automotive technician. Industrial trade shows utilize displays aimed more at selling programs such as tool control, safe tool use training, and hydraulic pulling systems, to name a few.

Snap-on's international dealer and industrial sales force, along with the distributor organization, utilize the same marketing principles used in the U.S. when bringing the Snap-on product and quality story to their customers abroad.

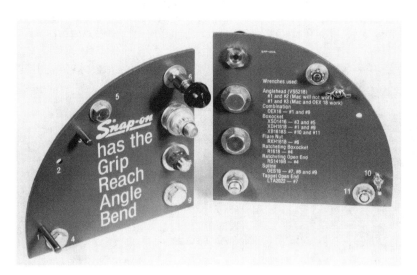

FIGURE 14-10 The multi-wrench prop enables the sales representative a way to effectively demonstrate the features and benefits of the wrench line. When coupled with competitive wrenches, the customer can prove for himself the quality difference between Snap-on and the competition.

Although the essence of the marketing principles is the same, special consideration is given to the language, customs, and ways of doing business in the foreign country.

Development of a Snap-on Dealer Display

In addition to displays being designed for a particular market, there are many other objectives that each display must meet. The object of any display is to help solve a merchandising challenge. In fact, it is a new opportunity for product sales which leads to the development of a display. As an example, let's examine the Snap-on screwdriver display.

Snap-on dealers needed a way to display screwdrivers effectively in their mobile stores in a very limited amount of space. The display needed to include all types and sizes of screwdrivers, in addition to multiples of each. While creating point-of-purchase sales and simplifying inventory control of the units, the display had to be eye-catching, inexpensive, and rugged. All these challenges had to be solved by the display.

In development of this display, several procedures were followed. First, a market and product research study was conducted to determine which screwdrivers were the most popular and how much space could be afforded the display in the dealer van. The display had to be designed to hold the common sizes and styles in quantities justified for the most efficient inventory control. Second, the display sample was designed for functional use and the objectives that had to be achieved. After the satisfactory sample was made, it was field-tested by the dealers and the results were evaluated. After the successful field test, prospective suppliers were given the opportunity to submit a price quotation for producing the display. A supplier was selected and production began. Finally, the screwdriver display was announced to the sales force with a flyer, which gave the dealers an idea of what the display looked like, what it could do for them, why they should have one, and how to order one.

If Snap-on Tolls were to classify its displays as to usage, they would fit into the following major areas:

Static, point-of-purchase displays used to hold inventory while telling the Snap-on quality story, such as the screwdriver display and hammer display.

Carry-in customer displays, such as the industrial sales representative's product demonstration case, the dealer's tote-and-promote tool tray, and specialized product props to show the difference.

The industrial demonstration motor coaches, used to take large tool product items and demonstration displays directly to the industry.

Special product displays, such as tool storage unit inserts and tool wallboard systems for hand tool set displays.

Specialized trade show displays using distinctive backdrops, lighting and feature product.

To keep Snap-on's sales force abreast of the merchandising aids available to them, a comprehensive and convenient book was developed, listing and illustrating all props, business aids, tool displays, and promotional supplies. All of the merchandise contained within this Sales Promotion and Business Aids Catalog was designed to do a specific job. This merchandise was not adapted to Snap-on, nor does Snap-on adapt to it, but rather each was developed to solve a particular merchandising challenge.

SUMMARY

Industrial display is practiced in a different setting from that of a retail store. However, the principles of display are the same. In every case, display people have a problem and must utilize all their knowledge, experience, and creativity in solving that problem. If they solve it successfully, they will meet the challenge to display and sell merchandise and image.

SUGGESTED ACTIVITIES

1. Class members may wish to form committees and obtain more information on industrial promotion by undertaking to
 a. Visit local industry and, by appointment, interview industrial executives to determine the industrial promotion they use.
 b. Search through magazines, texts, and other reference materials to determine how industrial promotion is implemented nationally and internationally.
2. If possible, visit an industrial trade show. To gain insight into a trade show, contact a local industry representative and attend the show as a guest of that industry. If only one or two class members can attend, let them report their observations to the class.

15

VISUAL MERCHANDISING TRENDS AND PRACTICES

LEARNING OBJECTIVES—CHAPTER FIFTEEN

1. Discuss the relationship among visual merchandising, store management, and the advertising/promotion department within a retail operation.
2. Explain how the visual merchandising staff works with manufacturers to create effective displays and merchandise presentations.
3. List the key points for developing an in-store merchandising plan for a manufacturer.

RETAIL DEPARTMENT STORE

Visual Merchandising as a Total Concept

More and more, visual merchandising is integrated with the total planning and operation of the store. Top-level executives such as the store planning director and the visual merchandising director meet with the top corporate executives of a company to determine such things as the corporate image, physical facilities changes, seasonal and fashion trend projections, and various other retailing innovations. Their decisions are reflected in physical store change procedures. (See Figure 15-1.)

VISUAL MERCHANDISING DIVISION
CLASS INTENSIFICATION/EMPHASIS AREA/
SEASONAL SHOP REQUEST

Date _____ Department _____ Division _____

Concept _____ Emphasis _____ Key Item _____

Spring/Fall Shop _____ Holiday Shop_____

Suggested Installation Date _____ Peak Stock Level_____

Termination _____ Projected Sales Volume 6 Months _____

Advertising Effort & Initial Ad Date _____ Vendor Cooperation_____

Pertinent Information About Merchandise (attach stock assortment):

Special Fixturing Requirements (hanging shelving, tables, mannequins, signing, etc.):

Stores	Units Purchased	Date of Arrival	Stores	Units Purchased	Date of Arrival

APPROVAL: Director of Stores _____ DMM _____ GMM _____

FIGURE 15-1

Today, visual merchandising is definitely tied to store policy. No longer is the "window trimmer" a smocked, custodial, in-store employee. The visual merchandising executive visits the New York fashion market as well as other important markets. There, the executive consults with fashion buyers and visits many display fixture vendors, making purchases to update the visual merchandising techniques used for a store and a season.

Visual merchandising executives agree that the primary purpose of visual merchandising is to sell the merchandise, thus making the coordination, imperative at every level, between merchandise purchased and merchandise displayed.

Merchandising and Visual Merchandising

Actually purchasing merchandise for a store to sell to the customer and presenting that merchandise to the customer in such a way as to make it appealing is and must be a two-way communication process if it is to be effective.

Buyers and visual merchandising executives often share opinions as to what will tell the story about what is "hot" in the market for the coming season. In the fashion area, the buyers make the decisions concerning purchases, but the visual merchandising people are in on these decisions all the way.

In the hard-line areas, visual merchandisers actually make decisions as to what could be purchased for a special promotion and/or visual presentation. In any case, the executives in charge of displaying a store's merchandise are no longer seeing the merchandise for the first time as it arrives in the store.

The visual merchandising department works with different departments in different ways, as we stated previously. It also does varying amounts of planning for different kinds of promotions. When it is important for the total store to present a unified theme, such as a holiday theme, the visual merchandising executives do up to 90 percent of the planning and ask each store's visual merchandising manager to carry out the plans. During other times of the year, promotions are executed almost entirely by the visual merchandising managers in the branch stores, and a great deal of interpretive freedom is given to them. This system will vary, of course, with any one department store's organizational structure.

MANUFACTURING AND MERCHANDISING — JOCKEY INTERNATIONAL

The following description of a visual merchandising program was set forth by Jockey International, Inc.[1]

Jockey International has been a pioneer in the men's fashion industry for over one hundred years and an innovator in women's fashions for over six years.

[1]Courtesy of Jockey International, Inc., Kenosha, Wis.

The company we know today as Jockey International was born in the year 1876, when six hand-operated knitting machines were purchased by S.T. Cooper and his sons to make heavy woolen socks, in the little town of Ludington, Michigan.

Jockey has led the industry in merchandising men's underwear with innovative ideas and techniques. (See Figures 15-2 and 15-3.) Jockey was the first to develop:

Self-selection fixturing
Packaged men's underwear
Lifelike mannequins for display
The brief garment
A full line of fashion underwear

As the fashion underwear business becomes more and more important, the need to adequately display and properly merchandise this category takes on an added dimension. Creative packaging has proven significantly important in selling fashion underwear and the need for a universal display/merchandising device is paramount.

The Changing Market

Retailing has changed dramatically in recent years. Society's lifestyles have shifted to a more casual atmosphere.

Today's cultural/social influences have caused store design to supplement merchandise. Aisles meandering through the store move customers to all areas using fixturing, ceiling structure, and variety of floor surfaces. The traditional

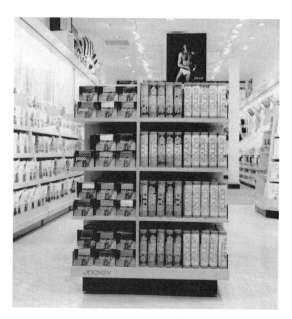

FIGURE 15-2 New Fashion Fixtures. We are testing new fashion fixtures that will accomodate both Jockey's three-in-the-tube product as well as all of our boxed products. The fixtures are shopable from all four sides and four separate products can be displayed in one fixture. Each size is shown on a shelf, small on the top and x-large on the bottom. Pictures illustrating garment style and fit are shown directly above the product to make self service shopping easy.

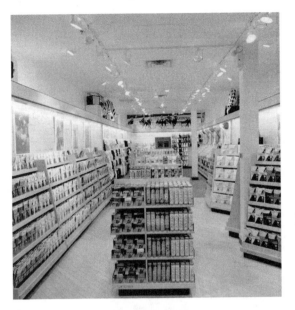

FIGURE 15-3 We made a special effort to make sure that the customer can visually project through the store with no obstructions. Theory is if the customer can't see it, there is a low chance to do business.

island counters with straight structured aisles have given way to a self-service approach.

Jockey merchandising programs have paralleled the cultural/social changes that have taken place in the retail design.

Fashion underwear is a big business today. In 1964, approximately 3 percent of sales were in color. In 1990, Jockey sales represented over 50 percent "fashion" underwear. In recognition of the importance of the new classic Jockey brief, Cooper's Underwear Company became Jockey International in 1972.[2]

1982 witnessed Jockey's entry into the women's intimate apparel market with the introduction of Jockey For Her panties. Three styles were unveiled at a fashion show held at the new York Athletic Club on October 26th. The styles were a brief, hipster, and bikini in basic colors, all in 100% cotton. The styles were so successful that fashion colors and stripes were added soon thereafter. (Figure 15-4)

In time for 1983 holiday gift-giving came a counterpart to the men's Elance with Jockey For Her. The same packaging with three styles of hipsters in color-complementary stripes and solids were available in a clear plastic tube package. (Figure 15-5)

At approximately the same time Jockey topped the women's underwear with three styles of tops. The camisole, tank, and "T" shirt were designed in coordinating stripes and solids to the bottom.

February 1988 marked another very special industry announcement by Jockey International. A new product line of hosiery for women was introduced

[2]NPD Research, Inc.

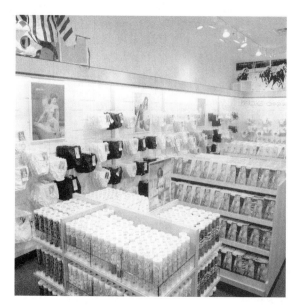

FIGURE 15-4 As we make the transition from men's product to women's, we change from wood floors and wood walls to carpeted floors and white walls. All fashion merchandise appears in the front and on the walls. All basic merchandise is set out in three sets of back-to-back four tier fixtures. The wall is holding our hanging cotton Lycra, Magic Ribs, and Jockey Silks program. The Elance bikini are followed by cotton basic, french cut, string bikini, bikini hipster and briefs.

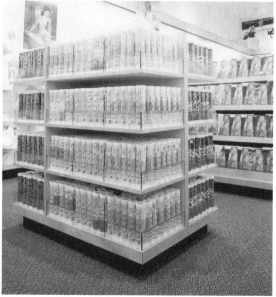

FIGURE 15-5 In JOCKEY FOR HER, we also add a second fashion fixture of JOCKEY FOR HER Elance Tubes. It has more capacity than the men's version because of its additional compartments.

in Chicago at the Men's Fashion Association Press Conference. The product called Jockey For Her "Sheer and Comfortable" made its debut in three styles—pantyhose, thigh-highs and stockings, and knee highs. Fashion opaques, tights, and footless styles have been added, a silk-like sheer style joined the Jockey For Her hosiery offering in 1991. (Figure 15-6)

A collection of athletic and fashion hosiery for men was introduced by Jockey International in 1989. Geometric, floral and abstract designs in ankle and over-the-calf lengths comprise the line.

Fall '91 introduced a group of fashion and athletic socks by Jockey For Her to the consumer. Colorful and decorative, the styles fit in with women's choice of accents for their feet to complete their casual wardrobes.

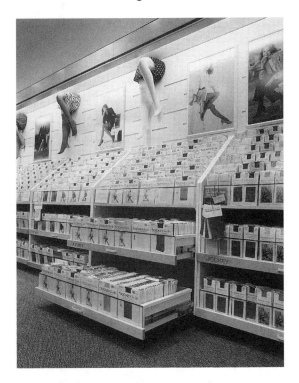

FIGURE 15-6 JOCKEY FOR HER HOSIERY. In women's sheer hosiery, we are also experimenting with a new high capacity fixture. As illustrated, the bottom drawers came out for additional back-up stock and colors. Again, we are using photographic illustrations to clearly tell the consumer what is available in the display below.

Objective

Develop a program for housing, display, merchandising, and identification of fashion underwear.

Develop a program on the importance of Jockey brand underwear relative to its performance, profitability, and return on investment to the retail store.

Pfeiffer and Miro Associates, New York, were commissioned to assist in the coordination of this study. Recognized as leaders in the field of retail planning and design, we drew upon their 20 years' experience, knowledge, and expertise in the retail business. They have served major department and men's specialty stores from coast to coast.

The findings and conclusions reached are from actual case studies, on-location observations, conferences, and surveys taken from over 100 top department and retail stores.

Tomorrow's opportunities are here today as Jockey extends its professional guidance, in the location, appearance, function, and fixturing of the men's underwear department as partners planning for profit.

Retail Planning

Today's customer is a sophisticated shopper extremely conscious of trends that influence his or her lifestyle and buying habits and have made a strong

impact on total store merchandising. Informality and naturalness in the store appearance and merchandising are a direct response to customer attitudes.

Men's wear, furnishings, and especially underwear departments are one of the major growth areas in department stores. It is indeed a very new phenomenon to locate men's underwear in a prominent location on an easily accessible traffic aisle. With visual merchandising directors beginning to have an interest in the display of personal furnishings, a very healthy maturing of attitudes is at hand.

Innovative planning, the design of the area, the modular fixturing, and the lighting all contribute to the proper merchandise presentation.

Components

Contemporary, functional, maximum capacity and display to complement and highlight the decor of a men's underwear or furnishings department. (Figure 15-7)

Basic and fashion basic merchandise housing in patented Jockey Dispens-o-matic units in singular or modular groupings. Capacity and display are paramount.

The high-fashion pyramid is designed and stepped vertically for sizing. Chrome, wood, and plexiglas complement any decor. Visual display of patterns and colors.

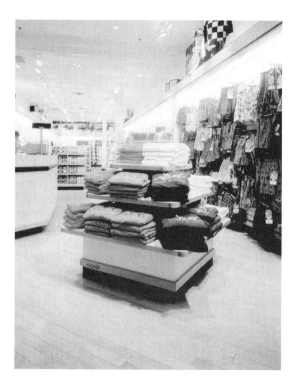

FIGURE 15-7 High intensity halogen lighting with low voltage usage is the newest development in lighting. We use the close-in "WEDDING CAKE" folded fixtures exclusively for folded sportswear products.

The pyramid on platform base with plexiglas envelop display. Torso and poster displays excellently relate high fashion with product in use.

A lighted superstructure to highlight merchandise presentation.

Concepts

Principles of internal arrangements of Jockey underwear departments:

Arrangements today are "natural."...Customers are encouraged to browse and walk around fixtures, providing good exposure of every merchandise category.

High-impact, impulsive fashion underwear requires prominent, up-front traffic locations.

Display and graphics are vital components to the merchandise and desirable to coordinate underwear selections and colors to the total men's wardrobe.

Jockey underwear is entirely packaged merchandise. Instant relation to a visible garment on a torso is essential to the organization of underwear in fixtures and unconfused selection by the customer, thus reducing package tampering.

Fashion underwear should showcase the department, be readily seen and accessible from anywhere within the underwear or furnishings department, traffic aisles, or vertical transportation.

The following are plans, designs and elements that suggest ideas contributing to a successful, efficient, definitive Jockey brand underwear department.

Flexible in size and shape of the area.

Use and appearance of walls to support department.

Fixture types and density in use for a complete underwear department.

Appropriate use of signing and Jockey logotype for department identification.

Colors and materials that complement, not conflict with, the merchandise.

Complementary displays and graphics to emphasize the fashion significance of underwear.

These all contribute to improved net profits. Improved Jockey underwear departments depend on a close coordination between merchandising, store planning, visual merchandising, and Jockey International. We then become partners in planning for profit.

Plus, Jockey provides:

Superior service
Productive fixturing and display
Complete merchandise programs
Attractive packaging
Strong national and local advertising
Inventory management

Today, Jockey International products are sold through more than 14,000 department and specialty stores and through 135 licensees in which Jockey brand products are sold from Athens to Zanzibar in over 100 countries in the free world.

Corporate headquarters remain in Kenosha, Wisconsin. An equal opportunity employer, Jockey International's chairman of the board is Chief Executive Officer Donna Steigerwaldt; Howard Cooley is President and General Manager.

SUGGESTED ACTIVITIES

Portfolio Project Nine: Display Construction in Total Store Interior with Student Evaluation of All Displays

This display construction is intended to give all students an in-store experience, with realistic time limitations, wide merchandise selection alternatives, and display-team cooperation.

The instructor will arrange for either half or all of the group to assemble at a retail store during slow traffic hours or when the store is closed. As the students arrive at the store at the appointed time, the instructor will assign one of the display areas of the store to each person or team, as the project. These areas may include hanging displays, front windows, cases, counters, table surfaces, mannequins, kiosks. Windows will be done by display teams; all other areas will be tackled individually.

You will be able to select merchandise from the stock in the store after brief consultation with the attending store consultant and after consultation with other class members to avoid duplications in displaying merchandise. The props provided by the store will be used. Available store signs will be used, and previously lettered signs of professional quality, which you might wish to have prepared as general statement signs, can be incorporated. Only store lighting facilities will be used.

The display effort in the store should be terminated after one and a half hours. Evaluation will be handled by appointment. The person putting in the display, the instructor, and the store consultant will confer in reference to the display. Because the store will have agreed to retain the displays for at least three days, appointments may be made within this time.

After the display is evaluated, it may be changed at the discretion of the store personnel. Each student may also be assigned a partial grade based on the appearance of the entire store at the end of the display team effort. Use the peer evaluation and general evaluation forms at the end of Chapter 2.

16

THE VISUAL MERCHANDISING TEAM

LEARNING OBJECTIVES—CHAPTER SIXTEEN

1. Explain the job responsibilities of a visual merchandising director.
2. Explain the job responsibilities of a visual merchandiser.
3. Discuss how the visual merchandising staff works with store management to maintain a competitive edge in the retail environment.

THE VISUAL MERCHANDISING DIRECTOR

One of the fundamental tasks of a store's visual merchandising director is the analysis of that store. The director must analyze the type of windows, interior display areas, and the overall layout of the retail facility, as well as considering such items as floor coverings, wall coverings, ceilings, and, or course, lighting.

Because much of the work of a visual merchandising director is performed in the display shop, this work area must be planned and organized carefully. The area should include an office, a large work table, a storage area, a painting space, and an area for the construction and creation of props, signs, and backgrounds.

The visual merchandising director must plan in advance all aspects of the store's display story if all merchandise and materials are to be ready when the display is to be constructed. Display materials assembled by the director might very well include woods, batting, seamless paper, wallboard, floor coverings, and a supply of appropriate power tools.

The visual merchandising director is seen as a store executive who must combine people, processes, and ideas successfully.

A sample job description for a visual merchandising manager will show the manager's involvement with other areas in regard to teamwork emphasis:

1. Act as liaison between the central visual staff and branch store personnel on presentation and problems.
2. Interpret and act on visual presentation problems within the manager's own store.
3. Relate any visual problem to the central visual merchandising department.
4. Train staff and store personnel on a daily basis in new techniques.
5. Work daily with store managers on store problems
6. Be responsible for calling visual problems to the attention of the general manager—for example, merchandise out of class, racks out of alignment, dirty fixtures, or poor lighting.
7. Communicate with the fashion office on trend problems.
8. Teach visual theory to the visual staff in detail.
9. Teach display techniques to staff: design elements, planning, execution, fashion trends.
10. Follow store policies and monitor staff on them.
11. Interview personnel for staff vacancies.
12. Monitor and approve general fixture use and vendor fixtures.

The career path often followed to allow promotional movement in the organization and the background that has proved to be most effective are as follows:

1. Experience in retail selling.
2. Experience in retail window trimming.
3. Technical college display courses where several displays have been executed.

There is simply no effective way to learn how to present merchandise to the customer without gaining experience in both handling the merchandise and relating to the customer.

Once a position has been obtained as a trimmer in a "flagship" or a suburban store, upward mobility on the organization chart follows as positions open and as experience is gained. Any formal training usually involves a two- or three-day session in visual merchandising if the trainee is in the executive training program, but training is more frequently accomplished on the job, where the new trimmer works with one or more experienced trimmers. Department stores usually have a visual merchandising director and one or two assistants; the number of assistants and their responsibilities will vary depending on the size and organizational structure of the retail operation.

THE VISUAL MERCHANDISER

General duties of a visual merchandiser would include, but are not limited to, the following:

1. Design and install displays of selected merchandise.
2. Follow recommended display designs given by the display manager.
3. Assemble, dress, and group mannequins.
4. Construct, paint, cover, and arrange display props.
5. Effectively arrange and group merchandise within a display.
6. Assemble and arrange fixtures following a preselected plan.
7. Construct, assemble, and install point-of-purchase displays.
8. Request signs and copy for a display.
9. Stock and store all display props.
10. Clean and maintain all display areas, including windows, showcases, ledges and wall units.[1]

The display person will also be involved in working with sales associates, management, and customers; a visual merchandiser must possess good written and oral communication skills as well as being a productive member of a display team.

The creativity and enthusiasm for developing displays and presentations must be cultivated. It is a continuous process that requires an awareness of the world outside of the display studio or prop room; it is in this environment that the development of display ideas will begin.

THE VISUAL MERCHANDISING DISPLAY TEAM

Regardless of the type of organizational structure an establishment has, all levels in the structure must perform as a team. Although many forces are at play deciding the team's effectiveness, each department can direct and control positive teamwork, gaining productivity through training and education.

Training the Team

The visual merchandising director should have a total training program for the department.[2] These questions should be considered:

Does each person have a job description?
Does each person know, understand, and implement the policies of the store and department?

[1]Barbara Ollhoff Ed.D., *Visual Merchandising Model Curriculum*, Waukesha County Technical College, Pewaukee, WI, May 1993.
[2]*Suggestion*: The reader should consider studying supervision as a separate course.

Do you have a regular meeting with your personnel to discuss current important topics?

Do your personnel feel like a part of the department and organization?

Do your personnel know when they've done well or badly?

Do you have an orientation program for new employees in your department?

Do you have a continuous training program for all your personnel, and do they know its content?

Do your personnel understand how they are to be enlisted in the program, and by whom?

The following checklist should be used by the visual merchandising staff prior to the daily store opening:

A. *All merchandise-related displays*
 1. Are they intact?
 2. Clean, fashionably correct?
 3. Enough merchandise to support the display?
 4. Is the merchandise located on adjacent fixturing?
 5. Are presentations adequately lit?
B. *Nonmerchandise displays*
 1. Plants clean and healthy?
 2. Pictures hung straight?
 3. Ledges clear of litter?
C. *Fashion forward presentation*
 1. Is there stock to support fashion forward?
 2. Platforms clean, mannequins undamaged?
 3. T-stands layered neatly?
 4. Accessory items signed on loan still intact?
D. *Signing*
 1. Are signs and toppers removed after a sale event?
 2. Are remaining signs in good condition?
 3. Sign holders readable from both sides?
 4. Proper sign holders being used?
 5. No taped signs?

Directing the Team

The visual merchandising director has now selected the overall training program, provided job descriptions for all personnel, and implemented the plan, attempting at all times to utilize human resources most effectively.

All plans, schedules, and sketches are published in multiple copies and distributed to all supervisors. All stores follow the same plans, schedules, and sketches, and the production efforts of all are intended to have the same appearance, disciplined by the master plan of a centralized system.

The visual merchandising director visits each store as often as possible, especially if a need is evidenced. Each store is visited at least monthly, and a meeting in the director's office once a month brings all the display supervisors together

with a preplanned agenda of forthcoming events. The notice of this meeting is sent out three weeks in advance.

After the monthly meeting in the director's office, the supervisors hold weekly meetings to develop further the ideas and plans with the members of their staffs and to activate the plans set forth at the director's meeting.

The display director is allocated funds at the beginning of the fiscal year. From these funds, the director and an assistant develop and administer the budget for display in all stores, including payroll, supplies, and minor categories. All budget information pertaining to any store is available to that store's manager, for that store only, for the purpose of containing the display department's budget within the structure of the store. The display director signs all purchase orders for the display department.

In summary, the effective utilization of human resources to achieve stated goals must be a top priority of any company.

A happy, committed team is a productive force.

THE TEN COMMANDMENTS FOR DISPLAY PERSONNEL

A Chinese banker conceived these "ten commandments" for his employees:

1. Don't lie. It wastes my time and yours. I am sure to catch you in the end.
2. Watch your work and not the clock. A long day's work makes a long day short and a short day's work makes my face long.
3. Give me more than I expect, and I will pay you more than you expect. I can afford to increase your pay if you increase my profits.
4. Keep out of debt. You owe so much to yourself that you cannot afford to owe anybody else.
5. Dishonesty is never an accident.
6. Mind your own business, and in time you will have a business of your own to mind.
7. Don't do anything here that hurts your self-respect. The man who is capable of stealing for me is capable of stealing from me.
8. It's none of my business what you do at night, but if dissipation affects what you do the next day, you will last only half as long as you hope.
9. Don't tell me what I would like to hear, but what I ought to hear. I don't want a valet for my vanity, but for my money.
10. Don't kick if I kick. If you are worth correcting, you are worth keeping.

The display director, manager, or other employee can certainly interpret these "commandments" in his or her own terms.

SUGGESTED ACTIVITIES

1. As a class project, create a total exhibit in the marketing department or maketing classroom area, promoting marketing programs and careers. Assign a display director to the total project and team directors the various

teams who will be creating displays in the areas under consideration. Use this total area display effort for an open house or a Christmas exhibit. Pay special attention to evaluating the total coordination effort. Have viewers cast ballots concerning their preference for one of the many display areas, thus evaluating display appeal.

2. Have a panel discussion including an industrial display director, a retail display director, a display supply-house representative, and a student of display. If professional directors are not available, students may prepare themselves to take these roles on the panel. Center the discussion around the functions of each of the directors and display team members. Get views from the panel on display as it exists today in our society and the role it will play in the future as competition increases in the marketplace.

Appendix A

SUPPLEMENTAL ALPHABETS

HAND/COIT LETTERING TECHNIQUES

Introduction

An appropriate sign must be included in each display so that the promotional message is effective. The method of lettering described here will enable you to produce professional signs for displays. With concentrated effort, individual practice, and some instructor aid as you begin, you will master the alphabet easily. It is an inexpensive and often highly stylized method of producing showcards for displays.

If preferred, you may use other methods of sign production if the school or store has special equipment or makes it available. These additional sign production methods include the Varigraph, sign presses, any number of sign machines and sign production kits, stencils, and press type.

Showcard Lettering Procedures

The creation of effective showcards for the display window is an integral part of display production, since the showcard is one of a display's five elements. Showcards are most easily created by using watercolor tempera paints in a proportion of three parts of paint to two parts of water and/or undiluted India ink. Other media may be used, but these two items are most accessible and most easily utilized by the display person. Eight-ply showcards are most adaptable for use in the production of a sign. Magic Markers and similar equipment may be used to decorate, border, and otherwise enhance a sign, but never to produce letters.

To lay out a showcard easily, use guide sticks. These are long, straight sticks constructed of 1/8- to 1/4-inch nonflexible materials. They are cut in varying widths and used in proportion to the varying widths of lettering pens. Lines are drawn on either side of the guide stick, giving the artist top and bottom border lines within which to construct the letters.

The widths of guide sticks used with different pen widths are as follows:

3/8-inch pen point with a 2-1/4-inch guide stick
1/2-inch pen point with a 3-inch guide stick
1-inch pen point with a 5-inch guide stick.

Letters should be 1-1/4 to 1-1/2 inches in width and should be drawn as close together as possible without touching each other. There should be a distance of approximately three finger widths between words when using a 3/8-inch pen, or a width of one and one half letters when using other width pens.

The Coit pen, the kind most often used in this type of showcard production, should be held at a 45-degree angle, regardless of the direction of the stroke.

Trial strokes should be made until pen control is mastered and the pen is distributing its ink evenly and precisely. If the ink flow is unsatisfactory, the pen point should be reset and cleaned with water and abrasive cleaner, and the paint or ink mixture reexamined.

The tip of the pen point must be kept in contact with the paper at all times while completing a stroke. With a full wrist and arm movement, *pull, do not push, the pen*, working fast enough to achieve uninterrupted flowing strokes in the production of a letter. Do not restroke letters.

When coming to the end of a stroke, slow up the speed with which you are lettering. Pause an instant at the end of each pen stroke before lifting the pen from the card, to avoid blotting.

Showcard Lettering Checklist

1. Materials needed:
 a. Coit pens: 3/8, 1/4, 1/2 inches
 b. Two empty bottles
 c. Two Magic Markers
 d. Poster paper
 e. Posterboard
 f. Guide sticks
 g. Paint
 h. Ink
2. Procedure:
 a. Mix showcard paint-3 parts paint and 2 parts water—or use undiluted India ink.
 b. Fill one bottle with water and one bottle with paint or ink.
 c. Select Coit pen and corresponding guide stick:

Pen	Guide Stick
3/8"	2-1/4"
1/2"	3"
2"	5"
1/4"	5"
	1-1/4"

 d. Make trial strokes on paper to get pen running.
 e. Make guide lines on paper.
3. Rules:
 a. Keep the tip of the pen point in full contact with the paper.
 b. Hold the Coit pen at a 45-degree angle.
 c. With a full wrist and arm movement, *pull*, do not push, the pen. Complete each stroke. Work directly in front of your body.
 d. Letters should be uniform in width.
 e. Letters should be as close to each other as possible (no more than 1/4 inch apart).
 f. For the Coit alphabet used in class, letters should slant slightly from upper left to lower right.
 g. Pause a moment at the end of each stroke before lifting the pen from the paper.
 h. Master each letter as you go. Follow the letter sequence suggested in class.

Instructional Sequence, Coit Uppercase

I

 1. Be sure to hold your pen at a 45-degree angle to the guidelines.
 2. Keep the pen in full contact with the paper and do not hesitate to use moderate pressure.
 3. Pull, do not push, the pen.
 4. Use the entire arm, not just the hand.
 5. Watch the slant of the "I." It should move slightly from left to right.
 6. Pause momentarily at the end of the stroke before lifting the pen straight up off the paper.

This is a basic stroke and should be perfected before going on.

T **1.** In making the first stroke (the crossbar of the "T"), hold the pen at the same angle as for the letter "I."
2. Make the stroke, using the entire arm, in one continuous motion. Make the crossbar touch the upper guideline all they way across (approximately 1-1/2 inches).
3. The second stroke is like the letter "I."

Continue to watch the slant of the letter and the 45-degree angle of your pen.

L **1.** First draw the letter "I." Then make a stroke like the cross stroke of "T," but placed at the bottom (about 1-1/2 inches).
2. The entire letter is completed without lifting the pen from the paper.

F **1.** The first stroke is the same as that for the "I."
2. The second stroke is like that of the top of the "T." Continue to maintain the 45-degree angle on the pen.
3. The third stroke is the same length as the second and is placed just below the midway point of the down stroke.

Always work from left to right and from top to bottom.

E
1. The letter "E" is similar to the "F."
2. After drawing an "L," complete the "E" in the same manner as the "F."

Keep constant pressure on your pen so that the flow of ink will be uniform.

H
1. The "H" is made by first drawing two parallel down strokes like the "I."
2. The third stroke, which joins the two parallel lines, should be placed just below the midpoint.

A
1. The first stroke is again the letter "I."

Note: Lettering sequence is based on progressive steps.

2. Making the second stroke is like drawing an upside down and backwards "L," starting at the top of the first stroke, without lifting the pen.
3. The third stroke is the same as the crossbar used in the letter "H."

Continue to check the 45-degree angle of the pen by observing consistency in stroke endings.

N 1. Two parallel down strokes are drawn as in the "H."
 2. The third stroke connects the top of the first stroke with the bottom of the second stroke.
 3. Be sure that there is a 45-degree angle at the bottom of the third stroke.

Check periodically to see that your lettering is slanting slightly from top left to bottom right.

M 1. The "M" will be wider than all previous letters because of the four-stroke construction.
 2. The first two strokes are parallel down strokes.
 3. The third stroke is similar to the third stroke of the "N" except that this stroke ends slightly past the halfway point between the two vertical lines.
 4. The fourth stroke starts at the top of the second stroke and crosses into the third stroke just above the bottom guideline. Note that this stroke violates the left-to-right rule.

V 1. The "V" is simply made of the third and fourth strokes of the "M."
 2. Watch the ending angle (45 degrees) where the two strokes are joined.

W
 1. The "W" is made by drawing two "V's" that are connected at the top in the middle. Like the "M," this letter is wider because of the four strokes used.
 2. Be sure that all the angles where lines are joined are 45 degrees.

X
 1. This letter is made wider at the bottom (1-1/2 inches) than at the top in order to prevent the appearance of instability.
 2. The first stroke is a diagonal drawn left to right, top to bottom.
 3. The second stroke is a diagonal drawn right to left and top to bottom. Note that the second stroke, like stroke four of the "M," violates the left-to-right rule.

Y
 1. The first stroke is similar to the "X," but ends at the midpoint of the guidelines.
 2. The second stroke begins at the upper guideline, meets the first stroke, and then continues straight down to the bottom guideline.

K
 1. The first stroke is the letter "I."
 2. The second stroke is like the second stroke of the letter "Y," but it is pulled down to the right to complete the letter.
 3. The width of the "K" at the base is greater than the width at the top.

Z
1. The "Z" is one continuous stroke.
2. The top of the letter is made like the top of a "T." The stroke is then completed by PULLING the pen at the 45-degree angle down to the bottom line.
3. The letter is finished by repeating the top stroke of the letter, but along the bottom guideline.
4. The base of the "Z" should be slightly to the right of the top to prevent the appearance of tipping.

P
1. Again, the first stroke is the "I."
2. The second stroke starts at the top of the first stroke and is slowly pulled down in the shape of a half-moon to a point just below in the middle of the space between guidelines.
3. The third stroke starts just below the midpoint of the "I" and is drawn across the paper into the second stroke.
4. Note the 45-degree angle where the second stroke and third strokes join.

B
1. The first two strokes are like the first two strokes of the letter "P."
2. The third stroke is similar to the second stroke in the "P," and is pulled down into another half-moon that just touches the bottom guidelines.
3. The fourth stroke is like the third stroke of the "P," joining the bottom of the "I" with stroke three.

Again, note 45-degree angles to test consistency in letter construction.

R 1. The first three strokes are the same as the letter "P."
2. The fourth stroke is a short diagonal beginning just to the left of the intersection of the second and third strokes. It is pulled down to the right to complete the letter.

D 1. The first stroke is the letter "I."
2. The second stroke is a large half-moon drawn from the top of the "I" and pulled down to touch the bottom guideline.
3. The third stroke is pulled along the bottom guideline, left to right from the "I," and slipped into the second stroke.

C 1. The first stroke is started slightly below the top guideline and is pulled down and slightly to the left at first, then straight down until the base is reached.
2. Without lifting the pen, construct the base by pulling the pen sideways in a looping action and sliding the pen slightly upward. The base takes on the appearance of a rocking chair.
3. The second stroke places a small half-moon on the top of the "C."

G

1. The first stroke is like that of the letter "C."
2. The second stroke starts slightly below the midpoint of the guidelines. It is pulled to the right and down to the left, into the end of the first stroke. Note the corner effect in the second stroke.
3. The third stroke is the same as in the second stroke in the letter "C."

O, Q

1. The first stroke is like that of the letter "C."
2. The second stroke is the first stroke in an upside down and reversed position.
3. Note the 45-degree angle where the two strokes are joined at the top and bottom.
4. This letter is not round, but instead has two flat sides and a slightly rounded base and top.
5. The first two strokes are the same as for the letter "O."
6. The third stroke is a short diagonal starting in the middle of the base of the "O" and continuing below the guideline.

U

1. The first stroke of the "U" starts like the "I" but is completed in a fashion similar to the first stroke of the "O."
2. The second stroke is like the "I" but slides left into the first stroke at the base.

J

1. The first stroke is similar to the base of the first stroke in the "U."
2. The second stroke repeats the second stroke of the "U."

S

1. The first stroke starts at the top of the paper, is curved downward, then to the right, and then slightly to the left.
2. The second stroke completes the bottom loop, starting a third of the way up the paper and curving to the right and into the first stroke.
3. The third stroke is like the second stroke of the "C."

?

1. The first stroke is like the beginning of the first stroke of the letter "S."
2. The second stroke starts at the top, touching the first stroke, curving along the top, down to the left, then back to the right to the bottom of the space, ending on a point.
3. The third stroke is the period.

"",- 1. Quotation marks are short, curved strokes and are placed about one-third of the way down in the space.
 2. The hyphen is made with one short stroke, slightly below the midpoint of the space.

LOWERCASE COIT ALPHABET

The following guidelines will enable you to learn about and acquire skills for a lowercase alphabet.[1]

Letters With Serifs

1. Draw three parallel guidelines, with the space between the top two lines slightly smaller than the space between the bottom two.
2. Holding the pen at a 45-degree angle, start the stroke at the middle guideline for the smaller letters, or at the top guideline for the taller letters, such as *b* and *h*.
3. Slide the pen horizontally for 1/4 inch, then stop. This top edge of the letter is called a serif.
4. Do not lift the pen from the paper.
5. With locked wrist, pull the pen downward.
6. At the bottom of the stroke, curve the pen slightly upward. (You may wish to release pressure on the pen while doing this.)
7. Check to see that the bottom right edge of the letter is parallel with the top left edge.
8. For letters that extend below the line—*g, j, p, q, y*—draw a fourth guideline, the same distance below the third as that between the second and third lines.
9. Begin the first stroke at the second guideline from the top.

[1]Courtesy of the State Board of Vocational, Technical, and Adult Education, Madison, Wis.

10. For all except *p* and *q*, extend the second stroke to a point one-half the distance between the bottom two guidelines.

11. Holding the pen at a 45-degree angle, slide the pen on its narrow edge to the left half an inch.

12. Begin the left edge of the third (bottom) stroke parallel to the left edge of the first stroke, and curve the third stroke to join the second.

13. The bottoms of the *p* and *q* are made like the bottom of the *i*.

Letters Without Serifs

1. Do not slide the pen horizontally to the right at the top of vertical strokes.

2. Pull the pen directly downward for all vertical strokes.

3. Do not curve the stroke upward at the end of vertical strokes (with the exception of the *t*).

4. Curved letters such as *o, c, x, e, s,* and *g* are made the same way in all cases.

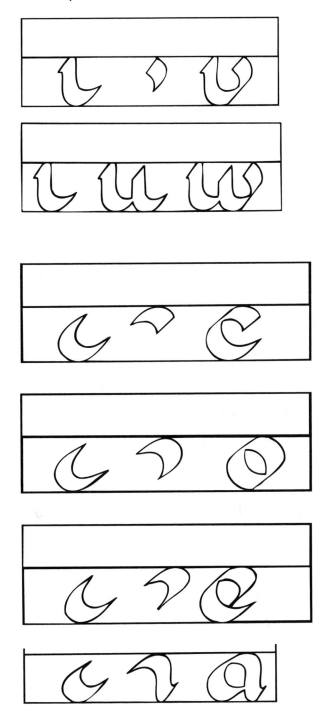

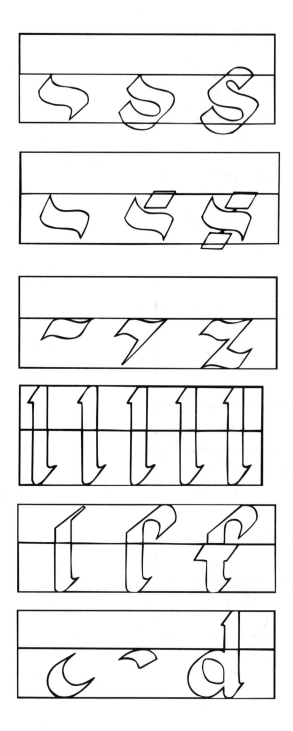

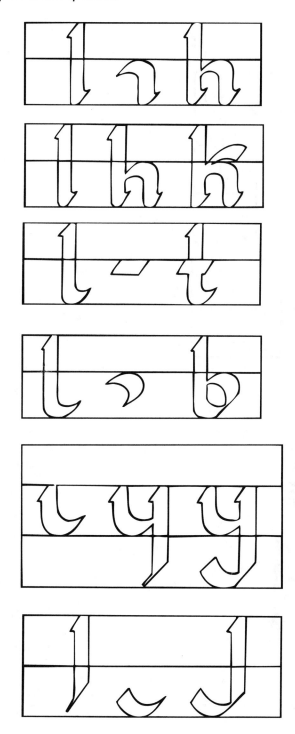

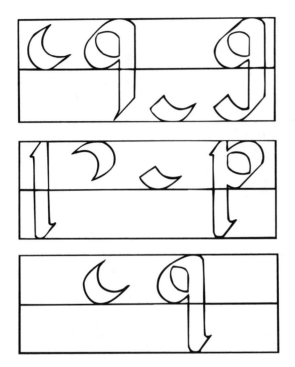

him
and
her

abcd
their
folly

OTHER TYPES OF ALPHABETS

The following types of alphabets can be produced using the principles set forth in the previous pages.

ABCDEFGH

Uppercase
Old English.

IJKLMNOPQR

STUVWXYZ

abcdefghij

klmnopqrs

tuvwxyz

Lowercase Old English.

ABCDEF
GHIJKLM
NOPQRST
UVWXYZ
abcdefghijklmno
pqrstuwxyz &
1234567890

ABCDE
Fghijk
LMNOP
QRStu
VWXYZ
123456789

ABCDEFG
HIJRLMN
GPQRSTU
VWXYZ&
abcdefghijklmno
pqrstuvwxyz
123456789

ABCDEF
GHIJKL
MNOPQR
STUVWX
Flat-nib YZ Script
abcdefghij
klmnopqr
stuvwxyz

Style variations.

Appendix B

VISUAL MERCHANDISING RESOURCE LIST

The following firms may be contacted for visual merchandising information in the form of brochures, articles, photos, and so forth; these firms are growing, successful businesses whose managements will be pleased to share their expertise with you.

Firms	*Products/Specialties*
ABC Display & Supply, Inc. 100 Cleveland Avenue Freeport, NY 11520	C, D, G, F[1]
Abstracta Designs, Inc. 7101 Fair Ave. N. Hollywood, CA 91605	A, B, D, K

[1]Legend:
- A—Architectural elements
- B—Decorations and props
- C—Display forms
- D—Fixtures and components
- E—Lighting
- F—Mannequins
- G—Signage and graphics
- H—Supplies and equipment
- I—Animations
- J—Materials
- K—Other types of description

Firms	*Products/Specialties*
Abstracta Structures, Inc. 347 Fifth Ave. New York, NY 10016-5010	D, E, K
Acme Display 1057 South Olive Street Los Angles, CA 90015	B, C, D, F, G, H, J, K
Adams Mfg. Co. Box 1, 3 W. Dark Rd. Portersville, PA 16051-0001	B, C, D, G
Admiral Store Interiors 27900 Chagrin Blvd. Cleveland, OH 44122	D, G, K
A.D.S. Store Fixtures (M&D) 2908 18th Street, N.E. Calgary, AB T2E 7B1, Canada	A, B, C, D, E, F, K
Advance Displays & Store Fixtures 139 East 3900 South Salt Lake City, UT 84107	A, B, D, E
Advance Fixture Mart, Inc. 1960 Swanson Ct. Gurnee, IL 60031	B, C, D, E, F, G, H, J
Ain Plastics of Mich., Inc., P.O. Box 102 Southfield, MI 48037	D, G, H, J, K
All Decor, Inc. 433 Oakton Street Skokie, IL 60076	A, B D, I, J, K
All-in-One Suppliers, Inc. 223 West 35th Street New York, NY 10001	A, B, C, F, K
Allen Designers & Manufacturers, Inc. 146 East Butler Ave. Memphis, TN 38103	C, D, E, J
Allen Display & Store Equipment 14301 Sommerville Ct. Midlothian, VA 23113	C, D, F

Firms	*Products/Specialties*
American Mannequin Co. 220 North Sunset Ave. City of Industry, CA 91744	B, C, F
American Woodcraft, Inc. 8480 Hwy 60 P.O. Box 38 Union City, MI 49094	A, B, D, K
Apple Visual, Inc. 150 Waverly Ave. Mt. Laurel, NJ 08054	A, B, D
ARC Sales, Inc. 7 Pond St. Salem, MA 01970	E
Arizona Store Equipment 2523 North 16th Street Phoenix, AZ 85006	A, B, C, D, E, F, G, K
Art Asylum 204 Brookfield Ave. Paramus, NJ 07652	B, C, D, J
Art-Phyl Creations 16250 N.W. 48th Ave. Miami, FL 33014	D
ASI Sign Systems 555 W. 25th St. New York, NY 10001	D, G
Astra Products, Inc. 238 Lindbergh Place Paterson, NJ 07503-2817	A, B, C, D, E, F, G, H, J, K
August Interiors, Inc. 295 Turnpike Street Canton, MA 02021	A, D, K
The B D Co. P.O. Box 3057 Erie, PA 16512	B, D, G, J, K

Firms	Products/Specialties
B & N Industries, Inc. 1300 Industrial Way San Carlos, CA 94070	A, C, D, E, F, H, K
Baltimore Display Ind. 1900 Bayard Street Baltimore, MD 21230	B, C, D, E, F, G, H, K
Bannerworks, Inc. 558 First Ave. S., 5th Floor Seattle, WA 98104	B, G, K
Barcana, Inc. (a Barthelmess Company) 1107 Broadway, Rm., #420 New York, NY 10010	A, B, C, D, E, F, G, I, J, K
Barr Display & Fixture 6170 Edgewater Drive Orlando, FL 32810	A, B, C, D, F, I
Barrett Hill, Inc. 133 West 25th Street New York, NY 10001	D, K
Batts, Inc. 200 Franklin Zeeland, MI 49464	A, B, C, F, J, K
Bay Area Display San Francisco, Inc. 20 Heron Street San Francisco, CA 94103	B, D, F, J, K
Beemark Plastics 7424 Santa Monica Blvd. Los Angles, CA 90046	D, J
Bendies Forms, Inc. 222 St. Urban Street Granby, PZ J2G 7T4, Canada	C, D, F, J
Bernstein Display 30 West 29th Street New York, NY 10001	A, B, C, D, E, F, G, H, J, K
Bingay & Son Corporation 295 Turnpike Street Canton, MA 02021	A, D, I

Firms	*Products/Specialties*
Bregstone Assoc., Inc. 500 South Wabash Chicago, IL 60605	B, E, H, I, J
Bronner's Christmas Wonderland 25 Christmas Lane P.O. Box 176 Frankenmuth, MI 48734	B, E, I
Burton Photo Industries, Inc. 3332-44 Rorer Street Philadelphia, PA 19134	G
Capitol Showcase Co. 4920 Charlotte Ave. P.O. Box 90323 Nashville, TN 37209	A, B, C, D, E, F, G
Cardinal Industries, Inc. 37 West 750, Route 64 St. Charles, IL 60174	A, B, D, J, K
Carlson Store Fixture Co. 1401 West River Road Minneapolis, MN 55411	A, B, C, D, F, G, H, J, K
Central Florida Display, Inc. 666 Clay Street Winter Park/Orlando, FL 32789	A, B, C, D, E, F, G, H, I, K
Central Sales Promotions, Inc. 130 N.E. 50th Street P.O. Box 53444 Oklahoma City, OK 73152	B, D, G
Central Shippee, Inc. 46 Star Lake Road P.O. Box 135 Bloomingdale, NJ 07403	B, D, J
Clamp-Swing Pricing Co. 2515 Blanking Ave. P.O. Box 2337 Alameda, CA 94501	G
Coburn Corporation 1650 Corporate Road West Lakewood, NJ 08701-5974	B, E, G, J, K

Firms	*Products/Specialties*
Art R. Cohen Co. 949 Penn Ave. Pittsburgh, PA 15222	A, B, C, D, E, F, G, H, J
Color Brite Fabrics & Display, Inc. 212-214 East Eighth Street Cincinnati, OH 45202	B, C, D, F, G, H, J, K
Color Text Incorporated 366 W. 6th St. Columbus, OH 43211	B, D, E, G, J, K
The Columbus Show Case Company 850 West Fifth Ave. Columbus, OH 43212	D, K
Consolidated Glass Corp. 1150 North Cedar Street P.O. Box 430 New Castle, PA 16103	A, D, G, H, J, K
Corman and Associates 881 Floyd Drive Lexington, KY 40505	A, B, C, D, E, F, G, J
Cotterman Company 130 Seltzer Road Croswell, MI 48422	H, K
Susan Crane, Inc. 8107 Chancellor Row Dallas, TX 75247	A, B, C, D, F, G, J, K
E.T. Cranston, Inc. 133 West 25th Street New York, NY 10001	C, D, F, G, K
Creative Industries, Inc. 700 Air Park Road Ashland, VA 23005	A, B, D, E, F, K
Customcraft Fixtures, Inc. 4914 Pan American Hwy N.E. Albuquerque, NM 87109	A, B, C, D, G, H, J, K

Firms	*Products/Specialties*
Daniels Display Co., Inc. 1267 Mission Street San Francisco, CA 94103	B, C, D, E, F, J
Dazian, Inc. 423 West 55th Street, 10th Floor New York, NY 10019	G, K
Decter Mannikin Co., Inc. 1118 East 8th Street Los Angeles, CA 90021	B, C, D, F, K
The Design Centre West Murdock Wichita, KS 67203	In-house design and fabrication of the following custom, 300 award-winning, cost-effective, targeted products for 16 years: Christmas floor and ceiling decor, purchase or lease, traditional and unusual themes; manufacturer touring promotions, strong product identification, durable, mall-oriented, custom fabrication; ICSC exhibits, portable structural systems for marketplace positioning, graphics, purchase or lease.
Design Industries, Inc. 1611 Southeastern Avenue Indianapolis, IN 46201	A, B, D, G, I, K
Dick Blick Central P.O. Box 1267 Galesburg, IL 61401	H, J
Discovery Plastics, Inc. 32140 Hwy 34 P.O. Box 330 Tangent, OR 97389	C, D, G, H, J
Dismar Corporation 4415 Marlton Pike Pennsauken, NJ 08109	B, D, G, J

Firms	Products/Specialties
Display Concepts 212 North Fillmore Amarillo, TX 79106	A, B, C, D, E, F, G, H, I, J, K
Display Creations, Inc. 1332 Broadway Detroit, MI 48226	B, C, D, E, F, G, H, I, J
Display Unlimited, Inc. 7400 N.W. 37th Avenue Miami, FL 33147	B, C, D, E, F, G, J, K
E & T Plastics Mfg. Co., Inc. 45-33 37th Street Long Island City, NY 11101	D, E, G, J, K
Eastern Chain Works, Inc. 144 West 18th Street New York, NY 10011	D, K
Eddie's Hang-Up Display Ltd. 910 Mainland Street, #61 Vancouver, BC V6B 1A9, Canada	A, C, D, F, G, H, J, K
Encyclopedia Britannica The Britannica Centre 310 South Michigan Avenue Chicago, IL 60604	Stretches the mall's budget, builds traffic, entertains customers, educates shoppers, and creates excitement. Britannica's marketing managers can assist in creating a special event tailored to suit center. International and U.S. flag display.
Engineered Plastics, Inc. 211 Chase Street Gibsonville, NC 27249	D, G, H, J, K
Entol Industries, Inc. 8180 N.W. 36th Avenue Miami, FL 33147	A, B, G, K
Equipto 225 South Highland Avenue Aurora, IL 60507	D, K

Firms	*Products/Specialties*
Fall Mountain Furniture, Inc. P.O. Box 191 South Road Templeton, MA 01468	D, K
Farralane Lighting & Audio 300 Route 109 Farmingdale, NY 11735	E, K
Fetzer's, Inc. 1436 S.W. Temple Street P.O. Box 26706 Salt Lake City, UT 84115	A, C, D, F, J, K
Fix-Play, Inc. 2300 First Avenue N. Birmingham, AL 35203	B, C, D, E, F, G, H, J, K
Fixtures & Forms P.O. Box 5606 Richmond, VA 23220	B, C, D, E, F, G, I, J
Fixtures by Howie 901 South Main Street Los Angeles, CA 90015	A, B, C, D, E, F, G, H, J, K
Flute, Inc. 1500 South Western Avenue Chicago, IL 60608	B, D, E, K
Flying Colors 127 South Street Boston, MA 02111	Custom-designed banner programs. Interior and exterior programs, Soft signing, special graphics, merchandising, seasonal programs, promotionals, flags, food court programs, atriums, corridors, core areas, and light pole projects. Offers both appliqued and dye-printed processes. All programs are architecturally planned for maximum effective results at low cost. Can provide Statue of Liberty banners and flags.

Firms	Products/Specialties
Gamma Technologies, Inc. 12255 Southwest 132nd Street Miami, FL 33116	G, K
Garcy Corporation 1400 North 25th Avenue Melrose Park, IL 60160	D, E
Garland Display Corporation 4700 Walton Street Chicago, IL 60651	Base designers and manufacturers since 1948. All types of decorative Christmas garlands, trees, wreaths, custom Santa houses, gazebos, Santa thrones, promotional decor, Easter, and seasonal displays.
Fomebords Company 211 North Elston Avenue Chicago, IL 60614	D, G, H, J
Frame Strips P.O. Box 1788 Cathedral City, CA 92234	D, G
Gemini Display & Store Fixture Co. 273 South Street Long Beach, CA 90805	A, B, C, D, F, G, H, I, K
Gemini Mannequins, Inc. 133 West 25th Street, 2nd Floor East New York, NY 10001	C, F
Glynco Plastics, Inc. 5415 Opportunity Court Minnetonka, MN 55343	A, D, G, H, I, J, K
Great Images by Dan Ruderman, Inc. P.O. Box 2866 Huntington Station, NY 11746	A, B, C, D, E, F, G, J, K
Robert H. Ham Assoc. Ltd. 4500 Drummond Road P.O. Box 77398 Greensboro, NC 27417	A, B, C, D, G, H

Firms	*Products/Specialties*
David Hamberger, Inc. 410 Hicks Street Brooklyn, NY 11201	A, B, C, D, I, J, K
The Image Makers/The Occasion Makers P.O. Box 493 Dunedin, FL 34296	B, D, F, G, K
International California Glass Corporation 4232 Santa Ana Street South Gate, CA 90280	A, B, C, D, I, K
International Display Systems 1529 Industrial Center Circle Charlotte, NC 28206	D, G
Jomar Table Linens, Inc. 215 South Myrtle Street Pomona, CA 91766	B, J, K
Joslin Displays, Inc. 327 Mystic Avenue Medford, MA 02155	A, B, C, D, E, F, G, H, J, K
JPM Store Fixt. Mfg. & Display Equipment, Inc. 6815 Shady Oak Road Eden Prairie, MN 55344	A, B, C, D, E, F, G, H, J, K
Kee Industrial Products, Inc. 105 Benbro Drive P.O. Box 207 Buffalo, NY 14225	D
King Merchandising Concepts, Inc. 3601 Greenwood Avenue N. Seattle, WA 98103	A, C, D, E, F, G, J, K
Lawrence Metal Products, Inc. 260 Spur Drive S. P.O. Box 400-M Bay Shore, NY 11706	A, B, D, G
Ledan, Inc. 167 Lexington Avenue New York, NY 10016	D, G, J

Firms	Products/Specialties
Letter Draft, Incorporated 280 Midland Avenue, Bldg. M Saddle Brook, NJ 07662	B, C, D, G, J
Charles E. Lipsman Co. 1160 Bower Hill Road, Suite 324-B Pittsburgh, PA 15243	A, C, D, F, G, J, K
LQ Enterprises 1 Hollywood Avenue Ho-Ho-Kus, NJ 07423	A, B, D, G, I, J, K
MACtac Permacolor 4560 Darrow Road Stow, OH 44224	G
Man I Can, Inc. 2542 Menaul, N.E. Albuquerque, NM 87107	A, B, C, D, E, F, G, I
Marcon 101 West 10th Avenue N. Kansas City, MO 64116	B, D, G, J, K
Henry Margu, Inc. 540 Commerce Drive Yeadon Ind. Park, PA 19050	F, K
Marketing Communications 290 Greenwich Road, N.E. Grand Rapids, MI 49506	B, C, D, F, G, J
Marquette Commercial Interiors, Inc. 4710 Canal Street New Orleans, LA 70119	A, D, E, G, K
Mannequin Service Co., Inc. 2422 North Charles Street Baltimore, MD 21218	F, K
Marketing Communications 290 Greenwich Road, N.E. Grand Rapids, MI 49506	B, C, D, F, G, J

Firms	*Products/Specialties*
Walter W. Martin, Inc. 1900 Federal Blvd. Denver, CO 80204	A, B, C, D, F, G, H, J, K
McGlinnen, Inc. 1100 Vine Street #1402 Philadelphia, PA 19107-1714	B, C, D, F, G, K
McGowan Displays, Inc. 3570 Consumer Street Riviera Beach, FL 33404	A, B, C, D, E, F, G, H, J, K
MJC/Tangible Advertising Specialties 8851 California Avenue Riverside, CA 92503	Established in 1972 and reliably serving shopping centers for many years. Giveaway items for every occasion. Easter, Mother's Day, back-to-school, Halloween, Christmas, and in between. All special occasions (ground breakings, anniversaries, etc.). More than 100,000 imprinted specialty items available.
National Decorators Supply Co. 443 Virginia Avenue P.O. Box 866 Indianapolis, IN 46206-0866	B, C, D, F, G, H, J
National Equipment & Decor 920-923 Broadway Kansas City, MO 64105	A, B, C, D, E, F, G, H, I, J, K
Richard Norris Associates, Inc. Suite One, Coles Hill Ind. Park P.O. Box 535 Blackwood, NJ 08012	A, C, D, E, G, I, K
Northeast Display, Inc. 1075 Southbridge Street Worcester, MA 01610	A, C, D, E, F, G, H, I, J, K
The Nu-Era Group 727 North 11th Street St. Louis, MO 63101	B, C, D, E, F, G, H, J, K

Firms	Products/Specialties
Otema Store Fixtures Ltd. 101 Don Park Road Markham, ON L3R 1C2, Canada	D, G, K
Outwater Plastics, Inc. 4 Passaic Street Woodridge, NJ 07075	A, D, J, K
Pacific Fixture Co., Inc. 21115 Qnard Street Woodland Hills, CA 91367	A, B, D, G, K
Wm. Perilstein Glass Co. One North Olney Avenue Cherry Hill, NJ 08003	A, D, G, J, K
Perma Groove, Inc. 21365 Hamburg Avenue P.O. Box 1016 Lakeville, MN 55044	A, D
Photographic Specialities 225 Border Avenue N Minneapolis, MN 55405	G, K
Pinquist Tool & Die Co., Inc. 63 Meserole Avenue Brooklyn, NY 11222	D, F, G, K
Polyplastic Forms, Inc. 49 Gazza Blvd. Farmingdale, NY 11735	D, G
Precision Integrated Industries, Inc. 512 S.E. 32nd Street Ft. Lauderdale, FL 33316	E, G, H, J, K
Presentations Plus, Inc. 6815 Shady Oak Road Eden Prairie, MN 55344	A, B, G, K
Poly Form U.S.A., Inc. 26 Aurelius Avenue P. O. Box 400 Auburn, NY 13021	C, F

Firms	*Products/Specialties*
Prolab, Inc. 4353 Sixth Avenue N.W. P.O. Box C 17044 Seattle, WA 98107	G, K
Promotion Display Co. 4048 Johnson Drive Oceanside, CA 92056	A, B, C, D, E, F, K
Radiant Products Company 750 North Skinker Blvd. St. Louis, MO 63103	A, C, D, G, K
Thomas Raguse, Inc. 9638 Fairdale Lane Houston, TX 77063	A, B, C, D, E, F, J, K
Red Wing Products, Inc. 190 Express Street Plainview, NY 11803	B, C, D, G, H, J
Rileighs, Inc. 1701 Union Blvd. P.O. Box 504 Allentown, PA 18105	A, B, G, I
Roctronics Entertainment Lighting, Inc. Roctronics Park Pembroke, MA 02359	B, E, G, I, J
Adel Rootstein, Inc. 205 W. 19th Street New York, NY 10011	F
Ross Display Fixture Co. 3419 1st Avenue South Seattle, WA 98134	B, C, D, E, F, G, H, J, K
Rotocast Plastic Products, Inc. 3625 N.W. 67th Street Miami, FL 33147	A, B, C, D
Sawitz Studio, Inc. 6 McDermott Place Bergenfield, NJ 07621	A, B, D, G, I, K

Firms	Products/Specialties
Scope Display & Box Co., Inc. 1840 Cranston Street Cranston, RI 02920	A, C, D, I, J, K
Self Serv Fixture Co. 1530 Inspiration Drive P.O. Box 57027 Dallas, TX 75207	D
Seven Continents Enterprises, Inc. 350 Wallace Avenue Toronto, ON M6P 3P2, Canada	A, B, C, D, F, G, I, J, K
Fred Silver & Company 145 Sussex Avenue Newark, NJ 07103	D, K
Sound Fixture Service 3846 South 305 Place P.O. Box 3465 Federal Way, WA 98063	D
Southern Importers 4825 San Jacinto P.O. Box 640 Houston, TX 77001	A, B, C, D, E, F, G, I, J, K
Southwest Fixture Company, Inc. 1240 Majesty Drive Dallas, TX 75247	A, B, C, D, E, F, G, H, I, J, K
Space Design & Display 1787 West Pomona Rd. #B Corona, CA 91720	A, D, G, K
Spacewall International P.O. Box 659 Stone Mountain, GA 30086	D, K
Spartan Showcase, Inc. P.O. Box 470 Union, MO 63084	D

Firms	*Products/Specialties*
Spaulding & Frost Company Main Street P.O. Box 170 Fremont, NH 03044	A, B, D, G, J, K
Stanford Display Studios, Inc. 285 Ellicott Street Buffalo, NY 14203	B, C, D, E, F, G, H, I, J, K
Studio Displays, Inc. 3021 Griffith Street Charlotte, NC 28203	B, D, G, I, K
Superior Specialties, Inc. 2525 North Casaloma Drive Appleton, WI 54015	C, D, J, K
TM Store Fixtures 99-1093 Iwaena Street Alea, HI 96701	C, D, E, F, G, K
Trimco 459 West 15th Street New York, NY 10011	B, C, D, E, F, G, H, I, J, K
Trio-Pioneer Display Fixture Corp. 1650 New Hwy Farmingdale, NY 11735	B, C, D, E, F, G, H, J, K
Vogue International 12460 Putnam Street Whittier, CA 90602	A, B, C, D, F
Vue-More Manufacturing Corp. 184 Franklin Avenue Nutley, NJ 07110	D, E, G, I, K
Werther Displays 40 Milton Avenue P.O. Box 7086 Jersey City, NJ 07307	B, D, E, G, H, J, K
J.A. Wilson Display Ltd. 1645 Aimco Blvd. Mississauga, ON L4W 1H8, Canada	A, D, G

Firms	*Products/Specialties*
Wiremaid Products Division Vutec Metal Industries Corp. 65 Orville Drive Bohemia, NY 11716	A, D, F, J, K
Young Electro-Mechanical Co., Inc. 2330-A Brickvale Drive Elk Grove Village, IL 60007	D
Zee Studio, Inc. 147 West 25th Street New York, NY 10001	K

BIBLIOGRAPHY

ALBERS, JOSEF. *Interaction of Color,* rev. pocket ed. New Haven, Conn.: Yale University Press, 1975.

ANDREOLI, TERESA. "Interview with Thomas H. Nigolian: Store Design Strategy." (Kmart store planning) *Stores* 74, no. 2, December 1992.

ANDREOLI, TERESA. "Kidstuff: Ames Creates In-Store Park for Children's Merchandise." *Stores* 74, no. 7, July 1992.

BENSON, JOHN HOWARD, and Arthur Graham. *The Elements of Lettering.* New York: McGraw-Hill, 1960.

BUCKLEY, JIM. *The Drama of Display.* Cincinnati: Display Publishing, 1962.

BUSTANOLEY, J. H. *Priciples of Color and Color Mixing.* New York: McGraw-Hill, 1947.

CAMINITY, SUSAN. "Romance: Lands' End Courts Unseen Customers." *Fortune,* March 1989.

"Developers Help Tenants to Help Themselves." *Chain Store Age Executive* 67, no. 11, November 1991.

FASHION & RESEARCH STAFFS OF WOMEN'S WEAR DAILY. *Fifty Years of Fashion.* New York: Fairchild Publications, 1974.

"Fixtures Enhance Western Image." (VF Corporation Wrangler's Division) *Chain Store Age Executive* 69, no. 12, December 1993.

FLOWERS, DEAN, JAN LATHROP, and BARBARA ED. D. OLLHOFF. *Visual Merchandising DACUM Study and Curriculum.* Pewaukee, Wis.: Waukesha County Technical College, 1992.

GRAVES, MAITLAND. *The Art of Color and Design*. New York: McGraw-Hill, 1968.

HART, ELENA. "Young Men's Stores a Bright Light." *Daily News Record* 20, no. 185, September 21, 1990.

HOTCHKISS, MELVIN S. *Merchandising Display*. Austin: University of Texas Press, 1972.

KOENIGER, JIMMY G. *You Be the Judge: Display*. Columbus, Ohio: Ohio Distributive Education Materials Laboratory.

KRIENKE, MARY. "Boutiques Exotiques." *Stores* 75, no. 9, September 1993.

LUSTIGMAN, ALYSSA. "Playing up Presentation." *Sporting Goods Business* 27, no. 1, January 1994.

Mall of America Inc., Bloomington, Minn., 1993.

MATTESON, MICHAEL T., ROGER N. BLAKENEY, and DONALD R. DOMM. *Contemporary Personnel Management*. San Francisco: Canfield Press, 1972.

"Megastores That Entertain and Educate May Signal the Future of Merchandising." *The Wall Street Journal Marketplace*, March 11, 1993.

MOIN, DAVID. "At Bergdorf Goodman: Art and Atmosphere with an Edge." *Women's Wear Daily* 164, no. 102, November 30, 1992.

MOIN, DAVID. "At Bloomingdale's: Fashion First; Whimsy Second." *Women's Wear Daily* 164, no. 102, November 30, 1992.

NELSON, GEORGE. *Display*. New York, Whitney, 1968.

PAGODA, DIANNE M. "Spruce up to Stir Sales." *Women's Wear Daily* 165, no. 20, February 1, 1993.

PAPANEK, VICTOR. *Design for the Real World*. New York: Bantam Books, 1973.

Principles of Merchandising Display & of Merchandise Display Workbook. Austin: University of Texas, Distributive Education Division.

REYNOLD, TOM. "Four Retailers Discuss Their Signage Programs." *Visual Merchandise & Store Design* 124, January 1993.

SAMSON, HARLAND E., and WAYNE G. LITTLE. *Display, Planning and Techniques*. Cincinnati: South-Western, 1979.

SIMONE, JOHN. "Visualizing the Future, the Direction of Display." *Visual Merchandise & Store Design* 123, August 1992.

SPEARS, CHARLESZINE WOOD. *How to Wear Colors with Emphasis on Dark Skins*, 5th ed. Minneapolis: Burgess, 1974.

Store Lighting—Interior and Exterior. New York: Illuminating Engineering Society, 1980.

Stores. New York: National Retail Merchant Association Publishers, 1980.

ZELANSKI, PAUL and FISHER, MARY PAT. *Color*. Englewood Cliffs, N.J.: Prentice Hall, 1989.

GLOSSARY

Accessorizing: Incorporating appropriate accessories with the apparel merchandise on selling fixture or mannequin.

Accessory outpost: A selling fixture(s) on which accessories are arranged to reinforce a nearby apparel theme away from the home-base department.

Achromatic: Description of neutral colors, such as black, white, or grays, that are either totally reflective or totally absorbent of light.

Analogous: Description of a color scheme that consists of from three to five or more different hues, placed consecutively on the color wheel and including no more than one-third of the wheel.

Angled front: Store window that parallels the sidewalk but angles away from the sidewalk contour.

Arcade front: Store window and frontage type that is very open in sweep.

Asymmetry: Lack of similarity of two sides of a display. Provides an inter–relationship of parts to form an esthetically pleasing whole.

Atmosphere lighting: Lighting that plays light against shadow to create a distinctive effect in specific displays.

Balance: Artistically, the state of equipoise between the totals of the two sides of an entity.

Black-light display: Displays in which ultraviolet fluorescent lamps are used in areas of reduced general light level.

Boutique: A small shop selling accessories and separates.

Chroma: Degree of saturation.

Chromatic: Description of colors, such as red, yellow, and blue, whose colors or hues are due to their respective reflective properties.

Closed-back window: Window that is shut off from the store completely by partitions.

Color: The presence of light as it is reflected from the surface of an object.

Color schemes: Ways that are calculated to combine colors successfully through the use of a formula (i.e., use of a color wheel).

Complementary: Description of a color scheme consisting of two colors or hues that are exactly opposite one another on the color wheel.

Conservative consumer (1): A person who seeks dollar value, easy care, traditional styles. Tightly-fixtured departments arranged for easy selection appeal to this customer.

Conservative customer (2): A person who seeks higher-quality, higher-priced merchandise. Face-front fixturing, environmental settings, and smaller merchandise quantities attract this consumer.

Copycards: Sometimes called signs, they do the talking for a display, providing the viewer with the desired information concerning salable items and consumer benefits.

Corner windows: On a store front, the central viewing point of converging traffic.

Counter/table displays: These displays are located in front of the stock areas bringing the goods nearer to the customer and allowing the customer to feel and touch the merchandise.

Curved lines: Artistic device, feminine for the most part, and adding flowing movement.

Diagonal lines: Artistic device, may extend from the left side to the right side of a display, thereby creating and inducing action.

Display theme: The central message in a display.

Double complementary: A color scheme consisting of four hues, widely separated and appearing on each of the four sides of the color wheel.

Dummy: A shape like a person, used for window and interior display.

Elements of display: Merchandise, shelf or display area props, lighting, and copycards.

Elevated windows: Store windows with a floor that may be raised or lowered.

Emphasis: The point that appears to be the most dominant in any particular bounded display area.

Fluorescent lighting: System of electrical energy causing phosphors to glow in a tube.

Focal point: A presentation using the point where the eye normally focuses. A key, highly visible area where the most important presentations are planned. Two kinds exist: The first occurs naturally at store entrances, aisle junctions, and escalator landings. The second is consciously constructed along aisles, inside themes.

Formal balance: The positioning of each object on the right side of a grouping with an exact counterpart on the left side in regard to size, placement, shape, and color.

Gondolas/end-of-island displays: Often called T-walls, are areas at the end of two back-to-back shelving or standing units.

Hue: Name of a color.

Incandescent lighting: System of electrical energy flowing through a very thin wire filament that resists the flow of energy. This causes it to heat up and glow.

Informal balance: Placement of objects in grouping to achieve component equality by using multiple varieties of object color, placement, size, and shape on opposite sides.

Intensity (in color): Degree of saturation.

Interdependent aisle (soft aisle): The carpeted aisle that connects adjacent departments or provides access from the main aisle to the core. Face-front fixturing and window-on-the-aisle approach encourage further browsing and sharpen the store's segmentation.

Interior displays: Displays located within a specific store and used to sell merchandise, service, and/or image.

Keyhole: The keyhole-shaped walkway of a fashion department that leads from the aisle to the mannequin grouping in the center. Face-front fixtures from the keyhole's borders.

Layering: The act of dressing the first bar of a face-front item rack with coordinated apparel and accessories to achieve an entire look and encourage multiple sales.

Layout: In lettering, the arrangement of copy, designs, or illustrations on a copycard.

Lighting: Lighting treatments are used to draw attention to part of the area or a specific item in the display or to coordinate parts of the total area.

Lobby windows: Store windows that follow the lines of deeply recessed entrances.

Mannequin: Lifelike dummy used in stores to display clothing. In French couture, refers to live model who wears designer originals.

Merchandise: The product that determines the purpose of the display; this first element of display is intended to be supported by all other elements.

Merchandise display: The arrangement and organization of display materials and merchandise to attract the viewer's attention and induce action; it is visual selling and acts as a silent salesperson.

Merchandise statement: A concentrated merchandise presentation of specific category or item. All colors, sizes, etc., are included to promote a theme or department.

Merchandise wall: The total background of the store. Walls are used to house and display basic merchandise categories and certain nonbasic cate-

gories (long items such as gowns, jumpsuits, etc.) and to help back up merchandise stories featured on the selling floor.

Monochromatic: Description of a color scheme that consists of one basic hue, which may appear at any point on the color wheel.

Motif: A main theme or subject to be elaborated on and developed.

Nonpromotional: In display, a store employing little advertising and few promotional techniques.

Open-back windows: Store windows open to the street-floor area.

Optical center: In lettering, it is one-tenth the distance above the true center.

Platform display: Used to raise mannequins off the floor at the side of an aisle.

Primary lighting: Bare essentials of store illumination.

Principles of design: They combine to create purposeful, effective, esthetically pleasing entities. Whether in the fine arts, commercial arts, or visual merchandise, they appropriately coordinate al parts of display in varying degrees.

Progression of sizes: Artistic principle of using similar shapes in varying sizes and consistently increasing them in size along the visual path.

Promotion (a noun): A long-term event of higher-quality, higher-priced merchandise with better markup. The market demand determines a promotion's duration. Themes and shops are good examples of promotions.

Promotional: In display, refers to the store that is committed to a policy of aggressive advertising and promotion.

Proportion: The ratio of one aspect of the display to any other.

Props: In display, includes all physical objects within the display area that are not considered salable merchandise.

Pyramid: A triangular arrangement culminating at a center peak created by the extension of two equal lines extending from a base.

Radiation: In art, either side of a sunburst effect.

Ramped windows: Store windows with elevated floors that form a display area slanted to the front.

Repetition: In display, an artistic device designed to align items in exactly the same manner as to height, spacing, and the angle at which they are placed.

Repetition of shapes: Repeating similar shapes throughout the display at regular intervals for emphasis.

Rhythm: In display, the measurement of motion, measure, and proportion culminating in the eventual flow in the entity.

Secondary lighting: In display, spot- and floodlights to augment basic window lighting.

Selling: In display, the five principles of selling are to attract the attention of the passerby, arouse interest, create desire, win confidence, and cause the decision to buy.

Semiclosed-back window: Partitioned store windows extending to a height below the line of vision.

Semipromotional: In display, refers to the type of store that promotes its products, but not vigorously.

Shades: Those hues that are closest to black.

Shadow-box windows: In display, small windows inside or outside a store, suitable for small items.

Shape: The visual form of an object.

Shop: A long-term promotion area where an entire merchandise category gets maximum exposure in a small, concentrated place in an overall department.

Size: Physical magnitude, extent, bulk, and dimension of an object.

Split complementary: A color wheel consisting of three hues, one determined as the basic hue in the scheme and the other two appearing on either side of the basic hue's complement.

Stage: The name some stores assign to the area farthest from the entrance, which needs a very strong visual presentation to draw attention from a distance.

Step: In display, a level elevation within an area.

Store: Retailing establishment. Stores may be classified as suburban, self-service, dealer, and exclusive shop.

Straight front: Store windows that parallel the sidewalk, with only entrances to break the monotony.

Symmetry: Interrelationship of parts to form an esthetically pleasing whole.

Texture: In display, the aspect of harmony relating to the sense of touch.

Tints: Those hues that are closest to white.

Tone on tone: A color scheme of two hues, next to each other on the color wheel with very little space between them.

Triadic: A color scheme of three colors equidistant from one another on the color wheel.

Value: A color's range of grays, from white through black.

Vertical line: A line whose direction is from the top to the bottom of a given area. A straight, upright line; when used, it gives a rigid, severe, and masculine quality to an area.

Visual merchandising: Presentation of a store and its merchandise to the customer.

Zigzag: A line based on the principle of the double-reverse curve.

INDEX